D0073208

GOVERNING CULTURES

ART INSTITUTIONS IN VICTORIAN LONDON

Governing Cultures

Art Institutions in Victorian London

Edited by Paul Barlow and Colin Trodd

ASHGATE

© Paul Barlow and Colin Trodd, 2000

All rights reserved. No part of this publication may be reproduced, stored in a retrieval system, or transmitted in any form or by any means, electronic, mechanical, photocopying, recording, or otherwise without the prior permission of the publisher.

The authors have asserted their right under the Copyright, Designs and Patents Act, 1988, to be identified as the authors of this work.

Published by
Ashgate Publishing Limited
Gower House
Croft Road
Aldershot
Hants GU11 3HR
England

Ashgate Publishing Company
131 Main Street
Burlington, VT 05401–5600
USA

Ashgate website: http://www.ashgate.com

British Library Cataloguing-in-Publication data

Governing cultures: art institutions in Victorian London
 1. Art museums – England – London – History – 19th century
 I. Barlow, Paul II. Trodd, Colin
 708.2'1'09034

Library of Congress Cataloging-in-Publication data

Governing cultures: art institutions in Victorian London / edited by Paul Barlow and Colin Trodd.
 p. cm.
 Includes bibliographical references and index.
 1. Art and society – England – London. 2. Art – England – London – Societies, etc.
 3. Art, English – England – London. 4. Art, Modern – 19th century – England – London. I. Barlow, Paul II. Trodd, Colin

 N72.S6 G685 2000
 706'.0421–dc21

 00–0038989

ISBN 1 84014 690 7

Printed on acid-free paper

Typeset in Palatino by Manton Typesetters, Louth, Lincolnshire, UK and printed in Great Britain by the University Press, Cambridge.

Contents

Figures

Contributors

Paul Barlow lectures in Art History at the University of Northumbria at Newcastle and is reviews editor of *Visual Culture in Britain*. He has published widely on many aspects of Victorian art, aesthetics and cultural theory. Recent essays on Leighton, Millais and avant-garde narratives are to be augmented by a jointly authored book with Colin Trodd on Carlyle and Victorian visual culture.

Stephanie Brown lectures in Art History at the University of Newcastle. She has written widely on different aspects of the visual arts. *Intimations of Mortality* (Arts Council/Available Light, 1995), her most recent book, was co-edited with Stephen Hobson.

Emma Chambers is Curator of the College Art Collections, University College London. Her research interests include nineteenth-century print culture and art education. *An Indolent and Blundering Art? The Etching Revival and the Redefinition of Etching in England, 1838–1892* was published by Ashgate in 1999.

Sara Dodd is an Associate Lecturer for the Open University in the Yorkshire region. Her publications include essays on Atkinson Grimshaw and the role of women artists in Victorian society.

Duncan Forbes is a Curator of the Photography Collection at the Scottish National Portrait Gallery. He is currently preparing a manuscript on the institutionalization of art in early nineteenth-century Edinburgh.

Lara Perry lectures in the Faculty of Continuing Education at Birkbeck College, and is the co-editor of *Modernities and Identities in British Art, 1860–1914* (Manchester University Press, 2000).

Alison Smith is the Special Projects Curator for the nineteenth-century British collection at the Tate Gallery, London. The author of many essays and articles on Victorian painting and cultural criticism, *The Victorian Nude* was published by Manchester University Press in 1996.

Greg Smith has been Assistant Keeper of Art at the Whitworth Art Gallery in Manchester and Head of Exhibitions at the Design Museum. His most recent book is *The Business of Watercolour* (Ashgate, 1997), which he co-wrote with Simon Fenwick.

Nicholas Tromans is Course Leader of the BA programme at Sotheby's Institute for Fine and Decorative Art. The author of a number of articles in *Apollo*, the *Burlington Magazine*, *Journal of the Warburg and Courtauld Institutes*, and the *Revue du Louvre*, he wrote his doctoral thesis on David Wilkie at the Barber Institute, Birmingham.

Colin Trodd lectures in Art History at the University of Sunderland. His publications include *Victorian Culture and the Idea of the Grotesque* (Ashgate, 1999), which he edited with Paul Barlow and David Amigoni, and *Art and the Academy in the nineteenth century* (Manchester University Press, 2000), which he co-edited with Rafael Cardoso Denis.

Shelagh Wilson lectures in Design History at the University of Northumbria at Newcastle. She has published on both contemporary and Victorian design. She is currently researching the institutional and personal networks established in Social Science and Art Congresses during the later nineteenth century.

Acknowledgements

The editors would like to thank the following for their generous help with this project: Liz Astandoust, Fiorna Cairns Smith, Jan Dodshon, Trisha Dodworth, Edna Edwards, D. W. S. Gray, Janeen Haythornwaite, Alison Lloyd, Janet Seeley and Rose Pearson. In addition, we are exceedingly grateful to our commissioning editor, Pamela Edwardes, whose patience and support we much appreciate.

Introduction
Constituting the public: art and its institutions in nineteenth-century London

Paul Barlow and Colin Trodd

Who are 'the public' and what is Public Art? These questions preoccupied the founders of the art institutions which continue to dominate London today. Yet recent critical attention all but ignores the rich archive of material in which these matters are debated. This set of essays seeks to challenge the critical conventions which have developed over the last few years by looking in detail at the problems with which institutions grappled as they attempted to define and sustain their values. Resisting the vision of institutions as monoliths, these essays do not seek to uncover or deploy accounts of organizational or bureaucratic power. Matters related to the rhetoric of institutional life are acknowledged, but we seek rather to explore the dynamic, fluid and multidirectional character of institutions. Indeed, it is our contention that what is circulated by institutions is as important as how they are governed. This leads us to engage with the problem of what institutions are able to *see* and how they imagine the effects of their activities.

In this introduction we will not seek to produce a definitive overview of the various models of the institution that have been developed in recent years. However, we should note that with the emergence of 'new art history' a particular theory-culture has become fashionable in debates about the function and purpose of art galleries and museums. The characteristics of such material are worth considering. The sociological claim that cultural institutions act as agents of 'social control' has become something of a cliché of late, especially in Foucauldian guise. Carol Duncan's assertion that museums generate 'civilizing rituals' leads her to argue that nineteenth-century art galleries used 'the new discipline of art history, whose system of classification was immediately employed by the state as an ideological instrument'.[1] It is not entirely clear what 'ideological' means in Duncan's account. However, she does argue that free access to the museum created a ritual space of egalitarian community experience, but awed visitors into accepting the spec-

tacle of wealth, now redefined by art history as 'the universal spirit as it manifested itself in the various moments of high civilization'. Tony Bennett's claims in *The Birth of the Museum* (1995) are more explicit. Adopting Foucauldian gestures and rhetoric, Bennett contrasts the disciplinary régimes of Foucault's 'carcereal archipelego' (prisons and clinics) with that of the 'exhibitionary complex', which worked 'as a set of cultural technologies concerned to organize a voluntary self-regulatory citizenry'.[2] This involved 'the transfer of objects and bodies from the enclosed and private domains in which they had previously been displayed … into progressively more open and public arenas where, through representations to which they were subjected, they formed vehicles for inscribing and broadcasting the messages of power throughout society'.[3] The solution, for Bennett, is the opening of the museum to 'groups outside' who would be enabled by curators – no longer experts but 'facilitators' – to 'make authored statements' in the form of exhibitions.[4]

It is clear that here we have a straightforward model of oppression and liberation. State mechanisms use museums – like schools – to construct citizens-subjects of a kind approved by the hegemonic group, but the museum, like the state itself, can be expropriated by the community which may then control and redeploy its resources. The problem with this approach is its self-validating logic. It assumes a transparency in institutional intentions which amounts to an explanatory mechanism that is little more than conspiracy theory. It further ignores the problem that displayed images and objects are not readily or fully articulable as 'messages'.

While we would not deny the importance of the Utopian vision of the 'egalitarian' museum space during the nineteenth century, as described by Duncan and as fantasized for the future by Bennett, we would see this imagined community within the complex of aesthetic, political and social values which circulated in Victorian Britain, condensing in different forms in distinct institutions, engendering divergent logics and aspirations. Likewise, the fact that some museums were engaged in the process of reconstituting the subjecthood of citizen-visitors is undeniable – indeed explicit in the case of the Whitechapel Gallery. However, Bennett's 'cultural technology' implies a curiously Benthamite model on the part of this professed Foucauldian – that a production-mechanism can be found by which human raw materials are transformed into products designed by their manufacturers. Instead we would say that the 'audience' for the museum could never be so defined (by 'power' or its objects), its activity in relation to its spaces was understood with reference to models of pleasure, control, and improvement which continually played against one another.

For this reason, the constitution, composition and consolidation of institutional spaces, their legitimation in and through social and cultural interaction,

are central to this study. That such processes of legitimation involved articu-
lations of experience that were supposedly communal or public, is, indeed,
of crucial importance. How, we might ask, did institutions seek to discover a
'public' identity with which to address the public? What sort of problems
did this model face or fashion? If, as we argue, the relationship between
public identity and the identity of the public is crucial, then our examination
of the proliferation of art institutions in Victorian London is connected to the
debates which emerged during the eighteenth century concerning the nature
of Public Art, and of the 'body of the public' itself, to borrow the subtitle of
John Barrell's seminal examination of these ideas in *The Political Theory of
Painting from Reynolds to Hazlitt* (1986). Barrell's now well-known thesis is
that for painters such as Reynolds the style and form of art were understood
as articulations of social values. These were initially, in the early eighteenth
century, defined by critics in terms of civic humanism:

> The republic of the fine arts was to be structured as a political republic; the most
> dignified function to which painting should aspire was the promotion of public
> virtues; and the genres of painting were ranked according to their tendency to
> promote them. As only the free citizen members of the political republic could
> exhibit those virtues, the highest genre, history-painting, was primarily addressed to
> them, and it addressed them rhetorically, as an orator addresses an audience of
> citizens who are his equals, and persuades them to act in the interests of the public.[5]

Barrell claims that these aesthetic and political values persisted throughout
the eighteenth century, but were increasingly compromised as theorists at-
tempted to come to terms with the development of commercial society and
its attendant values, in particular the valorizing of individual entrepreneurial
action and consumption. For Barrell, Hazlitt's attacks on Reynolds and his
dismissal of the conception of a 'republic of taste' represent the final defeat
of civic humanist aesthetics, though he accepts that throughout the nine-
teenth century Ruskin continued to stake a claim for the socially 'unifying
power of representation', in which landscape becomes 'the expression of a
love of liberty which can no longer find satisfaction in the civic life'.[6]

 While acknowledging the importance of Barrell's account of eighteenth-
century theorists of History Painting, we would take issue with his conclusion
that art theory during the later nineteenth century was characterized by the
stress on the 'individualism' he ascribes to Hazlitt, or that the concept of a
republic of taste ceases to be of importance. Belief in civic values and in
spaces of public experience unified by 'taste' continues to be central to
debates about art and the role of institutions. Indeed, as Duncan Forbes
shows in his discussion of the Art Union of London (Chapter 8), its defend-
ers saw themselves as engaged in an attempt to reconstruct values corrupted
by the Royal Academy, which had 'converted a republic of art into an aris-
tocracy'.[7] Likewise, the painter and critic George Foggo promoted fresco for

the decoration of the new Houses of Parliament because, he believed, it engendered civic values, as opposed to the 'luxurious' style encouraged by the oil medium and by aristocratic culture. In this, Foggo's views are consistent with Blake's earlier attacks on Reynolds, and on the colourist tradition in general.

Public art and the body of the public

It is this relation between theories of art and of the public, we would argue, that is central to an understanding of the rationale for art institutions during the Victorian period, not only in the writings of Ruskin, but in the governmental actions which established the National Gallery, National Portrait Gallery and South Kensington Museum (V&A). The various patrician, philanthropic and commercial practices of the institutions discussed in this book are also profoundly implicated in the debates with which Barrell deals, and from which the belief in the civic function of art has not disappeared.

This point is evidenced in public debate about the relation of art to its audience, and the mediating functions of institutions. In 1886 the *Pall Mall Gazette* published an article entitled 'At the East-End "Academy"', an account of the loan exhibitions organized in St Jude's church, Whitechapel, by the Reverend Samuel Barnett and his wife Harriet. The Barnetts' activities are discussed in detail in this volume by Shelagh Wilson (Chapter 11), who examines the relationship between these philanthropic exhibitions and the image of Whitechapel – the 'evil quarter mile' of the 1888 Ripper murders, and prime locus of *fin de siècle* anxieties concerning bodily and spiritual degeneration.

This may seem a far cry from the gentlemanly 'citizen members of the political republic' described by Barrell, and indeed the concept of the 'public' with which the *Gazette* engages is profoundly different. However, it is clear that the issues of citizenship, pictorial rhetoric and narrative painting are still central to the debate with which the periodical deals. The article begins with an account of the 'annual' debates in Parliament concerning 'whether the masses care for high art, whether they would like to have good pictures to look at on Sundays, and whether if they had, they would derive any pleasure or profit therefrom'.[8] These references to Parliament and to a body alien to it labelled 'the masses' marks the problems with which this book deals, the activities – discursive, legislative, social – of public institutions such as Parliament itself and the imagined bodies they seek to articulate or even to constitute: the mass, the public, the market, the community. The *Gazette* indicates that the parliamentary debates engage with intersecting problems. The masses are invoked as consumers, whose desires and preferences are to be identified (what do they like?), but these preferences, the

pleasures to be got from art, are understood within an account which takes aesthetic judgement as the province of Parliament, or at least of social agencies to which Parliament has access ('good' pictures are *known* to Parliament, but merely *experienced* by the masses). In the end the *Gazette* conjoins the terms 'pleasure or profit', leaving open the question of the kind of pleasure which 'good pictures' might give (as opposed to what other pleasures?) and the meaning of the profit to be had. Is the community to profit, or the individual? How is this profit to be understood, assessed, measured?

Accompanying this article were three illustrations (Figure 0.1).[9] The first depicted a rough-looking working-class family standing before a picture. It was captioned 'Consulting the Oracle'. The second, 'The Symbol', showed a socially lowly but neat and respectable couple, possibly a clerk and his wife, looking at another painting. In the third, a man surrounded by a crowd – Reverend Barnett himself – is pointing to a painting of a ruined castle. This was labelled 'The Gospel of Art'. Each of these illustrations explores the problem of the connection between social class and aesthetic experience, the independent gazes of the visitors, or their articulation by the explanatory mechanisms established in the gallery, epitomized by the figure of Barnett, preaching to the community through art. The article stated that the first illustration depicted a man who was explaining the painting to his family, having learned its meaning from the catalogue. The painting at which he looks is itself entitled 'Consulting the Oracle', but the caption plays on the 'oracular' status of the catalogue, and of the working-class paterfamilias himself, now possessor of the knowledge it contains. This pun is repeated in the next image, which shows the self-improving couple pointing at people in the painting. The occupants of the picture, another couple, seem to shrink back from these interlopers on whom they look down. The painted couple are clearly depicted as socially (and literally) higher than their viewers. For them, the banal and lowly people pointing at them are an intrusion. They react like film stars at a gala première, with haughty disdain. The illustration implies a connection between aesthetic pleasure and wealth, a connection threatened by the sincere efforts of the artisanal couple to engage with 'high culture'. The 'lower orders' are both invoked and resented by this image.

The painting at which this couple look is Sir Frank Dicksee's *The Symbol*, from which they are separated by a rigid barrier and by the frame of the painting itself. This pattern of forced distance, intrusion, alienation and threat was a theme of exhibition criticism ever since the first fully public Victorian display of art, the 1843 Westminster Hall show of preliminary studies for historical paintings in the new Houses of Parliament, discussed in this book by Paul Barlow. The *Punch* cartoon 'Substance and Shadow' (Figure 0.2) was published to coincide with the opening of this exhibition. It showed ragged, emaciated figures gazing blankly at portraits of wealthy,

Oracle" is about. Sometimes the tables are turned, and there is no prettier sight in the exhibition than that of some sharp lad—who has stolen half an hour in the morning to go round with his catalogue—bringing his father and mother with him in the evening, and showing them the points in his favourite pictures. Mr. Ruskin, in his evidence before one

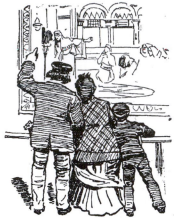

"CONSULTING THE ORACLE."

of the National Gallery Select Committees, said that what the common people wanted were good modern pictures of domestic pathos. "Nothing assists them so much," he said, "as having the moral disposition developed rather than the intellectual after their work; anything that touches their feelings is good, and puts new life into them." That is exactly the principle on which the promoters of this Whitechapel exhibition have acted. Here in our next sketch is "a couple" looking at

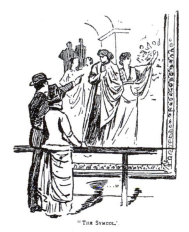

"THE SYMBOL."

Mr. Frank Dicksee's "Symbol," which is thus explained to them in the catalogue :—

A wedding party has broken up, and the revellers pass merrily down the stairs. "Smiling they live and call life pleasure ;" but in the shadow below is one to whom "the cup of life has been dealt in another measure." The old man asks for alms, and holds in his hands a crucifix—the symbol of self-sacrifice. "Is it nothing to you, all ye that pass by?" he asks. The plaintive question catches the bridegroom's ears ; and he is startled in a moment into the sense that sacrifice is nobler than pleasure.

Close to this picture hangs Mr. Briton Rivière's "Enchanted Castle."

What proportion, we wonder, of those who saw it in the Academy in 1884 would not have been glad enough—if they had dared to confess it—of such a help to its enjoyment as the following little entry in the catalogue :—

In all nations there is a legend of an enchanted castle, where rich treasures are to be found, but which is left untouched by the fear of men, and is guarded by beasts. Men cannot reach their hopes, such legends tell us, because of their passions and their fears—symbolized in this picture by the tigers that are "burning bright" between the pillars, and the adders and poisonous lizards that crawl about the polished floor. At last one man—like the Knight in Tennyson's "Sleeping Beauty"—strong in the strength of faith and inspired by the love of a woman, whose scarf he wears, is brave enough to face the dangers ; before love and faith the enchantment is broken and by one man's sacrifice the hopes of many are realized. The Sleeping Beauty is awakened, and "evermore a costly kiss" becomes "the prelude to some brighter world."

All precious things, discovered late,
To those that seek them, issue forth ;
For Love in sequel works with fate,
And draws the veil from hidden worth.

The catalogue does not, however, exhaust Mr. Barnett's "resources of civilization" for adding to the attractiveness of his show. Many of the visitors are "no scholards"; others do not care to spend their penny on the catalogue. For their sake it is that oral explanations are occasionally given. On the Select Committee referred to above, one of the members remarked how, "upon one occasion, a friend of his stopped in one of the galleries and explained some of the objects, and at once a very numerous crowd was attracted round him, until the officials ordered him to move on." There are no such restrictions at Whitechapel. This sketch, for instance, shows one of the crowds that assemble

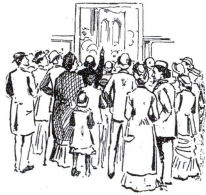

THE GOSPEL OF ART.

from time to time, and follow Mr. Barnett as he makes the circuit of the rooms and tells his visitors "all about it." Who are the visitors, it may be asked? They are very literally all sorts and conditions of men, from the West-ender who goes down to see how the common people behave, to the factory girls who couldn't tell you why they go, but for whom the pictures have a strange fascination, and who wander in, evening after evening, when their day's work is done. Mr. Barnett and his friends do not expect to regenerate the world by their picture shows, nor do they affect to believe—as the disputants at St. Stephen's sometimes do—that a general Sunday opening of museums would inaugurate the millennium. They only say—in the mottoes printed on their catalogue—that as "life without industry is guilt," so "industry without art is brutality," and that even the smallest service "is true service while it lasts." Any one who cares—just as the three months' picture season is beginning in the West—to subscribe towards the £150 that are wanted to pay for the three weeks' season now closing in the East may at any rate be assured that his charity will do no harm—which, to judge from the recent correspondence in our columns, is about as much as in this tangled world anybody has a right to expect.

A Paris correspondent telegraphing yesterday says :—"The weather is intensely hot and oppressive, and there have been some cases of sunstroke to-day and yesterday. Paris is crowded with tourists. The trees in the parks, boulevards and gardens are as leafy as at midsummer. I never saw the flower markets so well supplied. This morning I bought an armful of cowslips and other field flowers, including violets, with lilac, tulips, wallflower, and pink hawthorn, for a franc. I had enough to brighten up a couple of rooms."

0.1 'At the East-End "Academy"', *Pall Mall Gazette*, 2 April 1886

SUBSTANCE AND SHADOW.

0.2 John Leech, 'Substance and Shadow', *Punch*, March 1843

complacent individuals. Though these are clearly not the Westminster pictures, *Punch* is asserting that 'public art', such as the Westminster mural-studies, is to be understood in relation to the wider problem of the Condition of England, and that the claims of public culture are thus bound up with those of a public which incorporates the very alien 'masses' discussed forty years later in the *Pall Mall Gazette*'s article.

However, the differences between *Punch*'s 'Substance and Shadow' and the *Gazette*'s 'The Symbol' are crucial. *Punch*'s figures are depicted as wholly alien to the realm of culture, or the exercise of 'rational recreation', a problem discussed here by Colin Trodd in his account of the early years of the National Gallery (NG). In contrast, the self-improving couple in the *Gazette*'s illustration are directly interacting with the painting, forcing it to acknowledge their presence. Beneath its illustration, the *Gazette* quotes the entry in the Barnetts' catalogue, which describes the subject of Dicksee's painting. The characters, we are told, are leaving a wedding party. The newly-weds, stop as the bride plucks a flower from a plant. The husband, however, has seen an aged beggar holding out his hand for alms. He looks down at the beggar, feeling guilty that

he has been indulging in his own happiness. At that moment, 'he is startled into the sense that sacrifice is nobler than pleasure'.

This caption identifies the 'symbol' of the painting as the prostrate beggar, but the illustration places the standing, self-sufficient lower-class couple in place of this now invisible sign of social helplessness. They have become 'the symbol', of their claim on art and the response of 'art' (the fictive couple) to that intrusion into its space.

We have examined this little-known illustration because it connects the debates of the 1840s with those of the 1880s, and because it indicates the complex of problems with which this book deals. In particular, it illustrates the ways in which both the content of art and the definition of 'the aesthetic' are inseparable from the consideration of institutions and their development. This brings us back to Barrell's claims concerning the influential theorists of the early nineteenth century, whose ideas about how art should be exhibited, taught, or collected were so important to the establishment of the institutions covered in this book.

William Hazlitt was concerned with the very question of 'taste' among the populace as a whole. B. R. Haydon and his associates, such as Foggo, were likewise preoccupied with the mechanisms of art education, and the social identity of art. Haydon in particular was active in the often acrimonious debates about the reform of the Royal Academy (RA) and the establishment of schools of design. These problems were crystallized by the 1835–36 Parliamentary Select Committee on Arts and Manufactures, which epitomized the attempts to construct a post-1832 'Reform' agenda for public involvement in the visual arts and design.

Haydon, the most prominent critic of the RA, attempted to promote his work through independent exhibitions. This attempt to integrate 'public' art with commercial enterprise was allied to contemporary attacks on monopolies and restrictions on trade, associated with artisanal and mercantile critiques of pre-Reform Parliament and the vested interests of landed aristocracy. Haydon seems to have believed that a new community of taste could be brought into being through the interaction of individual creative genius with the body of the populace as a whole. But this new community of connoisseurs was inevitably 'virtual', manifest only in response to the exhibitions. This problem is central to the nineteenth-century examination of the condition of 'the public'. It is, of course, bound up with the emergence of urban mass culture itself, and with the much wider question of mass participation in government. While Reynolds could be assured that the 'audience of citizens' was knowable, united by the capacity to respond to rhetoric, for nineteenth-century commentators the public is increasingly construed, as we have seen, as a multiple, alien, fractured body, whose responses may not be predicted. This is the difficulty with which the *Pall Mall Gazette* deals, and

it is locked into its concern with the 'oracular' status of the catalogue, the chain of knowledge linking art to audience, and its image of an art threatened by that very audience.

These problems are already evident in the tensions between Haydon's, Foggo's and Hazlitt's opinions concerning the construction and identity of the community for art. Haydon, as we have seen, articulates his views with specifically political rhetoric. He is concerned to encourage public action through Parliament for the establishment of schools of design and the commissioning of public art. He believes that a reform of art on the principles of 'nature' will produce a community of taste in which the identity of genius with common experience will become manifest.

Hazlitt's position, though in agreement with Haydon as regards the need to constitute a public for art which resists the blandishments of the corrupt RA, is wary of the demagogic tendencies implicit in Haydon's claim to conjure up a new audience. It is in Hazlitt's response to Haydon that we see many of the concerns with which subsequent commentators dealt as they wrestled with the problem of the rationale for art institutions. Barrell rightly points to the attack on Reynolds's theory of types (the 'central form') as crucial to Hazlitt's project to generate an art and art criticism which will acknowledge the irreducibly multiple character of modernity. While Haydon holds to a belief in History Painting as the genre which may fully represent public values, Hazlitt's responses to art are deliberately dispersed – though with a telling emphasis on portraiture and on Hogarth's 'modern moral' painting. These emphases are important in laying the foundations for the debates which engendered the National Portrait Gallery and the Tate Gallery later in the century.

In essence, Hazlitt's view is that objects which exist in nature cannot, or at least should not, be analysed into general types, as Reynolds recommends. For Reynolds, of course, the particularities of a given object should not be represented, instead it is the function of high art to reveal its typical form. In Hazlitt's view, to adopt this method is to alienate oneself from the object itself, to claim a pseudo-Platonic position of indifference towards the specificities and sympathies inseparable from experience. Hazlitt's mode of writing about art is consistently directed towards an aesthetic education, the attempt to engender in the reader sentiments characteristic of *experiences*. Hazlitt's essays, on a seemingly endless diversity of topics, seek to identify in the modern social scene the possibility of an open form of cultural engagement, one which might acknowledge that the pleasures of art are also those of social experience itself and that the articulation and discrimination of these pleasures constitutes aesthetic value. For Hazlitt, the critic displays a culturally and socially enriched sensibility before images. His own descriptions continually suggest a 'stream of consciousness' in which the image

engenders fragmentary memories – of lines of verse, of experiences – which are reactivated by contemplation.[10]

For Barrell, the democratic possibilities of this approach are chimerical, as Hazlitt believes that the majority cannot enter the community of taste. While that may be so, the important point remains that this 'community' is fluid and is constituted in and through the sensibility which Hazlitt's writing seeks to engender. Our reason for considering this point is that it is closely involved with anxieties concerning the mediating functions of institutions. Hazlitt was suspicious of Haydon's attempts to constitute a public for 're-formed' historical painting, allying Haydon's methods with demagoguery. Haydon's 'puffing' of his own exhibitions by advertising them in the press was directly attacked by Hazlitt in his review of *Christ's Agony in the Garden* (1821). Hazlitt draws attention to the crowd in the background, which he describes as an unruly 'mob', manifesting Haydon's rabble-rousing tendencies.[11]

Of course, Hazlitt's language indicates the current anxieties about the agency of the mob and the oratorical powers of those who would seek to harness its power. Since the French Revolution the concept of what Barrell called 'an orator addressing an audience of citizens … and persuading them to act in the interests of the public' had a distinctly radical potential. Indeed, a study of 'Boadicea Haranguing the Iceni' at the 1843 Westminster exhibition was condemned in H. C. Clarke's guidebook because the 'violence of the action and dashing lights carry us away like the speech of a mob orator'.[12] The rhetorical character of history painting as recommended and practised by Haydon activated such implications. Hazlitt's own emphasis on the complexities, discriminations and details of communal social encounters resists this claim on oratory.

Haydon had long campaigned for national historical art of the kind displayed in 1843, but the most interesting account of the value of civic public art came from George Foggo, another artist who was strongly critical of the RA.[13] In a lecture, Foggo claimed that fresco was a medium peculiarly suited to democratic government. In a highly tendentious account of the history of the medium he opined that the 'hereditary mercantile aristocracy' of Venice encouraged oil painting, while fresco flourished under the 'popular governments' of the Tuscan republics. Wishing to appeal to 'the great body of the citizens', leading figures spent liberally on 'statues illustrative of favourite patriots and pictures commemorative of national events'. However, the spectre of revolution fatally compromised this system. The opening of fresco-decorated private houses to the public was not possible, 'for in times of turbulence and frequent contention no prudent man could admit promiscuous crowds into his own residence'. Sadly, the Church hierarchy took advantage of the situation in order to extend its power. It provided public spaces for fresco,

but, fatally, religious subjects were insisted upon, 'thus, at little or no ex-
pense, the church became possessed of the direction of art and patronage; it
influenced the elections and the people, whilst candidates for power thus
purchased the good will of the clergy and the votes of the citizens'. In this
corrupt state of affairs all pretence to democratic government was finally
abandoned. In Florence the Medici established themselves as yet another
hereditary aristocracy,

Then fresco, so long supported on municipal rights declined, and a softer and more
luscious style grew, like a parasitical plant on its withered stump. For near three
centuries fresco, and with it the once mighty genius of historical art slumbered, and
the exertions of a spurious progeny proved unintellectual. At length, after the
political convulsions of the present century men's minds began to long for a change.
But in most countries court influence or individual patronage, and not the spirit of
free municipal institutions, directed, controlled, the newly kindled aspirings of taste,
and their favour, as usual, promoted imitation, and not original independent
genius. Hence the artists of Munich imitate and copy Italian masters, and the
English are instructed to follow the steps of German imitations without attention to
circumstance.[14]

Foggo's words were reprinted in Clarke's guidebook to the Westminster
exhibition. Clarke's own appended comments seem more sceptical, but he
endorses Foggo's claims concerning the connection between luxurious style
fostered by aristocratic taste and the popular character of fresco. In Britain,
the 'combined influence of the nobility and the RA had for seventy years
impelled artists to the almost exclusive cultivation of colour, chiar-oscuro,
aspect, breadth and texture'. But now 'the palette knife had to be laid down
for the trowel, clothes, furniture, neatness and comfort were all smothered in
lime dust and mortar, burnt hands and hard labour became familiar to our
artists'.[15] Such explicit assertion of the connection between fresco-painting
and manual labour implies that the artist, with Carlylean devotion to toil,
participates in the condition of the labouring classes in order to burn away
the luxuries of excess. This salutary and medicinal corrosiveness reveals the
essence of community, which was hidden by the corruptions of the clergy
and aristocracy described by Foggo.

Here, then, the process by which public art is produced forces the artist to
enter the experience of the class to which he must communicate. By 'hard
labour' the artist is able to realise the identity of labour itself, and in so
doing to manifest the body of community in art. For Foggo, it is clear, this
process is problematic. Property, it is implied, inevitably alienates public art
from its community. Yet without it such art cannot be sustained, for the
'promiscuous crowds' are only ever the recipients of the bounty of 'prudent
men'. Property is continually threatened by this mass promiscuity, but is
itself both the condition and the corruption of communal culture, always
forced to displace itself in favour of despotic institutions which alienate the

people from public business. This paradox is implicit in much of the debate at this time. Hazlitt had approved the view that Burke's *Reflections on the Revolution in France* and Paine's *Rights of Man* should be 'bound in a single volume'.

Here, then, is the condition in which the early Victorian engagements with cultural institutions were undertaken. Haydon's own use of the independent exhibition is paralleled by that of other artists, including Blake (1809), Gericault (1820), and later W. P. Frith (1862) and Ford Madox Brown (1865). In the case of Blake, Haydon and Brown, such exhibitions were anti-institutional gestures. However, in all cases the mechanisms of commerce and the appeal to a public equated with the consumer, was a condition of the exhibition. The contradiction between these aims is explicit in Haydon, who committed suicide after the commercial failure of his last exhibition, staged in competition with an alternative attraction – Tom Thumb.

The proliferation of commercial exhibiting, marketing and consumption of images lies behind much of the discussion of the 'elevation' of taste, or its collapse into mediocrity which informs the rhetorics of the British Institution, the Art Unions, the RA and the NG. The British Institution, as Nicholas Tromans here demonstrates (Chapter 2), sought to deploy aristocratic patronage in order to maintain a space in which the values of 'disinterested' connoisseurship could be maintained against the frankly commercial RA Summer Exhibitions. As Duncan Forbes also shows (Chapter 8), the Art Unions were regularly attacked as organizations in which middle-brow taste was institutionalized.

The NG was established as a means to provide a national, and therefore public, space for art which would indeed be available to the body of the nation as a whole. But here, as Colin Trodd points out (Chapter 1), the promiscuous body of the public came to be seen as a physically corrupting, undisciplined mass whose very bodily presences violated the surfaces of the art against which they came.

Cultural spaces, public experience

This point brings us back to the problems with which Hazlitt was engaged and which were later expressed by the *Pall Mall Gazette*. How can we determine or constitute culturally legitimate communal experience? It is clear that the model for most public institutions in the period of the 1830s and 1840s was the 'private' gentleman's collection of pictures, with which, indeed, the NG began, with the purchase of J. J. Angerstein's collection. In so far as Hazlitt and other critics are concerned with the question of how such works were to be understood by the wider community, they were not significantly

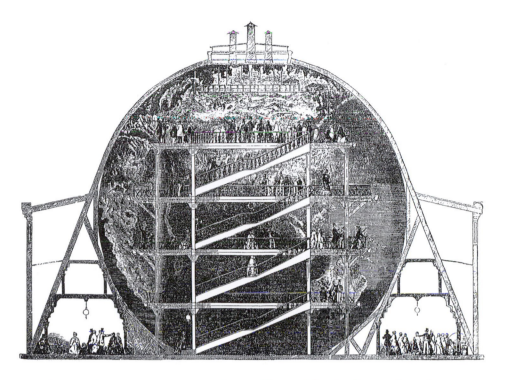

0.3 'Wyld's Monster Globe', Leicester Square, *Illustrated London News*, 23 June 1857

departing from the central political problem of the time, that of maintaining
continuity of property and culture in an urban industrial society dominated
by the potentially promiscuous crowd and the mechanics of commerce, in
particular the emerging forms of commercial entertainment epitomized not
only by Tom Thumb, but also by the technological spectacle of panoramas
like 'Wyld's Monster Globe' (Figure 0.3). For later writers, seeking the cul-
tural 'elevation' of the labouring classes, the issue of alternative pleasures, in
the alehouse, music-hall or nickelodeon, was central, as Shelagh Wilson
argues (Chapter 11).

Such matters are relevant to the question of the interaction of the commu-
nity with art, and the geographical location of that community. The Tate
Gallery was built on the site of a prison. As Alison Smith points out (Chapter
12), this irony was not lost on contemporary commentators. The Whitechapel
Gallery was, as we have seen, in the heart of what was considered the most
degraded location in the metropolis. This issue of the space of public culture,
of where public as opposed to private experience occurs, is significant. The
period under consideration here is one in which the cultural organization of
the secular space of the city becomes increasingly important. The establish-

ment of Trafalgar Square as a 'public' centre of London dominated by the
NG and, for a while, the RA, occurs alongside the rebuilding of Parliament
during the 1840s and 1850s.

Debate about the location of galleries was filled with anxieties about the
traversing of urban spaces. Pimlico, Whitechapel and Bethnal Green were all
seen as dangerous areas. As Lara Perry argues (Chapter 9), when the Na-
tional Portrait Gallery was housed at Bethnal Green, its accessibility to the
cultured public became entwined in debates about the extension of the fran-
chise. The traversing of the space of London forced citizens to encounter
alien extra-'public' identities. This problem of the city and the gallery space
is related to that of the audience for art. Illustrations of Whitechapel often
show a utopian community of visitors, comprising all classes mixing freely.
In contrast, the British Institution, the British Museum and the early build-
ings in which the NG and NPG were housed were criticized as restrictive,
overly 'genteel' spaces. Here, then, we have the double identity of the urban
gallery, that which forces into visibility the disturbances of the city, condens-
ing it for the gallery-goer forced into alien territories. Alternatively it offers a
'free' arena in which such tensions are dissipated. We will consider the
implications of this for contemporary commentary on the experience of the
gallery shortly, but at this point it is important to raise a theme that is dealt
with in this book by Greg Smith and Duncan Forbes (Chapters 7 and 8) – the
common claim that Victorian culture is 'middle-class' in character. This issue
is bound up with one of the recurring debates in Victorian culture – whether
there is a specifically 'British' school of art and how it is to be understood or
evaluated. It is not possible to examine in detail here the many and varied
discussions of this subject, but it is connected to the institutional histories
with which this book deals because the incarnation of the British school in a
particular place is inseparable from the question of national identity itself.

The status of British art is an issue that this book identifies at several
points. Robert Vernon's donation of modern British art to the National Gal-
lery in 1847 was incorporated into its Trafalgar Square building, but was
marginalized within the collection (Figure 0.4). The next major donation, the
Sheepshanks gift, was made to South Kensington, dedicated to commercial
and imperial values, rather than the NG. Discussions about the combination
of these collections, along with Turner's works, occurred during the century.
Similarly, the NPG was believed to express 'British' individualism. By the
end of the century the attempt to assert the existence and status of national
art was revived with the Tate Gallery, just as, slightly earlier, the Slade
School of Art had been implicated in debates about contrasting British and
French systems of training, as Emma Chambers shows (Chapter 6).

This issue is tied in with the debate on taste because of the common claim
that Victorian art is expressive of middle-class values, and that these values

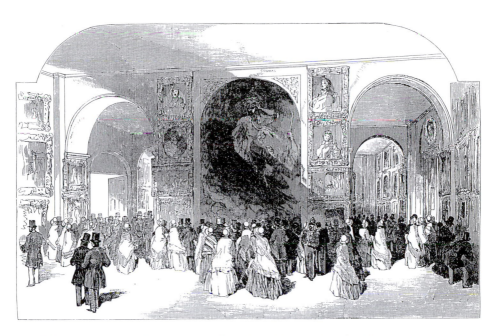

0.4 'The Vernon Gallery in the National Gallery', *Illustrated London News*, 4 November 1848

are themselves aesthetically 'mediocre'. Such correlations of class and taste raise a complex of problems. They are further complicated when female creative activity is added to the equation. In this book, Stephanie Brown and Sara Dodd (Chapter 5), cutting across traditional feminist accounts, examine the institutional incarnations of 'female art' in relation to the wider problem of aesthetic status. Thus the watercolourists, discussed by Greg Smith (Chapter 7), bolstered their precarious claim on serious professional status by denying 'amateur' female membership of their societies, while the Society of Female Artists adopted a purely economic rationale in which defence of professional 'standards' played no part. Chambers shows that the Slade encountered a middle-class female clientele who increasingly experienced the school as consumers rather than as apprentices, redefining its institutional imperatives.

There is indisputably a tendency within Victorian culture to claim that 'universal' experiences and common sympathies are expressed by artists in the tradition of Wilkie. The eager crowd all entranced by the 'picture of the year' at the RA is a commonplace illustration in newspapers. Such matters can be related to the way in which institutions were encouraged to frame aesthetic experience for popular audiences. James Fergusson, the architect and cultural manager, giving evidence before the National Gallery Site Com-

mission (1857), was asked about the 'taste' of the working-class audiences visiting Crystal Palace, a key venue in the development of institutions where popular pleasures were subject to the principles of 'rational recreation'. He replied:

> The most successful thing which has been done [there] has been the formation of the Picture Gallery ... When the other parts of the building are comparatively empty you always find a mass of people in the Picture Gallery. The sculpture they do not understand so much, the architecture they look upon as fine and curious, but they seem to have the idea that it is a mere building. They see buildings in the street, and they do not see anything wonderful in it.[16]

The fascination with the way in which mechanics and artisans experience paintings, the desire to make them see correctly and discriminate between different orders of experience, is a feature of the critical materials which address the identity of cultural institutions throughout this period. This was often expressed as an anxiety that the spaces of public experience were subject to the material forces of social life: that experience of the monumental fragmentation of urban space was the position from which members of a 'mass' audience read art. To this perceived problem about the nature of the conditions in which working-class visitors enter the public art realm, two positions were formulated in mid-Victorian London. Both accounts dealt with the problematic relationship between social and aesthetic spaces by seeking to specify the value of cultural leisure in the interplay between recreation and education, popular instruction and public knowledge.

The first position involved the classification and organization of collections according to historical principles. In a letter appended to the Report on the National Gallery, C. T. Newton, the curator of Classical antiquities at the British Museum, stated:

> We cannot appreciate art aesthetically unless we first learn to interpret its meaning and motive, and in order to do this we must first study it historically ... Museums should not merely charm and astonish the eye by the exhibition of marvels of art; they should, by the method of their arrangement, suggest to the mind the causes of such phenomena.[17]

Here the systematic accumulation of objects establishes the relational field which orders the information the subject gains from using the institutional spaces of display. The appreciation of cultural meaning, organized by the experience of cultural space, becomes a process of endless expansion and incorporation, the most obvious manifestation of which was the opening of the Nineveh Room at the British Museum in 1853 (Figure 0.5). Newton argues for the formation of a total environment, a place in which spectators read the vastness of historical development from the managed details of objects subject to an 'archaeological' method of display. Thus in imagining the British Museum as a metropolis of culture, a kingdom of time whose

HUMAN-HEADED AND EAGLE-WINGED BULL.

again, but in the act of standing motionless. The countenance is noble and benevolent in expression; the features are of true Persian type; he wears an egg-shaped cap, with three horns, and a cord round the base of it. The hair at the back of the head has seven ranges of curls; and the beard, as in the portraits of the King, is divided into three ranges of curls, with intervals of wavy hair. In the ears, which are those of a bull, are pendent ear-rings. The whole of the dewlap is covered with tiers of curls, and four rows are continued beneath the ribs along the whole flank; on the back are six rows of curls, and upon the haunch a square bunch, ranged successively, and down the back of the thigh four rows. The hair at the end of the tail is curled like the beard, with intervals of wavy hair. The hair at the knee joints is likewise curled, terminating in the pro-

file views of the limbs in a single curl of the kind (if we may use the term) called *croche cœur*. This elaborately sculptured wings extend over the back of the animal to the very verge of the slab. All the flat surface of the slab is covered with cuneiform inscription; there being twenty-two lines between the fore legs, twenty-one lines in the middle, nineteen lines between the hind legs, and forty-seven lines between the tail and the edge of the slab. The whole of this slab is unbroken, with the exception of the fore feet, which arrived in a former importation, but which are now restored to their proper place.

No. 2 represents the Human-headed and Winged Lion—9 feet long, and the same in height; and in purpose and position the same as the preceding, which however it does not quite equal in

execution. In this relievo we have the same head, with the egg-shaped three-horned head-dress, exactly like that of the bull; but the ear is human, and not that of a lion. The beard and hair of the head are even yet more elaborately curled than the last; but the hair of the legs and sides of the animal represents that shaggy appendage of the animal. Round the loins is a succession of numerous cords, which, we commented in a former article, is distinctly visible. The strength of both animals is admirably and characteristically conveyed. Upon the flat surface of this slab, as in the last, is a cuneiform inscription; 20 lines being between the fore legs, 25 in the middle 18 between the hind legs, and 71 at the back. J.B.

HUMAN-HEADED AND WINGED LION.

0.5 'Nimroud Sculptures at the British Museum', *Illustrated London News*, 26 October 1820

values escape the contingencies of the modern city, he sees in it the 'breadth' and 'unity' of art itself. Transcending its scientific methodology, the historicist discourse would transform the museum into a total art work; the space of the gallery becoming a transparency of culture in its purest state

in which the nations of the ancient worlds are grouped together in one great historical composition, and long intervals of time and space so abridged and foreshortened, that the mind embraces the whole complicated perspective readily and without fatigue. It might be said that juxtaposition is a relative term, that if so many and so manifest relations may be perceived between different classes of antiquities, these antiquities might be as conveniently compared if distributed in separate museums as if all under one roof. This is not the case; the comparison of objects in contiguous compartments or galleries is a very different thing from that strain of mind which takes place when we attempt to transport in our memories, through the thoroughfares of a crowded city, those fine shades of distinction in which classification mainly depends.[18]

The museum, generating an environment for history, manages space by making of it a series of coherent representations which establish the conditions for a visitor to experience knowledge as the classification of information. As the institutional logic of the museum is the catergorization of objects, the gallery-space codifies time, storing and revealing it; directing the viewer to his capacity to remember the differences and distinctions that comprise the universe of things becomes the mark of public experience.

Where Newton's historicist discourse locates the value of the experience of the visit in terms of the capacity of the collection to present itself as an ensemble of historical relations, Charles Kingsley's image of the value of gallery experience for a 'popular audience' is rather different. Historicist methodology, framing art through its serial arrangement, makes the gallery space and historical development symbiotic elements within a sequential pattern. Kingsley, though, offers a quasi-meditative vision, one that finds in art the practical forms of a common social identity or sensibility. This attitude is essentially Hazlittean. To be sure, where Newton's concerns are with a certain productivity of vision – visitors are obliged to 'work' to understand how they should understand the collection – Kingsley follows Hazlitt in presenting the gallery as a place of enchantment and reverie, although his fantasized space does not lead to the intensification of the sensual pleasures Hazlitt associated with the act of looking at art. However, for both Kingsley and Hazlitt, works of art work when they transform the experience of vision.

In 1848, using the pseudonym Parson Lot, Kingsley wrote an article for the Christian Socialist journal *Politics for the People*. Considering at length the value of the NG to a working-class audience, he claimed that 'Picture Galleries'

should be the workman's paradise, and garden of pleasure, to which he goes to refresh his eyes and heart with beautiful shapes and sweet colouring, when they are wearied with dull bricks and mortar, and the ugly things which fill the workshop and factory.

He continues,

if he can get the real air, the real trees, even for an hour, let him take it, in God's name; but how many a man who cannot spare time for a daily country walk may slip into the National Gallery for ten minutes. That garden, at least flowers as gaily in winter as in summer. Those noble faces on the wall are never disfigured by grief or passion. There, in the space of a single room, the townsman may take his country walk – a walk beneath mountain peaks, blushing sunsets with broad woodlands spreading out below it; a walk through green meadows, under cool mellow shades, and, overhanging rocks by rushing brooks. [Thus] his hard-worn heart wanders out free, beyond the grim city – the world of stone and iron, smoky chimneys and roaring wheels, into the world of beautiful things.[19]

Creating a narrative around the efficacy of space, Kingsley writes in order to enclose space, to find in it the complete reconciliation of social and aesthetic experience. If space is made to speak of a pleasure which gestures to something beyond itself, writing becomes the attempt to witness and embrace this epiphany. The place of absorption and purification, Kingsley's image of the cultural institution is one in which the worker projects himself as a subject at the moment in which experiencing pictorial space becomes a fantasy of the liberation from the space of work, which is to say, the material reality of city life. In describing the public value of the gallery experience, Kingsley wants to generate a moment of aesthetic embodiment when a specific image galvanizes a public body into being. If he writes vision as a form of collective, ritualized reverie, this is because he wants his *ekphrasis* to illuminate the homely nature of the plenitude which the gallery constitutes and commemorates. Here paintings become 'real' by tracing a presence beyond themselves, by inhabiting an authentic public space which is the complete fusion of the personal and the social.

That critical discourse was patterned in and through investments in the conditions of assembly imagined in the act of framing an audience, or writing the idea of gallery experience, can be confirmed when we examine how other bodies were articulated in the cultural press. In 1844 we find the following piece in the *Athenaeum*:

The boys of the Marylebone Workhouse, about three hundred in number, paid a visit to the National Gallery last Tuesday. The arrangements to prevent confusions were complete, each boy following close upon the other's heel, having secured his line of march by encircling with his left arm the rail which prevents a too near approach to the pictures. The perspective effect of this living line, threading in and out around the room, had a singular effect, and was not unlike some huge vertebra of grey cloth and brass buttons.[20]

In the movement from a coercive to a cultural institution, in the journey across the institutional spaces of the city, these modern subjects of the 1833 Poor Law Act are themselves subject to a particular process of aestheticization. Their mode of assembly – collectivized, massified, militarized – invokes both mechanical standardization and Hogarth's serpentine line of beauty. This is a sort of alien aesthetic: display, framed by the act of description, works through a system of seriality in which each subject is seen in the context of the social body it helps embody. Entering the space of the art gallery, these beings become absorbed by its pictorial logic, hovering between art ('perspective effect of this living line') and the fantasized body it generates ('huge vertebra of grey cloth and brass buttons'). This alien presence is figured as a form of consumption: marking and noting these subjects is an act of constituting the experiential conditions for imagining an art public unified through the act of reading.

What we are suggesting is that accounts of the formation and circulation of bodies in art galleries were linked to debates about how a community for art could be visualized in these new public spaces. If exhibitions were places where the display of social behaviour was monitored, the desire for such readability was endlessly complicated by the differential patterns of social assembly within such sites. Furthermore, as we have implied, the social relations of city life are traced across many contemporary readings of the governing cultures which frame the life of museums, galleries and teaching institutions throughout the Victorian period. So, having demonstrated that such issues are entangled with ideas about the constitution of a public for art, this introductory essay concludes by looking at a specific example of institutional public art, Leighton's frescoes in the V&A: works which attempted to sustain the Public Art tradition in the midst of a museum devoted to commerce, consumption, and empire.

The vitreous avatar

What type of cultural logic was at work in the formation and development of an institution such as the V&A? It could be marked out as an environment of accumulation, a place that wanted to fashion itself from structures, systems and processes that absorbed objects into networks of information and knowledge, multiplying its powers over them. As Paul Barlow and Shelagh Wilson point out in this book (Chapter 10), it has become customary to characterize these processes as evidence of an imperial project written into the institutional history of the V&A. Such an approach fails to explain what particular values and interests were served in and by the formation of what we might call the material culture of the institution itself. It could be argued

that the increase in the number, range and type of artefact collected and displayed at the V&A, enabled it to become a total institution of culture, one which surveyed all others within the spheres of art and design, consuming and reconstituting them within new economies of cultural management to create multiple communities of objects. From this we could postulate that such systems of display (objects placed in vitrines, illuminated and system-atically framed) connect the artefact with the commodity, the gallery experience with the locales of shopping, and the space of culture with the landscape of consumption. Such a view is not without its charms. It would enable us to claim a certain sort of symmetry to our cultural history of art institutions by projecting the culture–city relationship as the governing force of institutional legitimation. But does the theory that art institutions work to institutionalize and spectatorialize the cultural logic of capitalism, suturing the rational recreation of the self-fashioning citizen and the commodity de-sires of the consumer-subject, really work? We can begin to address such matters by looking at two works by Leighton, both of which were created for the V&A.

Tim Barringer has argued that *The Arts of Industry as Applied to War* (1878–80), and *The Arts of Industry as Applied to Peace* (1884–86) (Figures 0.6 and 0.7) are locked into accounts about the institutional registration of modernity because they deal with the 'libidinous relationship between people and things; the curious fascination of the commodity'.[21] So, instead of placing Leighton within the Reynoldsian tradition of academic Public Art, Barringer suggests that such images surface within a privatized realm of consumer pleasure: 'shopping, commodity fetishism, and the desiring gaze' constitute the conceptual terrain in which he analyses the meaning of these composi-tions. However, we would argue that the invocation of such theory is a way of denying the capacity of such images to articulate, embrace or engage with a Public Art aesthetic, and that to do so is to perpetuate Barrell's error when he implies that Victorian critics and artists made little in the way of a claim about the capacity of art to embody or constitute social or public values.

Although we would not seek to deny that the objects represented in Leighton's images are commodities, we are not convinced that the theory of commodity fetishism is adequate to their explication. In Marxist theory com-modity fetishism refers to a double process of alienation: of worker from the material processes in which labour is managed and organized; of consumer from the real conditions in which the object is made. Commodity fetishism, then, refers to the way in which the technologies and régimes of industrial capitalism seek to disconnect the commodity from its physical nature, render-ing it spectral or uncanny. If Marx called this process of alienation grotesque, this was because he was attempting to explain the contradictory characteris-tics of urban modernity, its spaces, experiences, markets and institutions.

0.6 Frederic Leighton, *The Arts of Industry as Applied to War*, V&A 1878–80

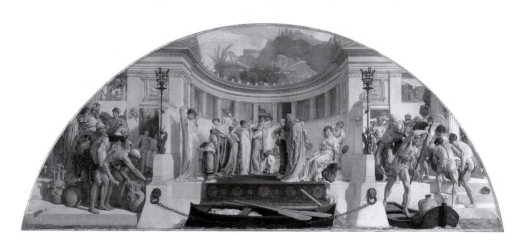

0.7 Frederic Leighton, *The Arts of Industry as Applied to Peace*, V&A 1884–6

The question is: do these images engage with the phatasmagoric space in which commodity fetishism is generated? If so, how is commodity fetishism pictorialized or registered within the visual logic of these works? And how would we recognize the pictorial character of commodity fetishism? What does it look like? These fundamental concerns alert us to the complex problem of writing the social life of paintings as they enter into engagements with public experience and its legitimating processes. All we can suggest here is that as neither image represents a specific moment within the material history of industrial capitalism – nowhere do we get a hint of the régimes of labour it is reproduced by or, indeed, the social relations of leisure and

consumption it engenders – it is difficult to see how commodity fetishism is in any sense constituted in these compositions.

What, then, do these images represent, and how can these representations be connected with the continuation of a Public Art aesthetic at the end of the nineteenth century? To be sure, both display an indisputable fascination with dress, jewellery, textiles, ceramics, glass, armoury and other luxury goods; but, far from revealing the alien nature of things within specific social environments, these communities consecrate the community of objects in constituting themselves *as* communities. Far from registering a moment of alien presence, Leighton presents us with a variant of a civic humanist vision, one which is in keeping with the Reynoldsian model of History Painting as the endless theorization and embodiment of the beautiful. That is, the idea of beauty is made to realize itself in a public space where it is manifest in shared social values and actions. Both images offer the prospect of a community narrative rather than a demonstration of commodity fetishism: not only do these Florentine and Athenian communities have access to the life of things, these objects come into being because in belonging to the public experience of these cultures they contribute to the processes of socialisation. What we see, then, is a double fantasy landscape of use-value in its purest sense; the prelapsarian time of public space where the object reveals itself by speaking the identity of the relations between people and things which is the life of the community.

This returns us to the status of the V&A itself. If it was a rationalizing institution, whose bureaucratic culture worked to demystify its collection of exotic things through the power of tabulation, then Leighton's images performed a sort of reverse magic: the demonstration of an imaginary history which is the wondrous charisma of the object; the articulation of its sacred position within those symbolic economies of representation where the community makes itself, speaks itself, repeats itself. Such works contrive to replay the Reynoldsian position, but from within the matrix of commerce: now the distribution of objects is a way of designing culture and fashioning subjects for whom all consumption is cultural and therefore beautiful. Here refinement, elegance and opulence seep into the character of form itself. Flowing into the Public Body, luxury, refigured as the endless commerce of things, appears as the illuminating material fabric of social life itself.

Such images connect two themes which run through the following essays. First, what critical resources did cultural agents use to engage with, or contribute to, the Public Art and commerce theories of modern culture, its promotion and progress? Second, how did museums and galleries seek to demonstrate their public identity through the display and orchestration of specific art objects? By reading Leighton's images through a double process of pictorial and institutional logic, we begin to grasp the complexity of the

traditions to which they belong. Of course, we associate Leighton with Aestheticism, which saw in itself evidence of the escape of art from historical contingency into a state of transcendent purity beyond the logic of commercial society. Here it could be argued that the aesthetic – and this was how Marx saw it – is fetishized as a quasi-religious experience, something endowed with magical qualities and properties. Indeed, if the institutional setting of Leighton's quasi-Raphaelesque compositions is equated with the resistance to the fetishism of commercial society, in his projection of the symbiosis of art and commerce we still find the relics of culture-worship. Because both images enact the act of wonder which forms the basis of worship, what is fetishized here is the imaginary resolution of the tensions between art and commerce. Here, at the close of the century, we find images devoted to culture fetishism, not commodity fetishism. It is our contention that these concerns about the articulation and constitution of the spaces of public experience connect Leighton with the debates about the institutional values of art we find in the claims made by Hazlitt, Haydon and Foggo. What, then, do we claim? It is our belief that the richness and longevity of the Public Art tradition should be an important element in any future projects which reassess the periodizing logic that has trapped the Victorian art world between the critical respectability of eighteenth-century History Painting and the self-validating purity of modernism.

Notes

1. Duncan 1991, p. 95

2. Bennett 1995, p. 63. Other works which share some of these characteristics include: Duncan, C. and Wallach, A. 'The Universal Survey Museum', *Art History*, 3, 1980, pp. 448–69; Duncan, C. *Civilising Rituals: Inside Public Museums* 1995; Sherman, Daniel J. and Rogoff, I. (eds), *Museum Culture*, 1994; Hooper-Greenhill, E. *Museums and the Shaping of Knowledge*, 1992; and Coombes, A. E. *Reinventing Africa: Museums, Material Culture, and Popular Imagination in Late Victorian and Edwardian England*, 1994. As in the case of Brandon Taylor's recent *Art for the Nation* (1999), what tends to happen in this type of research is that cultural institutions are defined as places which function in order to produce codifiable messages. If, as we indicate in this introductory essay, it is simply wrong to reduce the problem of institutional identity to issues of power, regulation and control, this suggests that further work needs to be conducted into the relationship between the formation and development of models of cultural management in the Victorian period and the contemporary material which attempted to outline or define the nature of the public experience of art. How, why and in what context, did different institutions seek to engage with or resist competing models of communal value? Is it the case, for instance, that the history of Victorian cultural institutions is the history of the impossible desire to reconcile Utilitarian and Arnoldian definitions of the function of culture in the development of the public life of citizens? Or is it because of the ineluctable antagonism between these two models of institutional identity that we discover the contradictory nature of the need to institutionalise culture for a 'mass' public? Such questions call for further critical investigation into the very archives that many of the essays in this volume seek to retrieve from critical neglect.

3. Bennett 1995, pp. 60–61.

4. Ibid., p. 104.

5. Barrell, 1986, p. 1.

6. Ibid., pp. 338–9. A point made clear in the periodizing logic which informs *Painting and the Politics of Culture 1700–1850* (1992), a later collection of essays edited by Barrell. Although they provide valuable material about the structure of ideas which support the execution of eighteenth-century painting, none of the essays in this volume address the complex of issues which lead towards Victorian culture's own alignment with a Public Art aesthetic, whether through institutional, critical or pictorial processes. Indeed, Haydon's demise, which is presented as the final alienating failure and death of civic humanism, is the end-point of a book which must close by implying that Victorian art is a culture of negation.

7. See Forbes, Chapter 8, p. 000.

8. *Pall Mall Gazette*, 28 April 1886, pp. 1–2.

9. Two vignettes appear on the first page: an intense-looking bearded (Jewish?) man – 'The Constant Visitor'; and a young, gangly woman – 'An East-End Beauty'. The illustrations discussed appear on p. 2.

10. These points are elaborated in Barlow 1990. Funnell (1995) and Postle (1995b) also examine Hazlitt's role in the changing reputations of Hogarth and Reynolds as embodiments of Britishness in art.

11. Hazlitt, 1930–34, vol.18, p. 144.

12. Clarke 1843, p. 19.

13. Foggo 1835. See also Colin Trodd's essay on the RA (Chapter 3).

14. Clarke 1844, p. iv. The eccentric hyphenation of 'chiaro-scuro' is Clarke's.

15. Ibid., p. v.

16. Parliamentary Papers, 1857 *Report*, para.2631

17. Parliamentary Papers, 1857 *Report* Appendix 2, p. 164.

18. Ibid.

19. Kingsley, Charles, *Politics for the People*, 6 May 1848, pp. 5–6

20. The *Atheneaum*, 13 Janurary 1844, p. 44.

21. Barringer 1999, p. 149.

I

National taste: from élite to public?

Part I examines the foundation of those national art institutions which dominated Victorian London. The Royal Academy was, of course, a pre-Victorian institution. It had been in existence for over half a century before the Victorian 'moment' with which this book begins. However, it was the struggle over the identity and future of the RA that crystallized early-Victorian debates about the meaning and prospects of national culture. While Reynolds and his associates in the 1770s had been primarily concerned to establish a national 'school' of art, the early Victorian critics of the RA saw in its *institutional* structure an embodiment of the confusion between truly public and élite values. The insistence among reformers that the RA should be either wholly private or wholly accountable to representative government epitomizes this position. The attempt to construct national cultural institutions from the constitutional struggles of the 1830s lies behind these debates.

The essays in Part I, therefore, all deal with the complex of political, commercial and aesthetic values which functioned during this period and which were manifested in the attempts to reform the RA and to construct from élite leisure-practices institutions through which the nation could come into being as a community of taste. The British Institution is a clear example of the institutional structures and cultural assumptions characteristic of early Victorian aristocratic patronage, while the National Gallery itself emerged from this same cultural context. The Palace of Westminster – identified with the old aspiration to create a British school of history painting – engendered a scheme of decoration in which civic and courtly values were organized in an intricate, if uneasy relation to one another.

What the early Victorian history of all these institutions involves is an attempt to manifest in institutional form the idea of the nation itself. In doing so, they opened spaces in which identity of the 'public' came to be debated.

The paths to the National Gallery

Colin Trodd

The public – the public, and none but the public – shall have a National Gallery, a Royal Academy – demand especial legislation, committees of taste, to tell this public what it wants, which it ought to know very well of itself, if the said public hath any individual bodily existence.[1]

No authority has ever informed the public what it is conceived the National Collection ought to be, of what it should consist, how it is to advance towards completion, what is to be its purpose.[2]

When you go to a painter's studio and ask him to show you a picture, he does not run upstairs with it and hang it out at the window of the third storey and tell you to go out into the street and look up at it. No; he puts it on an easel, level with your eye, wheels the easel into the best light, and you really *see* the work. Now in a rationally contrived gallery you ought to be able to see *every* picture just as easily and comfortably as that. And if I and others who think with me had our will about the National Gallery, every picture in it would be as accessible and as easily seen as if it were still on the easel in the studio of the master who painted it.[3]

We are placed before a space given over to vision, but how is vision recorded here, and what does it allow us to see? What are we looking at when we view the National Gallery (NG)? How do we approach it as a historical object and cultural institution? What routes and pathways do we need to discover and traverse? What problems do we uncover on our wanderings? What do we encounter there? How was this institution built into the habits and practices of cultural experience? What traces did it leave there? What values was the NG locked into and what processes did it block or intensify? These questions, just a few of the many that confront us, provide the foundations for an essay that seeks to connect what we might call the dynamic of institutionalization to the traffic of cultural discourse. This work, then, searches for a way of describing the possibility of aligning (or reconciling) institutional identity and critical commentary; or a way of delineating how it was possible to possess this thing, the NG, in the multiple registers of

'Nation', 'State', 'People' and 'Culture'. How were these projections of pos-
session made? How was the space of the institution imagined and what was
it imagined could be found there? These are the gateway questions that form
our route into the historical density of this, the most socially significant of
art galleries in Victorian London.

Making the National Gallery and modelling art

In April 1824 Lord Liverpool's government purchased, for £57,000, the
collection of the late banker John Julius Angerstein, and displayed paint-
ings by Claude, Raphael, Sebastiano del Piombo and others in Angerstein's
residence at 100 Pall Mall. Under the administration of a keeper, William
Seguier, but effectively managed by a powerful group of patrician-trustees
including Lord Farnborough, Sir Charles Long, Sir George Beaumont, Sir
Thomas Lawrence, the Prime Minister, Lord Liverpool, and the Chancellor
of the Exchequer, Frederick Robinson, the NG opened to the 'public' on 10
May 1824.[4] Space was at a premium: no more than 200 people could con-
gregate at any one time in the display areas. That the trustees treated the
gallery as a continuation of their own private cultural interests can be
found in two sets of evidence. First, the Chairman of the trustees, Lord
Farnborough, declared that, as working people found it difficult or impos-
sible to understand art, they should not imagine a NG would be of much
value to them.[5] Second, the informal or private nature of NG business is
confirmed by the fact that the trustees, known as a 'Committee of Gentle-
man', did not meet on a regular basis until 1827; and, indeed, minutes of
their meetings were not made before 1828, when, with the arrival of Sir
Robert Peel and George Agar-Ellis, a somewhat more 'modern' model of
administration seems to have developed.[6]

Although we know surprisingly little about the early management and
administration of the NG, the parliamentary debates recorded in *Hansard*
suggest some degree of political interest in the constitutional workings of
this new venture. However, the actual opening of the institution made virtu-
ally no impression on the journals and newspapers of the period.[7] From the
evidence we possess – and this is comparatively scant – the place seems to
have been run not unlike a club for connoisseurs. The *Morning Chronicle*, for
instance, found in the birth of the NG evidence that beauty would be dif-
fused throughout 'cultivated society'.[8] Complementing Farnborough's claim
that those in 'inferior stations' lacked the prerequisite skills of aesthetic
judgement and discernment,[9] another dominant institutional figure, Agar-
Ellis, soon to be Lord Dover, made this interesting observation in one of the
rare opening notices:

[This] acquisition ... forms undoubtedly a most important era in the history of the arts in this country ... Our artists might, possibly, have gone and studied in Italy ... [but] the great body of the people, the middling classes, as well as very many of the higher orders could not ... have done this; and therefore, their only chance of becoming acquainted with what is really fine in art, was the establishment of a National Gallery.

He went on to claim that:

To have a gallery of paintings generally and frequently seen, there must be no sending for tickets ... its doors must be always open, without fee or reward, to every decently dressed person; it must not be placed in an unfrequented street, nor in a distant quarter of town. To be of use, it must be situated in the very gangway of London, where it is alike accessible and conveniently accessible to all ranks and degrees of men – to the merchant, as he goes to his counting house – to the peers and the commons, on their way to the respective houses of parliament and to the men of literature and science, on their way to the respective *societies* to the King and the Court ... to the frequenter of clubs of all denominations – to the hunters of exhibitions (a numerous class in the metropolis) – to the indolent as well as to the busy – to the idle as well as the industrious.[10]

Here two points are immediately evident. First, Agar-Ellis affirms that the NG catered for 'all ranks and degrees of men', but his list – containing a rather less expansive body of beings – comprised a different configuration, and one perhaps best described as corresponding to what commentators called 'fashionable' or 'cultivated' society. His image of the NG public overlaps with members of a political public, or those aspiring to representation by political culture; his vision of the NG is one where companionship, fashion and leisure form an organic continuum. Second, the reference to the 'indolent' and the 'idle' is significant. As we shall see, by the 1840s and 1850s such terms acted as derogatory appellations in the lexicon of institutional criticism: 'loungers' denoted the materialization of a sub-public within the public spaces of cultural pleasure where leisure, fashioned by instruction, was a labour of sorts; 'idlers' declared the presence of those members of the 'lower orders' for whom cultural institutions were not venues for the demonstration of 'rational recreation'. Agar-Ellis, of course, associates idling and indolence with the performance of gentlemanly leisure: they are part of the body semiotic of fashionable society; key elements in a social network which indicates freedom from the thralldom of work itself.[11] That the rituals of fashionable society blocked the needs of other segments of the social body was recognized by some commentators dealing with the NG in the relatively early years of its existence. In 1842, the *Athenaeum* suggests that the trustees should avoid closing the building in the second part of September, and for the duration of October, simply because 'the town' was elsewhere during this period. 'The autumn', it opined, 'is just the season when the Gallery would be frequented by working men and mechanics.'[12] This sense of the

luxuriousness of leisure, and of its ritualized performance in the exhibitory sites of the fine arts, confirms that the original public for the NG was peculiarly selective, and this despite the nature of official government rhetoric.[13]

The ceremonial nature of the NG in the 1820s and early 1830s, being an extension of the rituals and practices of assembly one associates with a Pall Mall élite, would hardly have been conducive to the idea of the 'homely', such as it would have been experienced by artisans, mechanics and some members of the middle classes. Assuming that they could stare-down the imposing facade, these visitors would have been faced with the disorientating prospect of looking at paintings *sans* captions, or, indeed, accompanying material of any kind. The organization of the collection, then, operated to present the space of the gallery as a place of consolation or refuge for the art specialist, the connoisseur. For the ordinary visitor, the collection, 'hung without any arrangement, as chance has decided', as the eminent German art historian Gustav Waagen complained, must have offered more in the way of gnomic mystery than artistic knowledge.[14] Indeed, the original Angerstein NG, which was neither 'national' nor 'public' in the sense in which most Victorian commentators used these terms, continued an aristocratic image of the 'home' of art as a rarefied space, a place of spiritual nobility. Hazlitt's brilliant reverie on the aesthetic power of Angerstein's collection is the most noticeable example of this approach. His remembrance is of space itself disappearing into the transfiguring timelessness of perfect images, an autotelic realm of aesthetic profusion and plenitude beyond the 'shifting scenery' of modern life.[15] In such accounts the sensibilities generated by art, fashion an audience made aristocratic by the magical fecundity of the forms they survey. Here the realm of art is the space of charisma in which taste, judgement and social power constitute the wondrous unity from which the institution is seemingly made.

On 7 April 1838 Queen Victoria opened the new NG in a building it shared with the Royal Academy until 1868. However, as will become apparent, the NG's positioning within the symbolic geography of London fascinated and worried commentators. If the ceremonial quality of this entire area in and around Trafalgar Square has come to be associated with the material powers of the state, Victorian audiences were confronted with a rather less seamless cluster of monuments. Jutting into the salubrious spaces of the NG, confronting, we might say, its civilizing values, were an intriguing couple of state institutions: the St Martin's Workhouse and the St George's Barracks.[16] Both are clearly present in the map which accompanied the *National Gallery Report* (1850) (Figure 1.1). It is interesting to note that the criticisms of Wilkins's building were often made in a language that alluded to the shifting or amorphous character of this environment. Thackery describing the NG as 'a little gin-shop'; *The Times* comparing the internal arrangement of the galler-

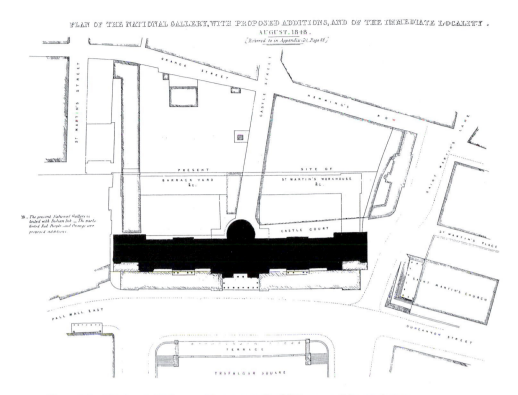

1.1 Plan of the National Gallery with proposed additions, and its environs

ies to the 'cells' of a prison; and the *Literary Gazette* suggesting that the architecture resembled that of 'the poor house', are all examples of a recognition of the sheer strangeness of a space as yet not fully determined as cultural.[17] The placing of the NG troubled some commentators, particularly with the massive increase in its yearly visitors from 60,321 in 1830 when it was still located in Angerstein's house in Pall Mall, to 503,011 when it had moved to its current site in Trafalgar Square.[18] The precise composition and social profile of such visitors is not known, but as early as 1840 the *Art Union* applauded the appearance of 'the many aproned sons of industry, not only on holidays, but on those Mondays dedicated of old to tippling and riot'.[19]

From 1838 the NG entered fully into what we might call the public discourse of art, circulating in discursive spaces knitting together such places as the library, the park, the museum, the mechanics' institute and other venues for the performance of popular recreation. In the 1840s and 1850s it was identified as a key institutional site for the reformation of public manners. Associating the inspection of art with discipline or self-control, many commentators believed the institution would act on the leisure-time of the masses,

linking the processes of aesthetic display to mechanisms of instruction, or into what Foucault has called a 'pedagogical machine'.[20] This period, then, marks the re-formation of the NG as an institution whose value was to be calibrated in terms of its 'national-popular' efficacy. A space of social utility, it no longer operated as a place remote from the machinery of everyday life. Well before Mathew Arnold's famous dictum that culture suggests the idea of the state, Gladstone's *The State in its Relations to the Church* asserted the moralizing role of public institutions of culture, claiming that 'the State offers to its individual members those humanizing influences which are derived from the contemplation of Beauty embodied in the works of the great masters of painting'.[21] Gladstone was not the only figure for whom the appreciation of art was locked into a reading of social renovation, or the projection of an image of an ideal social order. The reformist parliamentarians Sir Thomas Wyse and Joseph Hume, as well as George Godwin, editor of *The Builder* and President of the London Art Union, argued that the real public for the NG comprised those groups who 'needed' it rather than those individuals who knew how to 'use' it, and that, in the words of the *Art Journal*, 'to encourage visits to picture galleries is to promote social order'.[22]

As a consequence of such developments, the NG began to draw upon the curatorial methods and systems used in German public art galleries, this to reassess the nature of the collection and the values it embodied. Calls for the redefinition of the collection according to schools and styles were made by a number of significant commentators, such as Prince Albert, William Dyce and John Ruskin, for whom the public display of art was associated with the need to develop systems of popular cultural education. The central claim took the form of addressing the instructive value of the spatial arrangement of the collection: the visitor would, in walking through the spaces of a chronologically organized display, see the historical nature of art unfolding in rooms, corridors and the relations established between these places. This sense of the narrative power of space was tied up with an image of the public art gallery as a common place of illumination and curiosity rather than an élite place of ceremony and ritual; for the historicist model, the art work realized itself by entering a vast community of objects and styles.

From the 1840s and 1850s the NG became a space of memory: the recollection of the communal experiences and cultural relics of former societies was identified as the destiny of the public art gallery. This process of remembering should not be imagined as the dismemberment of taste, but as a new codification or calibration of value. Making the collection through the historical sequencing of objects was a way of digging a path into the landscape of art. The NG appeared as a museum when it connected 'muse' and 'use' through the fashioning of the collection working in and through space, finding in history a network of schools, styles and processes that had to be

classified and defined in order to *live* as art. As a memory machine the institution was articulated in a panoply of discursive sites – select committees, *Hansard*, cultural journals and the general press.[23] Elsewhere, Prince Albert, Dyce and Godwin, as well as Henry Clarke, the writer and publisher of cheap guidebooks, proclaimed the pedagogic value of the historicist model, with its 'scientific arrangement' and 'educational character'.[24] In each case the space of the gallery was framed as the place in which collective public experience could be expressed as experience of the historical life of art, its patterns, sequences and structures.

Collecting the past and the consolations of history

This emphasis on movements paralleled the investment in the movement of people in the NG. At the moment when art was made to 'speak' of the communities and cultures from which it was seen to emerge, the building found itself traceried by waves of bodies. The periodization of the collection was entangled with the management of space and the movement of people within it. Space chained the collection, establishing the ordering of objects for the viewer, determining the movement by which vision engaged with the workings of art. Accessing the rules and laws of art, the NG became a place where information was stored and knowledge retrieved. The ability to recognize historical coherence was therefore as significant as the performance of connoisseurship. No longer a fabulous arena in which the experience of art was the imitation of the raptures of creation, as it had been for Hazlitt, the NG became a localized site in which the collection was 'explained' through spatial arrangement and accompanying textual information. Rooted into the social fabric of space, art was to be understood as a looping process of stylistic growth and diversification; and by surveying the similarities and differences comprising the history of art, the viewer would be absorbed by the essential being of its organic form.

 As we can see, by the 1850s a fantastical institutional field developed which addressed the cartography of the visit, imagining that in the kinetics of assembly could be revealed the nature of the visit. The institution operated as an archive in which evidence concerning the truth of the visitor's vision was stored. This optical fascination shadows the historicization of the collection. The gallery was seen as a projective space in which the meaning of art became the formation and display of the relationship between different objects; between schools and styles; between moments in a single career. In 1857, Ruskin spoke of the need to bring together in a single space the works by an individual master, because 'the character of each picture would be better understood by seeing them together; the relations of each are sometimes essential to be

seen'.[25] This sense of removing the accretions that block or make blind gallery vision, as well as the need to locate history in the unfolding of the aesthetic, become crucial principles in this period. One manifestation of this process was in the affirmation of value through the idea of seriality. The *Edinburgh Review*, for instance, supported historicism because, 'it is only as a series that … pictures acquire their full value, and therefore they are particularly fit for an institution which has a corporate existence, independent of the caprice of private will and the changes in private prosperity'. Therefore pre-Renaissance art can be purchased and displayed, because although

Such works would not have been attractive to the majority of persons visiting the National Gallery… we do maintain that, as illustrating the progress of painting before the time of Raphael and Michelangelo, they constitute records of one of the most important chapters in the history of European Civilization. In this point of view, they are peculiarly fitted for such an institution as a national gallery, where they should be stored up and arranged so as to give them their full historical interest.[26]

In a sense the NG was seen to complete history: it provided a powerful space in which art revealed itself through the display of historical formations; it was illuminated by the vision of truth that it embodied. In seeking to seize or control space, this historicist discourse established a portrait of the NG: at once tracing the life of art in the connections between paintings, and thus writing the institution into the historical consciousness of objects; and also, by making narratives about experiencing the unfolding development of art, functioning as a technology in the science of periodization.

If the collection was a network of forces tending to the completion of a vision of the identity of art, the building became a maze that led nowhere and everywhere, a universe of paths, tracks, series, classifications and categorizations; a revelation or refusal of the world of things outside this realm of resemblance and difference, this place from which alienation and solitude were to be vanquished by the historical destiny of the life of art and its objects. Prince Albert, a central figure in this institutional utopianism, wanted the NG to embody a scientific model of the aesthetic:

Public opinion seems to be agreed that [the National Gallery] should be as complete a school of art as it is possible to create … that the endeavour should not be merely to form a collection of pictures by good masters, such as a private gentleman might wish to possess, but to afford the best possible means of instruction and education in the art of those who wish to study it scientifically in its history and progress.[27]

The NG would authenticate its public identity in animating the collection; as it brought the nature of art's historical being into focus; as it viewed itself as the place where historical authority connected with social space. These processes would unveil the higher values of the historical system as a way of addressing the nature of public experience; for, as *The Builder* claimed in 1857,

... improvement in art may be effected by presenting to persons even those works which may not be desirable for direct imitation; even faults and errors may be exceedingly useful subjects of instruction and still more of comparison with reference to different schools, and different masters; in what respect they excelled, and in what respect they were deficient.[28]

We recognize the interlocking processes that governed the public nature of the NG when we understand that it became a 'homely' place of mass assembly when it ordered its collection as a family of things; it emerged as an 'open' environment when it adjusted its patrician practices to the 'needs' of instruction and education. However, critics like Morris Moore argued that this process involved the suppression of the status of the object associated with traditional cultures of display. Rather than a form of enchantment, Moore defined the chronological method of organizing paintings as the means by which art was disenchanted from itself, and where the uniqueness of the individual object was surrendered by an obsession with systemization.[29]

The crowded spaces of the people's public

Shadowing the institutional ascendancy of the historicist model, we find the formation of a management discourse which examined the habits, actions and expressions of visitors inside the NG, and the environmental consequences of mass assembly with regard to the health of the collection. The act of looking at a painting became the object of an institutional gaze that calibrated vision through the rituals of the bodily, through the performance of customs and conventions of public intercourse. And these concerns were part of a set of practices which linked physicality and utility in the search to uncover the authentic public body within the NG audiences. This desire to inspect the content of the visit emerged from two imperatives. First, the need to assert the particular cultural and pedagogic characteristics of the NG, this to distinguish its identity from the institutions, buildings and places adjacent to Trafalgar Square; and second, to separate 'real' from 'false' visitors. In both cases the institution pursued its plans by focusing on the working-class body, the material form in which, it was imagined, the relationship between labour and leisure could be examined (Figure 1.2). Cultural managers, digging deep into this new landscape of popular education, became fascinated by the mysterious 'work' of leisure and the idea that consumption of recreational activity could be measured, analysed and calculated.

This interplay between social and discursive space was particularly acute when the institution repositioned itself as an environment of mass instruction rather than a place of pure connoisseurship in the 1840s and 1850s. As a space of rational recreation, however, this 'national-popular' institution was

170 APPENDIX TO REPORT OF

CIRCULAR. NATIONAL GALLERY SITE COMMIS ON.

Name and Address of Employer_____

NAME OF WORKMAN	ADDRESS OF WORKMAN	Number of Visits paid during the Year 1856 to									
		National Gallery.	British Museum.	Crystal Palace.	Marlborough House.	Zoological Gardens.	Hampton Court.	Museum of Practical Geology, Jermyn St.	Dulwich Gallery.	Windsor.	Kew Gardens.

Answers were received from Thirty-five of those to whom the above Letter and Circular were sent, and the following presents an abstract of the substance of their replies, the Residences of the Workmen being omitted.

NAME OF EMPLOYERS.	Number of Workmen.	Number of Visits paid by Workmen during the Year 1856 to										
		National Gallery.	British Museum.	Crystal Palace.	Marlborough House.	Zoological Gardens.	Hampton Court.	Museum of Practical Geology, Jermyn St.	Dulwich Gallery.	Windsor.	Kew Gardens.	
Allen, Robert, and Co., Butchers	9	1	1		1	2					
Balls, Forman, and Co., Upholsterers	28	23	22	27	17	15	13	21	3	11	
Bramah and Co., Locksmiths	26	13	14	20	27	18	8	3	1	8	35	
Broadwood and Sons, Pianoforte Makers	182	218	257	136	125	148	91	188	9	22	171	
Caldecott, William, Upholsterer	36	27	55	20	29	14	6	6	2	15	
Chance James, Carver and Gilder	28	82	26	25	24	44				
Clowes, Printer	117	290	201	129	174	82	84	81	26	22	117	
Crosse and Blackwell, Pickle Merchants	36	27	7	31	27	12	11	3	1	1	18	
Cubitt, Builder	15	8	16	11	2	4	3	2	2	5	
Farrer, Ouvry, and Farrer, Solicitors	13	6	8	7	5	13	6	1	2	4	
Faulding, Stratton, and Brough, Linendrapers	7	12								
Forrest and Son, Tailors	17	15	15	14	13	8	11	8	1	3	19	
Goding, Jenkins, and Co., Brewers	21	9	13	14	3	21	19	4	13	
Grosvenor and Chater, Stationers	33	13	18	26	8	11	15	1	4	22	
Gunter, Confectioner	29	21	26	34	18	15	14	2	7	29	
Halling, Pearce, and Co., Haberdashers	68	32	30	73	10	27	45	4	1	19	73	
Hill, Brothers, Tailors	29	85	54	28	71	30	8	11	1	27	
Hooper and Co., Coachmakers	40	60	45	33	36	23	21	14	3	5	78	
Hunt and Roskell, Jewellers	35	21	25	45	13	28	20	3	1	1	23	
Jackson, Builder	338	563	412	366	301	280	196	110	31	77	588	
Lewis and Allenby, Silk Mercers	14	12	7	20	6	13	14	3	24	
London and Westminster Bank	24	111	30	22	143	25	15	9	4	6	35	
Lucas, Brothers, Builders	122	212	210	119	62	66	34	39	11	29	56	
Maudslay, Sons, and Field, Engineers	99	123	95	142	51	60	48	15	2	7	60	
Murray, Publisher	4		1		1	4	
Newson, Builder	33	10	7	8	18	4	2	4	2	9	2	
Powell and Sons, Gas Works	57	40	62	28	30	36	18	5	1	5	23	
Smith and Elder, Publishers	50	65	72	96	31	44	29	8	5	11	39	
Spottiswoode, Printers	29	31	29	33	20	18	11	3	2	1	17	
Stiff, Potter	19	21	11	9	16	17	1	3	2	2	3	
Swan, Nash, Ironmonger	19	9	10	11	3	1	2	4	4	9	
Truefit, Hair Dresser	5			4	7	2	1	1	
Truman, Hanbury, & Buxton. Brewers	131	23	47	137	1	28	17	1	5	30	
Wood and Co., Brewers	41	3	1	8	3	1	2	3	
Whitbread and Co., Brewers	42	3	13	30	7	2		8	
Total	35	1796	2107	1839	1740	1284	1077	760	491	90	268	1536

1.2 Returns from Employers, *National Gallery Site Commission*, 1857

taken to generate a range of problems. To be sure, it was the very popularity of the NG, moving from the quasi-private space of Angerstein's residence in the salubrious and exclusive environs of Pall Mall, to the public place that is Trafalgar Square, which produced anxiety for many commentators, for whom this migration was associated with the assembly of illegitimate figures. Both Peel and Lord Russell questioned the appearance of 'idle and unwashed' persons who used the NG 'for other objects than of seeing the pictures'.[30] The fear, widely shared, was of a space penetrated by the quotidian banalities of the city, and the vagrant and fugitive pleasures of its street-life. This led John Seguier to declare in 1850 that the NG was 'in too great a thoroughfare'; 'that the rooms are overcrowded'; and that 'disfigurement' and 'destruction' of the paintings would result from the 'dust and breath' generated by crowds.[31] Clearly the worry was the formation of a space that somehow negated itself, blocking the experience of cultural pleasure the institution was supposed to embody. This was how Waagen presented the congregation of bodies at the NG. Such 'great crowds', he said, cannot be compared 'with the visitors [who] enter private collections' in either status or appearance, for they bring with them the fatal 'dust' which injures the paintings.[32]

From Waagen's definition of the crowd as the medium by which the alien and alienating city entered the realm of culture, it is not much of a leap to Frederick Hurlstone's claim that paintings were decaying because of the 'immense influx' of common visitors and the 'effluvia arising from them'.[33] If the NG needed the public in order to realize its own identity, the pursuit of that identity – through the formation of an educational culture which welcomed mass assembly – made that public impossible precisely because the popular-national discourse that sustained this approach encouraged the 'wrong' type of person. Thus certain forms of leisure were construed as forms of trespass, transgressions of the rituals and conventions the institution should have encouraged. The Assistant Keeper, Thomas Uwins, giving his melancholy evidence in 1853, spoke of 'country people' bringing 'meat and drink' into the gallery; of the 'little accidents' left by 'lower class' children; of the 'multitude' attracted by the regimental procession from St James's to St George's Barracks behind the NG; of the ubiquitous litter in the rooms, mostly in the form of orange peel. He continued:

On another occasion, I witnessed what appeared to me to evidence anything but a desire to see the pictures: a man and woman had got their child, teaching it its first steps; they were making it run from one place to another, backwards and forwards; on receiving it on one side, they made it run to the other side; it seemed to be just the place that was sought for such an amusement.[34]

Such behaviour must be corrected, Uwins believed, because it indicated deviation from the 'correct' use of leisure-time in this cultural realm. More-

over, the activity performed by these individuals seemed to undermine the desire that the public art gallery might form a transparent public sphere in which people assembled as apparently equal subjects in search of cultural knowledge. Ignoring the educational quality of this cultural environment, the crowd was taken to fracture the body of the public, thus rendering the space of art at once anonymous and alien. This anxiety that in becoming an 'open' space the NG would be dominated by individuals indifferent to cultural instruction and the civilizing virtues it encouraged, was common in the official reports of the period. The Keeper of the NG, Sir Charles Eastlake, presented the crowd as the opposite to the legitimate public, claiming that 'many persons ... especially ladies, avoid the National Gallery on account of the crowds who go there'.[35] It is as if the crowd erodes the capacity of the institution to define itself as authentically cultural and valuable. Unlike the real public in its unknowable purity, the crowd is no more than a trail of bodily traces, whose 'impure vapours' cover the pictures with 'films of dirt and grease'.[36] Destroying the discursive purity of culture and the public it would body forth, the crowd emerges as the contaminating process by which 'miasma' or 'effluvia' descend on paintings, making for them a viscous materiality. By the 1850s cultural management includes measurement of 'human exudation', because in addition to studying the effect of paintings on subjects, officials demand to know the effect of subjects on the paintings themselves.[37]

Culture, hygiene and chemistry, aligned in this institutional optic which looked at the look of the visitor, resulted in the appearance of a new type of evidence, personified in the figure of Sir Michael Faraday. When the Chairman of the 1850 Select Committee asked him if he had examined 'the sorts of people who go to the National Gallery', he replied by saying 'I have often had the occasion to observe them'. The exchange continued:

Did you observe that there were numerous persons without apparent calling or occupation who came in there to lounge, merely on account of its being in the vicinity of a great thoroughfare? – I have seen persons there, women suckling their infants, and others sitting about upon the floors, and others not looking at the pictures, but I could not say that they had not been looking at the pictures.[38]

Elsewhere this conflation of managing the collection and patrolling the quality of spectatorship was made equally clear when Uwins was asked if he had 'observed any improvement in the character of the visitors' when they looked at the paintings.[39] Space, then, could be surveyed and policed, but for the purpose of finding a knowledge that could never be seen; for how would it be possible to recognize the quality of vision? It might be one thing to remake the NG as an institution of rational recreation, but how could it be seen that artisans and mechanics displayed respect in looking at art? What sort of vision would this be? How is vision respectable? What type of vision

of social behaviour does this investment in vision suggest, desire or need? Such questions confirm that the issue of the quality of public experience was entangled with the claim that the gallery in some sense encouraged members of the 'popular audience' to define themselves in relation to 'public property'. That the idea of 'cultural democracy' connected art, leisure and politics in complex ways is confirmed by the comments made by many cultural writers in this period.[40]

The vanishing point of the National Gallery

Our journey into the matter of the NG has been an engagement with its double definition as institutional system and cultural model. This is a perpetual doubling rather than a duality of operation. It is not a question of reading off or against components and chronologies, nor is it a case of comparing the authenticity of institutional norms against the fantasy of exhibitory techniques. Instead, by witnessing the contradictory logics working through the practices of assembly at work from the 1840s, we have wandered deep into an instutional *aporia*. We have settled at two points of assembly. First the congregation of objects in such a way as to suggest public education in art by the division of the collection into navigational paths, parts and sequences. Second, and as a consequence of this 'national-popular' mode of instruction, social assembly is seen to be the occasion for new problems of social intercourse, concentrated on the intentionality of the working-class visit. It is as if the realm of culture is always about to be transmogrified into the landscape of the grotesque, the soul of art soiled by a physicality engendered by all too solid bodies.[41] A fear that values might melt, as culture became available to the masses, results in a discourse directed to, and blocked by, the collective body of the working class.

Our path has taken us to a place that is less of a public location than an archive, chamber, or depository, or their phantoms, and our journey has made us wonder at the impossible fantasy of the socialization of art through the alien crowd. And this path or journey has tracked another track or territory; for it seems that the public art gallery became the home of art at the moment when the public experience of art was beginning to lose its places of refuge in the world. That is, cultural managers and commentators formulated a model of art where the object was at once generated by and protected from time, and claimed that historical experience would preserve the expression of aesthetic value. This is what we have found in our search for the foundations of the NG or its formation and formulation in the governing cultures of the state. Yet it was possible for the mechanisms of governance to be blocked by the very processes they would govern. If the space of the NG accelerated into the

routes of history from the 1850s, and if the need to examine the flow of the crowd resulted in a fascination with the impenetrable darkness of the visitors' body, then the institution became a kind of impossible space, a heterotopia endlessly traceried (and invaded) by incompatible forces, values and requirements concerning space and its representation.[42]

Notes

1. Eagles, John, 'The Fine Arts and the Public Taste in 1853', *Blackwood's Edinburgh Magazine*, 1853, pp. 265–82, pp. 266–7.

2. *Art Journal*, 1857, p. 236.

3. Hamerton 1873, p. 243.

4. Martin 1974.

5. Farnborough 1826, p. 2.

6. See Trodd 1994.

7. See Whitley 1930, p. 73.

8. *Morning Chronicle*, 20 November 1824 (unpaginated).

9. Farnborough 1826, p. 2.

10. Agar-Ellis, George, *Quarterly Review*, April 1824, p. 213.

11. One of the many points Taylor 1999 fails to notice, see pp. 34–7.

12. *Athenaeum*, June 1842, p. 528.

13. Martin 1974.

14. Waagen 1838, vol. 1, p. 185. Edwards 1840, pp. 120–31.

15. Hazlitt, W. 'The Angerstein Gallery', *London Magazine*, December 1820, pp. 489–90. Hazlitt's reading of Angerstein's collection is examined in detail by Trodd 1994, pp. 42–4.

16. Although I have been unable to find a great deal of information relating to the St Martin's Workhouse, useful sources include *Survey of London* 1940, p. 113; and Elmes 1831, p. 289.

17. *The Times*, 11 April 1837, p. 187; *The Literary Gazette and Journal of Belle Lettres, Arts and Sciences*, September 1833, p. 586; Thackeray 1904, p. 4. In 1838 the *Spectator* referred to 'the meanness of the building ... [the] motley collection ... [and] shabby lining of the walls ... the place has more the look of an auction-sale room than a national picture gallery' (pp. 357–8). As late as 1873, Hamerton, the critic, painter and etcher, called the NG 'thoroughly bourgeois from dome to pavement', with its 'plain and homely little rooms' (Hamerton 1873, pp. 236 and 238). Mace 1976, provides a useful social history of this space.

18. Parliamentary Papers, 1841 *Report*, p. 180.

19. 'Public Statues and Monuments', *Art Union*, 2, June 1840, p. 90.

20. Foucault 1977, p. 172.

21. *Art Journal*, 1859, p. 258. For Wyse, see Trodd 1994, pp. 38–40; for Hume, see Thomas 1979, pp. 33–40; for Godwin, see the essay in this volume by Duncan Forbes (Chapter 8).

22. Arnold 1903, 'Culture and Anarchy', vol. 6, p. 76; Gladstone 1841, vol. 1, p. 151.

23. Trodd 1994, pp. 39–47.

24. See Albert 1862, p. 181; Dyce 1853; Godwin, G., *The Builder*, 1857, p. 82; Ruskin, J., Parliamentary Papers, 1857 *Report*, paras. 2437–75; and Clarke 1842, p. iii.

25. Parliamentary Papers, 1857 *Report*, para. 2248.

26. *Edinburgh Review*, vol. 86, 1847, p. 212.

27. Parliamentary Papers, 1853 *Report*, Appendix 17, p. 791.

28. *The Builder*, January 1857, p. 231.

29. See Moore's evidence in Parliamentary Papers, 1853 *Report*, paras. 9739–10007.

30. Ibid., paras. 8186–7.

31. Ibid., para. 617.

32. Ibid., para. 586.

33. Ibid., para. 7119.

34. Parliamentary Papers, 1850 *Report*, para. 82.

35. Ibid., para. 393.

36. Ibid., p. iv.

37. Parliamentary Papers, 1857 *Report*, para. 1197.

38. Parliamentary Papers, 1850 *Report,* paras. 663–4.

39. Ibid., para. 83.

40. For an account of this topic, see Trodd 1994, pp. 33–9, where the belief that art would offer comfort to a popular audience by transforming rule into ritual, law into custom and convention into sentiment, is examined in detail. Nor were such accounts of the symbolic union of classes through the consciousness of public property confined to those places in which the property was in any sense public. Here is John Eagles (1857, p. 67) waxing lyrical about the experience of Hampton Palace: 'If poor, you are made rich in a moment; for all is your own. You walk through the richest galleries and rooms furnished with the greatest treasures of the world, and are not asked questions. You feel the luxury of a proprietor, without the burden of property.'

41. For an account of the operations of the Grotesque in Victorian culture and society, see the introductory essay in Trodd et al. 1999, pp. 1–20.

42. Foucault 1986, pp. 22–7.

Museum or market?: the British Institution

Nicholas Tromans

The existing scholarly literature on the British Institution for Promoting the Fine Arts in the United Kingdom (BI), established in London in 1805 to encourage the patronage of British artists, has focused upon the body's controversial career before 1830, paying little attention to the thirty-seven remaining years of its existence.[1] This emphasis is understandable given that it was particularly during its first thirty-or-so years that the BI had interesting connections with the Royal Academy (RA), the National Gallery (NG) and the Royal Institution, and that it was run by prominent intellectuals and connoisseurs such as George Beaumont and Richard Payne Knight. (Artists – being the objects of the institution's essentially charitable purposes – were not allowed to become Governors or Directors of the BI on the grounds of potential clash of interest.) It is also to this earlier period that most of the surviving documentation and contemporary commentary relates.

Why, then, did the BI apparently become less interesting to its contemporaries, and therefore remain so for later art-historians, after about 1830? One general answer may be that the BI was the victim of its own success in widening the constituency of patrons, or at least that the London art-market greatly expanded whether or not the BI is to be credited with the fact. In 1843 it was estimated that since the foundation of the BI the number of British artists had increased threefold:[2] in that year the BI showed 440 pictures at its annual spring exhibition devoted to the sale of new British art, having refused over 460 others, while the Society of British Artists had been in existence for almost two decades, having itself been set up in frustration at the rejection of its members' works from other exhibitions. And since 1838 the New Society of Painters in Water-Colours – established in 1832 to supplement the space available at the original ('Old') Water-Colour Society – had held its exhibitions in a gallery immediately next door to the BI in Pall Mall. As the demand for and supply of paintings grew, the market became

more conspicuously stratified into a hierarchy, with the RA maintaining its political hegemony and prestige, and the BI and other societies increasingly embedded in a 'second division.' Indeed the BI had little alternative but to further sanction this hierarchy if it wished to retain any sense of independence in the face of the overwhelming number of pictures submitted to its exhibitions. Repeatedly the Directors of the BI felt compelled to exclude (or at least discriminate against) works previously exhibited elsewhere, which in effect meant encouraging artists to choose between itself and the RA.[3]

If we had to name a date at which the BI succumbed to this 'supporting role' it would be necessary to go the best part of a decade further back in time even than 1830. In 1821 James Ward exhibited his enormous *Battle of Waterloo in an Allegory* at the Egyptian Hall on Piccadilly. Commissioned in 1816 by the BI, this should have been a demonstration of what an ambitious painter and an enlightened body of patrons could achieve when offered the opportunity to commemorate a great national event. Instead, the entire project was a disaster – the picture an empty, overblown pseudo-Rubensian monster from which the BI Directors and the general public looked away in embarrassment.[4] Meanwhile, at the BI gallery in Pall Mall, in 1821 the picture of the year was John Martin's *Belshazzar's Feast*: evidently much more closely related to popular panoramas than to the grand style of the classic Old Masters, the huge popularity of this image seemed to make a further mockery of the BI's attempts forcibly to graft living art on to the stem of that classic tradition.[5] Also, 1821 marked the last appearance at a BI spring exhibition of David Wilkie, the most successful subject-painter of the period, who had dutifully supported his many friends among the Directors after they had bought his *Distraining for Rent* (National Gallery of Scotland) in 1815 in an effort to encourage the celebrated genre painter in a move towards 'higher' topics. Wilkie's painting had been one of several British pictures bought from 1811 onwards by the Directors as the nucleus of a British contingent of a national gallery, into which the BI had harboured hopes of transforming itself. But frustrated at its inability either to expand or to find alternative premises, the BI began to dispose of these pictures in the early 1820s, largely by giving them to churches, although the Wilkie was sold to the engraver Abraham Raimbach. Following the establishment of the NG just along Pall Mall from the BI itself in 1824, the Directors revived their efforts to promote British art within it, donating pictures by West, Reynolds and Gainsborough.[6] But the last work of art to be acquired by the BI was purchased as early as 1830: a Chantrey bust of the Marquis of Stafford, a former President, which remained on permanent display in the BI's galleries (Figure 2.1) as what must later have been a melancholy monument to the early curtailment of the BI's first ambitious hopes for the encouragement of intellectually

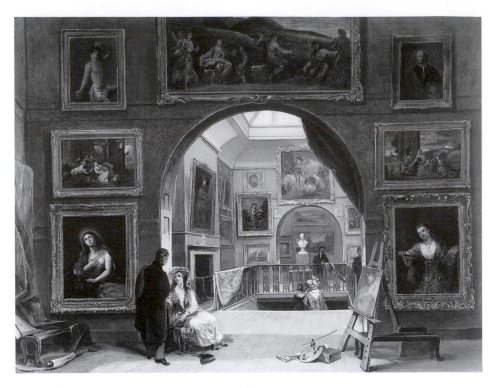

2.1 Alfred Joseph Woolmer, *Interior of the British Institution*, 1833

ambitious British art. The year 1830 also marked the end of the annual award of premiums to promising younger painters.[7]

Reviewing these facts, the lack of interest in the post-1830 BI seems all the more easily explained, and we might instead ask how the BI managed to limp on to 1867. The explanation of this survival (beyond the fact that the lease of the Pall Mall property had been purchased for 62 years in 1805) lies in the separation and increasingly autonomous development of the two strands of the BI's initial remit, which had originally been conceived in tandem. Since its first operational year (1806), the BI had gathered together each summer a group of Old Master (or 'ancient master' as they had it) pictures to be studied and copied in oils by art students. In particular the Directors wished to cater for those talented graduates of the RA Schools who would have been given little if any guidance there in painting *per se*. In practice the 'British School', as it was known, attracted not just beginners but also more established professionals ranging from Constable to Wilkie and West.[8] The BI school's deeper purpose was to connect British art more firmly with the great art of the past: the keener the notion of a rising British

school of painting became, the greater became the anxiety that this fragile growth threatened to become estranged from the sources of technical and intellectual nourishment which were available in the works of the 'ancient masters', to which, however, few artists had access, particularly at a time when travel on the Continent was not possible.

The 'British School' at the BI and the spring exhibition were thus intended to have a symbiotic relationship with one another: the benefits of the study of the pictures loaned in the summer would be apparent in the new art created over the winter and exhibited in the spring. But this practice-centred rhythm was interrupted as early as the summer of 1813 when, instead of the loaned pictures being arranged just for the benefit of students, a large public exhibition devoted to Reynolds was mounted – effectively the first thematic loan exhibition of the kind which was subsequently to become the paradigmatic 'event' of the art-world. The Reynolds show, it seems, had been partly inspired by the great success of the Directors' purchase, and exhibition at the BI, of West's *Christ healing the sick* in 1811. This had dramatically drawn attention to the subtle tension inherent in art exhibitions between, on the one hand, the interest of the contributing individual in selling his picture and, on the other, the interest of the body organizing the exhibition in 'putting on a show'. A spectacular painting which drew the crowds was less rather than more likely to sell to the modest patron wishing to decorate his drawing room, and, while the great majority of exhibitors at the BI inevitably had just such modest patrons in mind, the BI itself was able to secure itself financially for years to come with the profits from the huge number of visitors to West's picture and from an engraving made after it. What began to happen during the Regency years at the BI, following on from the recognition of this difference between showing and selling pictures, was the start of the separation of the performative from the retail aspects of the exhibitions held there.

From very early on, few had anything complimentary to say about the BI spring exhibitions *as* exhibitions, whatever exciting new talent was to be found hidden in corners, Beaumont himself, for example, declared the 1812 show 'a wretched display' which led him to think 'it would be better to admit not more than a dozen respectable pictures than such a heap of bad ones'.[9] Thus the summer loan exhibitions of 'ancient masters and deceased British artists', which followed annually after the Reynolds show of 1813, took on the performative burden of the BI's need to maintain its finances with admission money, and generally to maintain a position on the 'stage' of the London art world. The distinction in terms of spectacle between what were, from 1813, the two annual exhibitions at the BI was already extreme by 1816 when the spring show was generally perceived as dismal, while the summer saw an exhibition of Italian Old Masters which was nothing short of

a sensation. But the important point is precisely that to draw this obvious comparison in terms of 'performance' is unfair: the spring exhibition of new art in fact continued to be a success on its own terms, which were becoming more or less exclusively commercial. During the 1850s and 1860s, when the press and art-world gossip had all but ceased to recall its existence – with the exception of the *Art Journal* which campaigned perennially against what it saw as corruption in its organization – the rate of sale of works from the BI spring exhibition actually improved, despite the admission of larger numbers of (ever smaller) pictures.[10] In 1853, when for the first time prices began to appear in the catalogues, some 30 per cent of the 589 pictures exhibited were sold, compared with a rate of sale in the earlier years which seems to have hovered around 20 per cent. This was a better rate than that of the Royal Academy during the 1860s (its last decade at Trafalgar Square) when only some 12 to 14 per cent of the exhibits were sold annually.[11] Furthermore, this higher rate of sales at the BI was achieved through a much smaller audience than that of the RA summer exhibition. The typical attendance during the BI spring exhibition was between 12,000 and 14,000, later falling to between 7,000 and 10,000 from at least the 1840s, while the BI summer loan exhibition attendance also declined to a similar level from the 20,000-plus which had been usual before about 1830.[12] The numbers attending the RA show, on the other hand, consistently reached six figures. With its healthy rate of sales to modest numbers of visitors, and gradual disappearance from the press exhibition reviews, in its later years, to all intents and purposes, the BI gallery was no longer an exhibition venue at all during the spring, but rather something like the shop of a shabby-genteel dealer. This is made clear in what is probably the BI's unique appearance in Victorian fiction, chapter 27 of 'Fernyhurst Court' by Lady Verney (Florence Nightingale's sister), which appeared in *Good Words* in 1870. May, the heroine, visits the spring exhibition when her sister-in-law, Sophia, 'declares she must be painted, and there are some portraits there by a man she has heard of who is not too expensive', May's only feeling in regard to exhibition *per se* being to regret that it is not one of the summer loan shows.[13] That May should come to the BI to search out a cheap portraitist points up with particular irony the transformation of the spring exhibition since the beginning of the century, when portraits had not been admitted to what was supposed to represent the assembled high-minded 'performances' of the British School.

I have suggested that, while the spring exhibition continued unostentatiously to help the 'second division' of London painters make a living, the needs of the BI as an institution were increasingly served by the summer loan exhibitions of 'Ancient Masters'. By making up the performative deficit left by the all-too-often lacklustre spring shows, the loan exhibitions – through admission money and sales of catalogues – underwrote the BI's finances, but

also maintained the allegiance of the many collectors and connoisseurs among the founding Directors who might well have lost interest in the body if it had remained little more than a charity and school of painting for living artists.[14] A further incentive for the Directors to remain loyal to the BI, concomitant with the beginning of the summer loan shows in 1813, was the *soirée*, or evening exhibition, held weekly during the summer, at which the gas-lit pictures competed for attention with the flamboyantly dressed lords, ladies and gentlemen, who themselves competed ferociously for tickets to these events. Maria Bicknell summed them up most succinctly in a letter to Constable in which she described the BI on the night of an evening exhibition as 'certainly a very fine place to see, and be seen'.[15]

The allocation of more or fewer tickets to these evenings was the principal means by which the BI discriminated in terms of privileged treatment between the hierarchy of different categories of its membership. From the beginning the highest of these had been the Hereditary Governorship, which was exactly that: for a single-sum subscription of 100 guineas or more, a member could bequeath his 'interest in the BI' – which in practice meant his right to a certain number of tickets to the *soirées* – to his heir. The attractions and problems of this hereditary principle led to an intriguing sub-plot within the history of the BI. In 1822, under the presidency of the politically liberal Marquis of Stafford, the Directors resolved to allow no more Hereditary Governors to be elected, and to strongly urge those living to allow their 'interest' to terminate with their lives. Only a minority of them were inclined to comply, however, the hereditary principle being one which guaranteed so much in British life that those who benefited from it felt they could not allow it to be compromised; and after the Reform Act of 1832 placed the aristocracy on the defensive, the leadership of the BI backtracked from its position of 1822. In 1834 Stafford's successor as President, the Earl of Aberdeen, resigned due to the pressure of his political commitments, and wrote to suggest as his replacement 'a person whose station and disposition are likely to prove highly advantageous to the BI, and who indeed possesses a kind of hereditary claim to the regard of its members'.[16] He meant Stafford's son, the Duke of Sutherland, who served as President until his death in 1861, for most of that time having as his Deputy-President his younger brother, the Earl of Ellesmere. In 1836 the principle of Hereditary Governorship was formally reinstated. After 1832, then, the BI took on an additional role, the guardianship of the aristocratic principle in London's art world. More specifically, it represented the persistence of the families who had owned the two great private collections of early-nineteenth-century London, the Stafford and Grosvenor galleries: the last President of the BI was the son of Earl Grosvenor, the Marquis of Westminster (who married Sutherland's sister). Right up to the bitter end the BI embodied the continuing presence of what

Francis Haskell has described as the 'Orleans generation' of the turn of the nineteenth century: those plutocrats-become-aristocrats who had been enabled by the revolutionary 1790s to become the first British collectors since the age of Charles I to acquire large numbers of famous pictures by the canonical Old Masters.[17]

It seems likely that this renewed aristocratic tone at the BI after 1832 was one reason for its failure to attract to it intellectuals and art-world personalities of the type which had helped to make the body's early years so lively. Thomas Bernard, the philanthropist who had been the original prime-mover, had died in 1818, Beaumont and Payne Knight in the 1820s, and the names of the following generation of opinion-formers are conspicuous by their absence from the BI. In this context, the role of William Seguier became all the more key. Seguier's arrival at the BI was another of the developments associated with the first loan exhibition of 1813, which he was brought in to organize. Trained by his father as a picture cleaner, restorer, dealer and probably pasticheur (and apparently also taught by Blake, presumably in printmaking) Seguier had by 1813 already assumed an enormously influential position in London's art scene through acting as consultant to the great collectors of his day, precisely the men who set up the BI: what he said with regard to authenticity and value, went.[18] Seguier became Surveyor of the King's (and later Queen's) Pictures, first Keeper of the NG in 1824, and Superintendent of the BI in the same year. In fact that third title was probably only given him in order formally to distinguish his existing role of organizer of the summer loan exhibitions at the BI from his new post as head of the NG. (Although, if that was the case, the overlapping of his various briefs, to put it lightly, continued.[19])

Seguier has a claim to be considered the first curator in our modern sense of someone not only entrusted with the care of a permanent collection, but who says something about art using the exhibition as the medium of communication. That we can see in his work for the BI the embryo of a new profession is apparent in the fact that his key role had no title for more than a decade, and that his novel powers made him so controversial. The gossip that surrounded him turned on the tension between public and private interests. In general terms, of course, the negotiation between the two precisely defined the new-fangled loan exhibitions which Seguier curated, allowing as they did relatively large numbers of the public to see pictures to which they would not normally have had easy access. But whatever deeper layers of meaning it might be tempting to read into this public–private negotiation, it should be remembered that there were often simple opportunistic explanations for what was shown and when. For example, the King was praised for his generosity in allowing his private collection from Carlton House Palace to be exhibited over the road at the BI during 1826–27: but this

was not such a sacrifice as it might seem, as Nash was in the process of
demolishing the palace at the time. And in 1828 the Duke of Wellington's
rarely seen paintings were conveniently hung at the BI while a new picture
gallery was built at Apsley House. Wellington was certainly one of those
grandees whom the *Athenaeum* had in mind in 1835 when it praised the BI
summer loan exhibitions for being 'the best set-off to the illiberality with
which our grand signors shut up their pictures from the public – making, in
fact, *close boroughs* of their collections'.[20] The BI thus perhaps provided an
excuse in the suspicion-ridden years after 1832 for the great collections to
curtail the access they had traditionally granted to all 'respectable' visitors.[21]

The loan of ten paintings from the Duke of Wellington's collection in the
summer of 1828 raises another interesting question: how to read what Seguier
'meant' by the exhibitions he organized.[22] After the first loan exhibition
devoted to Reynolds in 1813 and another devoted to Hogarth, Gainsborough,
Wilson and Zoffany in 1814, the BI summer exhibitions had typically fo-
cused on a narrowly conceived repertory of European Old Master painters,
beginning with selections of the Dutch and Flemish schools in 1815, the
Italian and Spanish in 1816. These two shows, which so dramatically en-
acted the separation of the performative from the charitable or retail functions
of the BI, famously gave rise to the anonymous *Catalogues raisonnés*, absurd
but entertaining satires upon both the pictures exhibited and the Directors of
the BI.[23] But the notoriety of these pamphlets has distracted attention from
the fact that in general it was assumed that art criticism was not equipped to
deal with these loan exhibitions: 'To praise the great painters whom all the
world admires would be a ludicrous waste of words' wrote *The Times* of the
1816 show.[24] If the pictures on display constituted a kind of abstracted mani-
festation of the canon, what job was there for the discriminating critic to do?
Only when the exhibition organizers disrupted the canon might the critic
intervene to bestow or withhold approval. In 1828 we find this confused
confession from a critic: 'An exhibition of this nature is not a proper subject
for detailed criticism; but we cannot refrain from expressing our unqualified
admiration for the works of Velasquez.'[25] Reluctant to break ranks with his
reticent colleagues, this writer cannot help recognizing something new, extra-
canonical. Among the pictures from Wellington's collection that year were
three attributed to Velázquez, among them the authentic *Waterseller of Seville*
and *Portrait of a Gentleman* (both still at Apsley House). These had a huge
impact on the audience of the BI summer exhibition, marking the first full
recognition of Velázquez's realism among the London art-world. Given that
Wellington's pictures were only at the BI in the first place because Apsley
House was being refurbished, it might be inferred that the 'arrival' of the
Spanish master was a virtually random phenomenon. But in the 1828 exhibi-
tion there were also several other impressive Spanish pictures from other

collections which led to a general impression of the show having a Spanish theme.[26] It would seem that Seguier had succeeded in what many curators have since had to attempt. Beginning with an unexpected opportunity to borrow exciting pictures, he quickly put together other works to provide a context for them, and in the process appeared to have caught the *zeitgeist*: another art-world event of the summer of 1828 was Wilkie's return to London from Spain where he had admired Velázquez and had bought pictures attributed to him on behalf of Robert Peel.

In this 'rediscovery' of Velázquez in 1828 we have the essence of the intellectual importance of the BI summer loan exhibitions at a time when their role might be expected to have been compromised by the appearance of the NG in 1824. While this had begun with the small but exquisitely formed collections of Angerstein and Beaumont, the power of the display was becoming diluted through bequests of – inevitably – lesser quality. The BI summer exhibitions allowed would-be critics and connoisseurs to compare and contrast good quality pictures from different schools and periods in annually changing combinations; and, as the taboo against criticism of the Old Masters which had been apparent in the 1810s and 1820s gradually lifted, the BI later developed into the primary location in London for the generation of art-historical discourse.[27] By the time of the NG's move from its cramped quarters in Pall Mall in the late 1830s, the *Athenaeum* could write of a BI loan exhibition that, 'An examination of 183 such pictures as are here to be seen, must draw more largely on the eyes and the mind than a survey of the whole 1289 attractions at Charing Cross.'[28]

Few of the debates which must have been prompted by the BI summer exhibitions are recorded, although one controversy which did explode into print was again the result of the re-estimation of a Spanish painter: the 'Murillo mania' of the late 1830s. Following on from the exhibition in 1836 of two huge Murillos just acquired by the BI President, Sutherland, the fashionable art world was apparently in raptures over this painter whose genre scenes had been extremely popular throughout Europe in the later seventeenth and eighteenth centuries, but whom the BI now seemed ready to take seriously as a great religious artist. The critic of *Blackwood's*, the Revd John Eagles, not only disapproved of Murillo, but considered the BI guilty of cynically 'puffing' his reputation, partly by drawing attention to the source of Sutherland's pictures – Marshal Soult, whose thefts of works of art during the Spanish War of Independence against Napoleon were notorious:

There is a fashion in masters, and it sometimes happens that a fortuitous circumstance as a great purchase from some public robber of note, will, in no common degree, direct the attention of the public to a painter. We should not be surprised, if shortly Murillos were to be sought after with new eagerness, and be more valued than Raphaels and Correggios.

By 1840 Eagles was complaining that Soult was responsible 'for infecting us with a Murillo mania.'[29] These years also saw the arrival of religious subjects by Murillo at the NG: the *Two Trinities* in 1837 and *Infant Baptist* in 1840.

No sooner had the 'Murillo mania' died down than the controversy over the admissibility of the 'primitives' into the canon and into museums and exhibitions got fully under way. At the 1841 BI summer exhibition several 'pre-raphaelite' pictures were on show, some lent by the new Consort. George Darley, the poet and art-critic of the *Athenaeum*, generally encouraged the representation of early art, but wrote *à propos* of Van Eyck's *Arnolfini portrait* (exhibited in public for the first time in 1841) that, although an object lesson in how to paint long-lasting pictures, 'its merits are few besides those of colour and finish. It affords good materials wherewith to assail us for our amorous descants on primitive Art, our love-laboured songs about the deep feeling, solemn beauty, simple grandeur, and so forth, of very ancient pictures, despite their uncouthness, stiffness, &c.'[30] Darley's blasé tone suggests that the debates around early art were already well rehearsed, and ironically the very next year the NG showed itself ready to accept Darley's general arguments by purchasing (on Seguier's recommendation) the *Arnolfini* picture, the one great early painting of which he had not approved. If the BI can be seen as functioning as a kind of testing-ground for the NG, as it seems to have done in the cases of Murillo and Van Eyck, then the most striking example of this was the loan exhibition of 1848 at which one of the BI's three rooms (the least prestigious) was given over to an experimental chronological survey of painting from the time of Giotto up to the seventeenth century, with each picture accompanied by a label giving the painter's dates. Five years later, for the first time, the NG collection was re-ordered according to an equally methodical school-by-school hang.

When the BI's lease on its Pall Mall premises expired in 1867 the regret expressed in print centred exclusively upon the demise of the summer exhibition: the living artists deprived of a selling space were left to commiserate among themselves. After some unproductive negotiating between the BI and the recently established Burlington Fine Arts Club, the Royal Academy, in a flush of magnanimity brought on by its acquisition of new premises at Burlington House, opened a BI-style loan exhibition at the beginning of 1870 combining various Old Masters with retrospectives of C.R. Leslie and Clarkson Stanfield, just as the BI had held 'tribute' exhibitions of the work of Hilton, Stothard, Wilkie and Callcott in the early 1840s. However, as the acting RA Secretary wrote to Lady Eastlake, 'every arrangement must be uncertain as the Academy regard the present Exhibition quite as an experiment, and carefully guard themselves against any engagement for another year'.[31] A good reason for this caution was that the RA first took on the responsibility for holding loan exhibitions with no prospect of financial

advantage to themselves.[32] The intention was to give any profits to art-related charities, although in the event income from the first exhibition was so substantial that some of the money was retained, thus setting the RA on course towards the lucrative blockbusters which it hosts today.[33]

Meanwhile the BI's capital of some £15,000 was left to accumulate after 1870 until the 1880s when the BI Scholarship Fund was established, managed by a board of trustees representing various art and educational institutions, to award scholarships to art students. The first of these was given in 1890, and in 1911 – a century after West's *Christ healing the sick* caused a sensation at Pall Mall – a BI scholarship was awarded to Mark Gertler at the Slade.

Notes

1. See especially Fullerton 1982, Funnell 1992, Pullan 1998 and Pomeroy 1998.
2. *Artist and Amateur's Magazine*, 1843, p. 80.
3. Such policies were announced in 1810, 1827, 1832 and 1844, although it is not clear how long they remained in force in each case.
4. Farington 1978–98, vol. XVI, p. 5677 (6 June 1821).
5. Feaver 1975, plate III and pp. 49–55.
6. In 1828 the BI resolved 'that a sum of £4000 be appropriated to the building of an additional room, or gallery, to the National Gallery of pictures in Pall Mall, provided the Government, or will grant the ground, rent free, on which it may be erected to extend the National Gallery for British Art' (*BI Minutes*, V, ff.71v–72r).
7. Further awards were however made in 1834 and in 1840–42. In 1842, when the four recipients were all aged over 30 (and one over 50), the Directors finally confessed that 'the effect of these premiums has not been commensurate with their anticipations and they do not think it advisable to continue them' (*BI Minutes*, IV, f.40v).
8. The name 'British School' recalls that of the brief-lived exhibiting society which immediately preceded the BI: see Gage 1995.
9. Farington 1978–98, vol. XI, p. 4100 (30 March 1812).
10. The longest-running of the *Art Journal*'s numerous objections was the alleged lack of confidence on the part of the artists in the selection procedure, which was carried out by minor officials while the Directors were still 'out of town'. The organization of the exhibitions (it was claimed) was thus not respectably supervised and as a result was open to abuses including bribery and the accepting of pictures from dealers hoping to sell on at a profit paintings acquired cheaply from struggling artists.
11. Statistics derived from figures given in RA *Annual Reports*. Many of the pictures exhibited at the RA would, of course, have been commissions and so not for sale. Commissioned pictures were in theory excluded from the BI.
12. Exceptional 'peaks' in attendance patterns include 87,000 in 1811 (for West's picture), 33,000 in spring 1821 for Martin's *Belshazzar's Feast* and 55,000 in summer 1826 for the King's pictures from Carlton House.
13. Verney 1870, pp. 801–5.
14. Egerton 1998, p. 400, notes the leading Director William Holwell Carr's much greater enthusiasm for the loan exhibitions than for modern British art.
15. Constable 1962–68, vol. II, p. 126 (22 June 1814).
16. Aberdeen to the BI Directors, 16 June 1834 (*BI Minutes*, V, ff.125r–126v).

17. Haskell 1980, p. 124.

18. See Laing 1998, and Egerton 1998, pp. 388–98.

19. In 1819 Seguier hung Parmigianino's *Vision of St Jerome* in the prime position in the BI summer loan exhibition. In 1823 he bought it from the George Watson Taylor collection (to which he was consultant) on behalf of the BI (of which he was already the *de facto* Superintendent) and in 1826 the picture was given to the National Gallery (of which he was Keeper).

20. *Athenaeum*, 1835, p. 416.

21. See Pullan 1998 for an interpretation of the early BI loan exhibitions as a safety-valve for public–private tension.

22. The standard procedure was for Seguier to draw up a list of proposed loans which was submitted to a meeting of the Directors. Request letters were then sent out to owners with the signature of the President, whose aristocratic status would have made it hard for most to refuse.

23. These remain anonymous, but see Hamilton 1997, p. 180.

24. *The Times*, 25 May 1816, p. 3. A letter to the *Champion* (1816, p. 222) signed 'D.E.C.' mocked the powers of criticism in the face of such great works.

25. *Literary Gazette*, 1828, p. 348.

26. The *Gentleman's Magazine*, 1828, 2, p. 156, even exclaimed that the Spanish school 'possesses more real merit than any other'.

27. Scharf 1858, a very scholarly catalogue prompted in part by the striking series of pictures attributed to Leonardo exhibited that year. One of these probably also inspired a poem by D. G. Rossetti: see Weinberg 1997, pp. 55–6.

28. *Athenaeum*, 1837, pp. 427–8.

29. *Blackwood's Edinburgh Magazine*, XL, 1836, p. 545, and XLVIII, 1840, p. 486.

30. *Athenaeum*, 1841, p. 509.

31. S. A. Hart to Lady Eastlake, 7 December 1869 (RA Archives, MS.796).

32. RA *Annual Report*, 1869, p. 9.

33. RA Archives, 1319.A ('Winter Exhibition Report 1870'). I am very grateful to the Royal Academy's archivist, Mark Pomeroy, for sharing with me his discovery of this document.

Representing the Victorian Royal Academy: the properties of culture and the promotion of art

Colin Trodd

The Royal Academy (RA) is a classic institution of modern British state culture. Hovering between government and monarchy, it seems to be a concrete realization of the nature of British political life by making and effacing the relationship between the public and the private in the process of articulating them. Promoted and patronized by powerful agencies, its nineteenth-century history is one in which issues of identity, function and duty are entangled with the operation of institutional power and cultural authority. And such matters are themselves bound up with debates about the nature of the legitimation and sovereignty of the Victorian RA, the relations between its customs and the governance and administration of art. As will become apparent, commentary about the state of Victorian art tends to focus on the status of the RA, seeking to identify the 'correct' institutional conditions for the generation of an 'authentic' relationship between artists and the public. This relay between institutional and social legitimacy runs through a number of nineteenth-century meditations on the nature of the RA as a space of cultural display and edification.[1]

To this engagement with the institutional-legal nature of the RA we could add other definitional processes: its activity as a national arena for the purchase of art; its production of artists through the operation of teaching systems; its articulation as the place of the 'National School' in sympathetic journals; its identification as an 'oligarchic' organization in hostile criticism. Such issues, it could be claimed, lock into the social and conceptual ambiguity of the institutional profile of the RA. Was it indeed a public space in which could be found expressions of national art? Were its Summer Exhibitions the commercial necessities of a private body concerned with the formation and perpetuation of academic rules, the codification of which was confirmed in presidential discourses and in specific teaching methods? What were the connections between these public and private profiles and processes? Did

the institution generate a specific cultural programme through the deliberate manipulation of these dual registers? Any attempt to deal with such matters must recognize the multiple places in which representations of the RA were made, as well as the contradictory values and claims that were made for it.

Commercial cultures, governing cultures

The sense that in the composition of the cultural realm one can delineate specific rules and laws concerning the correct promotion of art is a noted feature of institutional analysis throughout the nineteenth century. From the anti-monopolistic rhetoric adumbrated by the *Examiner* in the 1820s and 1830s to the quasi-legalistic ruminations of William Laidlay at the end of the century, cultural critiques of the RA engaged with those policies and practices which were seen to shape the market for art.[2] Conventional attacks defined the RA as a private body which represented the interests of its members instead of supporting the general body of artists.[3] That is, the 'behaviour' of the institution was seen to deform the spaces of cultural production, transaction and distribution: in becoming a corporation the RA had incorporated art, making it an extension of itself. This identification of the nature of art with a community of self-governing producers and consumers embracing the ceaseless circulation of things is caught as late as 1860 by *Fraser's Magazine*:

There is nothing more prejudicial to the true interests of art than the transcendental view of the artist's position which some zealous sticklers for his dignity are fond of taking. They would treat his vocation as one altogether independent of the rules which govern others, and free him from all the obligations which exercise a salutatory control over the actions of other men ... An exhibition of pictures is a kind of Art Exchange, where the painter lays out his imagination, ... and his technical skill, and awaits the effect of his wares on the passer-by, which, as in the case of any other chapman, will depend upon the amount of merit of his merchandise, and the ability to perceive it in the public ... hence the necessity for competition in art; and it is not only the interest but also the duty of every artist who wishes to elevate the school of his country, to widen that competition.[4]

For this anonymous critic the mechanisms of political economy are taken to direct the institutional activities in which the fine arts operate. If it is not a question of 'importing' doctrine to transform a dormant cultural space, but of understanding the logic of production, organization and management in the modern art world, this is because the components of commerce are already locked into the operation of the cultural realm, shaping its material character.

Such observations were part of a long-established tradition. The conclusions of the *Select Committee Report on Arts and their Connexion with Manufactures* (1836) formulated art as a complex of networks where tastes

and skills were realised in the interplay between production and consump-
tion, the generation of utilities and their operation as objects of property.
This attitude – that the symbiosis of art and design constitutes the formation
or realization of a commercial culture that at once represents and reforms a
mass public of consumers – is a notable element in these debates about
institutions. W. B. S. Taylor, echoing this rhetoric, finds in the mechanisms of
modern art signs of its popularization beyond traditional support systems.
'A great commercial nation,' he claims in 1841, 'is bound to encourage the
fine arts.' Therefore, the relay of art within a market economy assists 'in
extending the spirit of commercial enterprise, by which the national wealth
is extensively increased'.[5]

These ideas could be aligned with readings of the nature and progress of
British art in such a way as to celebrate those artists associated with entre-
preneurial flair rather than academic knowledge. Writers like Allan
Cunningham and Tom Taylor charted the development of modern British
painting in terms of its capacity to embrace a quasi- 'Hogarthian' business
ethos, where the energies of a 'naturalistic' aesthetic were conjoined with the
values of a commercial public body. Taylor finds in C. R. Leslie the perfec-
tion of the businessman-artist, one for whom 'homely' subjects perform a
more public function than the most ceremonial examples of public art. Be-
cause Leslie's work 'promotes culture' more intensely than the creations of
the 'epic' history painter, his paintings are purchased by the commercial
classes rather than connoisseurs. Taylor imagines a popular audience of
northern factory-owners and operatives forming a public body in the space
between work-time and leisure-time, seeing their collective humanity in
images 'eminently calculated to counteract the ignobler influences of indus-
trial occupation by their inborn refinement, their liberal element of loveliness,
their sweet sentiment of nature … and their genial humour'.[6]

Such readings of the history of modern British art were generally sceptical
of the ability of academies to function as dynamic spaces in which such
interests could be realized. Leslie himself, associating the rise of academic
culture with the formulation of autocratic rules which supplant the laws of
nature, divided French academicism from British empiricism, finding in the
latter a more direct understanding of the truth of art, which he defined as
the attempt to register a psychology of sentiment that forced viewers to
confront the experiences embodied by subjects in images. Distinguishing
between imitative types and observed facts, he conflates Hogarth and Raphael
as examples of a counter academic tradition which, in combining vision and
experience, knowledge and beauty, generates a model of the emotional com-
plexity of social beings and the actions they perform.[7]

This belief in the formation of a visual community – that artists reach a
mass public by allowing its members to make 'investments' in images which

suggest the alignment of the aesthetic and the social at the level of the density of human experience – could be augmented by other readings celebrating the fecundity of the commercial nature of art. Where Cunningham, Taylor and Leslie identify the engraver and printer Boydell rather than aristocratic patrons with the promotion of the eighteenth-century 'British School', the assumption that commercialist systems carry within themselves virtues which transcend patrician culture was a feature of those engagements with the fine arts which drew from the ideas of the Philosophical Radicals. Detailed arguments were formulated about the value of free trade and the imagined reformation of the relations between different social classes by the vivification of a public taste for art unfettered by corporate 'laws'. The market appears as a utopian space in which a public body emerges in and from 'free' economic activity performed between traders and buyers. Thus the public value of art is authenticated when it becomes the private property of a mass audience; and because art circulates within the social body, its character is always about to be communal rather than individual, democratic rather than aristocratic, particularly if it is transmitted via reproductive techniques. Art, then, speaks the language of property which self-regulating subjects possess in their expression of themselves as social agents subject to the impulses and needs arising from the logic of acquisition. If by the 1850s art is figured in terms of the expansion and diversification of material appetites and requirements, traditional forms of patronage could be construed as processes of negation. The nineteenth century, claims the *Athenaeum*, 'has broken from the patron's drawing room, and appeals to the crowd, who do not patronize, but purchase'.[8]

More radical articulations of the apparently democratizing values of the commerce position would find in the act of consumption the purest idea of taste itself. Social improvement, so this argument goes, results from the restructuring of the art world, turning it into a public mass of property consumers rather than a select body of patrons for whom art signals an élite realm of private wealth. The *Westminster Review*, probably the most notable exponent of this attitude, printed two long review articles in 1837 and 1851 to accompany the publication of papers emanating from parliamentary investigations. The first article, a review of the 1836 *Report*, supported George Foggo's evidence that Parliament should establish free access to public knowledge in the form of libraries and museums; claimed that the RA was monopolistic in character; affirmed that Art Unions expressed 'fair and open competition' between artists; and asserted that, because the issue of value is explained by the science of political economy, 'the interests of taste in art and those of commerce are identical'.[9] The second essay on the RA criticized the self-regulatory nature of a 'national' body which restricted its membership to forty:

The arbitrary restriction of shares in the academic Paradise, like the Associate-sophism, and every article in the polity, a mere relic of the old competing fundamentals, is totally inept in a national institution; unmeaning, vexatious. It secured preponderance to the original junta, and a barrier against democratic attempts on the constitution.[10]

Deploying a commercial definition of art, the anonymous writer presented the RA as a relic of a pre-modern economy, an atavistic and obsolescent institution or 'close borough' operating exclusive 'trading advantages' for its 'liverymen', cancelling 'living art and artists' through its 'protectionist barricade'.[11] Obviously, this is not an attack on the commercial origin of artistic practice itself, but a criticism of the subordination of the cultural spaces of competition to the institutional interests of the RA. This commerce discourse addresses itself to the way in which the RA represents art, or rather, how it represents itself as art, to patrons, connoisseurs, and other artistic societies. The focus is on the mechanisms by which this 'private' body controls the nature of modern art through practices derived from eighteenth-century political culture. As such, a division is made between a conservative patronal model perpetuated by the RA and the idea of the public as the totality of legitimate consumers within the nascent market-place of culture. The argument is that organizations, far from seeking to organize consumption, should align producers and consumers within diverse commercial systems and structures.

The belief that art would become truly public and accessible when its objects were seen as properties freely circulating within society, became a standard claim of radicals writing from the 1830s. Institutions allegedly blocking such transmission were taken to be hostile to the realization of a public body of art, transforming consumption into a fantasy about the status of their members and the things they created. Here is the Liverpudlian artist, Thomas Skaife, attacking Sir Martin Archer Shee, the President of the RA between 1830 and 1850, who had claimed that art is destroyed if it is conducted as a trade,

Does Sir Martin mean the moment an artist works for hire, he ceases to be an artist? Can ... the learned President assume that a work of Art becomes more deteriorated by the process of its being sold than any other article of commerce, of which political economy takes cognisance? If the sale of verses do not destroy poetry, how can the sale of a picture destroy the art which produced it?[12]

For Skaife the RA curtails the freedom and property of the artist by generating a 'monstrous' system of 'tyranny' which denies the logic of a commercial culture, whose 'liberal institutions' are a characteristic feature of a country 'blessed with a constitutional government'.[13] Skaife's opinions are related to those of John Pye and Edward Edwards, both of whom saw engraving as a cultural technology that could fashion a new popular audience or commercial public. Here the fantasy is of a commercial aesthetic where images are

repeated in and through networks of consumption, diffused through the social body to liquidate the institutional power of the RA.

This desire to integrate art into consumer culture and the concomitant declaration of the identity of art as property, the value of which was to be expressed in private gratification, was a problem for those for whom the institutions of the fine arts were claimed as bearers of a public culture defined in terms of its capacity to block or transcend private feelings and interests. Such anti-commerce discourses tended to separate values from needs, modelling the function of art in terms of its contribution to a civic ideal which rejected the 'popular-nationalism' of political economy apologists, for whom consumption betokened the intensification of, or acceleration in, the processes by which commerce could generate new forms of cultural association. Modern political culture was seen as a form of consumption in which values were deracinated by manufactured desires. In these accounts the RA appeared as an emanation of the 'popular mind' of the nation, a nation being dismantled by the machinations of the modern state itself.[14] Consider, then, the terms used by Martin Archer Shee, here introducing an account of his father's presidential battles against the first wave of radicalism in the 1830s:

A considerable portion of the work … has reference to what I term the political history of the Royal Academy – and recalls the memory of that gallant and successful struggle maintained by that body, in defence of their character and rights, against the reiterated assaults … [by] … a small clique of parliamentary doctrinaires, to whom … slight honorary distinction and slender privileges … were alike odious, as repugnant to the principle of social equality, – so dear to their republican sympathies, – and incompatible with the true theory of free trade, and the eternal maxims of Utilitarian wisdom.[15]

This seems like knockabout stuff in which the universalizing claims of political theory are checked by the self-authenticating 'truths' embodied by the RA. A variant of Tory discourse in which the localized, organic accretions of an authentic political culture act as a buttress against the powers of abstract reasoning and its mechanical model of the nation-state, Shee's presentation of the RA's critics is worth noticing in some detail. The unnamed rebels, probably William Ewart, Joseph Hume and Thomas Wyse, are associated with levelling forces that would efface crucial distinctions and differences. To question the administration and operation of the RA is to suggest a model of society which would eradicate status and rank, attacking the very nature of value itself by, in the words of the *Art Union*, offering every 'half-brutalized gazer' free access to the Summer Exhibition. Because cultural 'radicalism' is construed as an extension of 'dangerous' social ideas, it is associated with the dismantling of political culture and the destruction of the constitutional settlement of 1688.[16] Indeed, Shee's attack is a standard criticism of Utilitarianism:

that it presents itself as a science of the state based on a particular set of *a priori* maxims concerning the identity of human nature. As with other supporters of the RA, this enables Shee to identify the language used by its critics as a continuation of an abstract political philosophy which ignores the historical conditions in which institutional spaces are created and perpetuated.[17]

Although he refrains from mentioning specific individuals, Shee's comments were also directed against representatives of rival bodies, such as Frederick Hurlstone and George Foggo, both of whom presented evidence to the 1836 *Report*. Hurlstone, the President of the Society of British Artists, was a high-profile critic of the RA. He testified that, despite the cultural richness and material prosperity which characterized contemporary British life, the fine arts were in a depressed state. Not only did the rich lack real judgement, but problems of taste were exacerbated by the practices of the RA:

[I] consider the Royal Academy the principal, if not the sole cause, as at present constituted it exercises an unbounded and most depressing influence on art … It does this by its privileges and advantages, together with its laws, destroying competition … if all monopoly and privilege in the arts were done away with, art would rise to a higher state in the country than it has ever done before.[18]

What did Hurlstone mean by privileges and advantages? Why was he so hostile to monopoly and why did he believe that its eradication would result in the production of a more authentic art? To address such questions it is necessary to return to an earlier moment in the history of the RA.

Forming the aesthetic, forging the public

From its inception in 1768, problems concerning the relationship between the progress of art as aesthetic form and the promotion of the infrastructural environment for its display were addressed in terms of the ineluctable coupling of commerce and culture in modern society. Indeed, the nature of art within commercial society haunted the theoretical writings of Reynolds and Fuseli, the dominant figures in the history of the pre-Victorian RA.[19] If the former tended to be ambivalent about the specific relationship between material wealth and cultural value, the latter was pessimistic about the effect of social power upon the direction and nature of the fine arts. Reynolds's vision of the RA was not so much of a material organization, institution or corporation with specific formal structures, but of a set of governing aesthetic principles by which authentic art articulates itself.[20] Fuseli, by contrast, binding together the progress of art with the material life of the institutions of art, framed the history of art as the history of its sequestration by fashion, of its appropriation by a narcissistic élite:

As long as [the Arts'] march was marked with … dignity, whilst their union excited admiration, commanded attachment, and led the public, they grew, they rose; but when individually to please, the artist attempted to monopolize the interest due to Art, to abstract by novelty and to flatter the multitude, ruin followed. To prosper Art not only must feel itself free, it ought to reign: if it is domineered over, if it follow the dictate of Fashion or a Patron's whims, then is its dissolution at hand.[21]

Fuseli's resolute claim – that the value of art was an expression of those values that existed only in the public sphere, and that the association of art with domesticity weakened its identity – was a variant of the neoclassical aesthetic where virtue was coupled with disinterestedness, and where subjects were possessed by art rather than possessors of it. He continues:

Our age, when compared with former ages has but little occasion for great works and that is the reason why so few are produced:– the ambition, activity, and spirit of public life is shrunk to the minute detail of domestic arrangements – everything that surrounds us tends to show us in private …[22]

The commitment to a public aesthetic grounded on such a rigorous opposition to the commerce narrative of art became increasingly attenuated in the Victorian period, although in artist-writers like Howard, Haydon and Foggo one can still find the conviction that art is ceremonial and civic rather than intimate and homely. However, where these figures reasoned that authentic national art would come into being only in the context of direct state patronage, the dominant position during the Victorian period was that the state should act as a regulator ensuring competition between groups, organizations and academies.

Of course, an anti-commerce discourse could be applied to the workings of the Victorian RA. Throughout the 1830s it was claimed that, although the RA had helped to increase the numbers of professional artists within the fine arts, many non-academicians were no better than servile workers. Unlike the political economists, writers like John Eagles found in the art-trade nexus evidence that artistic identity was already manufactured before the production of an individual art work:

We have left the poetry for the drudgery or mere mechanism of the art, feeling for display, and exhibit and admire our glittering gaudy wares like a nation of shop-keepers, whose glory is the manufactory. What is the cause of this? Independently of something wrong, morally and intellectually wrong, in the public taste, which is in a state of alternate languor and feverish excitement, and looks with suspicion on whatever is offered, but with the profession of modern improvement, we fear it is the nature of Academies and Exhibitions to multiply artists, but not to promote genius.[23]

This is a refiguring of Hazlittean discourse. That is, Eagles repeats Hazlitt's criticism of the RA, where he had identified it as the institutional space of artificial stimulation, a place designed to attract figures undeserving of the

title 'the public', or any other noble appellation. Where Hazlitt had identi-
fied authentic art with a national spirit, the nature of which would form a
public from the experiences of spectators recognizing the communal grounds
of their constitution before appropriate models, Eagles laments the impossi-
bility of reconciling such claims about the formation of a national cultural
community to the material conditions of seeing modern art. The commercial
exhibition of art, as embodied by the RA, generates a space where objects are
seductive and vulgar commodities, as vagrant and capricious in their form
as the anonymous consumers to whom they are directed. Instead of reveal-
ing the social nature of aesthetic pleasure, modern art is characterized in
terms of its alienation from critical consciousness, or by its embracing of
'cold materialism'.[24]

Such criticism is Hazlittean also in its identification of publicity with the
arrest and decline of artistic identity. In succumbing to the demands of
glitter and glare, by suppressing the qualities of variation in the pursuit of
optical novelty, artists have lost the capacity to distinguish between the
public authority of style and the publicity of technique. Paradoxically, the
public identity built from the publicity the artist factors into his work is the
very thing that blocks the realization of a position that encourages the for-
mation of an authentic community for art. By embracing techniques and
technologies of display the artist unmakes the conditions which precede the
formation of real art, real taste. The adornments of an authentic aesthetic are
disfigured by the ornamentation that fashions itself into the fabric of the
painting, transforming it into the sensational emptiness of mechanical style.[25]

The anxiety about the institutional conditions of exhibition become increas-
ingly apparent in mid-Victorian reviews of the RA. By the 1870s – when
average attendance at the Summer Exhibition reached 300,000 – many com-
mentators felt that the interests of art had been written out by a space dominated
by the 'gossip' and 'amusement' of 'multitudes' drawn to the idea of 'curios-
ity'.[26] A landscape of tourism, here exhibitory space becomes the place of
meaningless assembly: the aggregation of things and bodies engendering the
self-cancellation of both. Writing in the *Fortnightly Review* of 1876, H. H. Statham
deals with this alienation of cultural space in terms of technique fetishism, the
deracination of the aesthetic in search of a signature 'style':

Art in England tends to become very much like a trade. Of the several thousands of
works that line the walls of various annual exhibitions, a large proportion represents
merely the manufacture, in slightly varying forms, of some trick of effect or manipu-
lation which the artist has made his own, and which, having been recognized as a
success is repeated ad infinitum, at little expenditure of thought or feeling.[27]

This rejects the commerce definition of art by denying the taste-consumption
thesis. For Statham, when taste becomes consumption it is a negation of the
value of patronage; and the art perpetuated by such a system blocks the

experience of the aesthetic by revealing the commodified materiality of the object. Again, when Henry Morley claims of Sir Francis Grant's portrait of the Duke of Rutland that 'his clothes have swallowed him alive', he continues a critical language that went back to Hazlitt's reading of the power of property to register itself by effacing art.[28]

Although variants on the commerce discourse were perpetuated by such journals as the *Magazine of Art*, many of its claims were increasingly threatened by developments in the late-nineteenth-century art world. By the 1880s and 1890s, in the writings of critics like George Moore, the commerce narrative of British art was refigured to reveal the business nature of the RA as a cultural institution. Thus Moore announced that the RA was not a true space of art, 'but a mere commercial enterprise protected and subventioned by Government. In recent years every last shred of disguise has been cast off, and it has become patent to everyone that the Academy is conducted on as purely commercial principles as any shop in the Tottenham Court Road.'[29]

Such attacks – and they were commonplace in this period – associate the business success of the RA with the decline of art. Moore, for instance, finds in Herkomer evidence of the power of the commerce system to generate technologies that displace the values of an authentic individualism in art.[30] Elsewhere, Laidlay suggests that the institutionalization of a business ethos at the RA produces a mercantile culture rather than an artistic spirit.[31] Far from creating authentic individuals within the artistic community of a 'National School', commercial culture reduces art to the endless competition between personal, but empty, signature styles.[32]

Reproducing the Royal Academy

Throughout the 1880s and 1890s attacks on the commerce thesis of art were formulated in and through reviews of the RA itself. *Blackwood's Edinburgh Magazine* generated a melancholy 'Darwinian' meditation on the prospect of Reynolds returning to survey the art world of the 1880s. Not only would he discover that his teachings 'concerning High Art had become obsolete', but 'the lapse of a century, he would see, had brought evolutions not always securing the survival of the fittest, and transmutations in species not everywhere showing developments upwards'. If commercial culture is aberrant and deforming, the competition it engenders is a form of death, because 'as the supply rises in excess of the market demand, the few may prosper, but the many must starve'. Cultural identity dissolves into the conflict of schools, the very opposite of 'national art'; and the government of the RA ensures the 'degeneration' of art into 'something to be measured' and 'weighed', as any other commercial product. So the institution acts

the part of certain politicians who lower the franchise, let in the flood of democracy and with the consequent multiplication of constituents, open additional voting-booths … A morning's walk through our exhibitions is a perplexity and distress. We might at moments mistake a gallery for a street of tombs; in fancy we stumble across bodies that have lost their souls … the nineteenth century, brilliant in discovery and unparalleled in progress, fails to leave its mark on our contemporary art … [much of which] might have been anticipated from educated mechanics.[33]

Earlier in the century critics had addressed the tension between the national and aristocratic claims on the identity of the RA. In the 1820s the *Examiner* asserted that state intervention would invigorate the institutions of art. By the 1830s Parliament involved itself in such debates by identifying the progress of art with the development and diversification of art institutions: in the Art Union of London it found a microcosm of the associative principle working through civil society. In the 1863 *Royal Commission* on the RA, which I have dealt with in detail elsewhere, interest in the social consumption of art was subordinated to matters pertaining to institutional consumption. It recommended that a reconstituted RA, governed by a Royal Charter, should advise governments in all matters relating to the regulation and management of civic art.[34]

By the 1870s and 1880s the belief in the emancipatory power of mass consumption itself was no longer so commonly expressed, as questions concerning the progress and government of art were refigured. Writers as diverse as Sidney Colvin, J. B. Atkinson, Joseph Comyns Carr, Alfred Austin and George Moore were disinclined to embrace the idea of the market as a liberatory space in which modern art would form from itself a national community of culture. Instead of the unification of production and consumption through 'free trade' in art, and in place of the image of a commercial culture of self-governing citizens, we find a new interest in art laws and their pleasures; a new interest in discovering the basis by which an authentic aesthetic space is known, identified and registered; a new way of ensuring that its specific qualities are not suppressed or obscured by the business of art institutions; and, in the case of Whistler's argument with Ruskin, a new concern with the forms and limits of temporality, which is to make 'work' pass as an ironic comment on the finish, style and pictorial logic of those objects locked into the academic market.

This is not, however, to suggest that issues relating to the economic promotion of art were suppressed, but that they were reworked in debates about the autonomy of professional bodies and the autotelic nature of the aesthetic; for, in both cases, the issue of value, its association with self-defining élite 'experts', was a response to the marketized logic of the commerce discourse of art with its claim on the consumer public. If we find in the professional society an articulation of quality that disconnects itself

from the leisure culture of certain 'amateur' bodies, and if we discover in Aestheticism the attempt to escape from the 'gallery picture', the commerce definition of art was a burden they could neither bear nor overcome. For instance, although the formation of the Grosvenor Gallery can be seen as an escape from the 'vulgarity' of exhibitory techniques at the RA – Mary Watts wrote excitedly of an environment in which 'the works of each artist, grouped together and divided by blank spaces, allowed the spectator's eye and mind to be absorbed entirely by … the mind of the painter' – its technologies of display worked to isolate the elements of public experience.[35] Indeed, this very idea of the exhibition as a concatenation of spaces framed by the atmosphere of specific paintings, or the consciousness of an individual creator, was locked into an environment where the pleasures of aesthetic purity were entangled with techniques that encouraged less disinterested forms of consumption.

Notes

1. This subject is tackled in Trodd 1997, pp. 3–22.

2. Ibid., p. 11.

3. See the *Athenaeum*, 1829, pp. 283–4; 1834, p. 355; 1863, pp. 147–8; *The Morning Chronicle*, 3 May, 1830, (unpaginated); *The Spectator*, 1836, p. 1189.

4. *Fraser's Magazine*, 1860, p. 874.

5. Taylor 1841, vol.2, p. 149.

6. Leslie 1860, vol.1, p. xxi; Taylor T. 'English Painting in 1862', *The Fine Arts Quarterly Review*, 1863, 1, pp. 1–26; Cunningham 1829–33.

7. Leslie 1855. Leslie claims that 'in invention and expression, the only master whose works, taken together, I would compare with Raphael is Hogarth' (p. 120).

8. The *Athenaeum*, 1857, p. 564.

9. *Westminster Review*, July 1837, pp. 119–21. See Foggo 1837b, where the RA is characterized as 'that secret, self-elect society … [of] convicted monopolists' (p. 15).

10. *Westminster Review*, July 1851, p. 405.

11. Ibid., p. 405. The RA is described as ' … one of those anomalous institutions, of a partly private character, which could not have grown up in no country but England, its history is that of a class of jealousies, royal favouritism and the induration of feud' (p. 394).

12. Shee, M.A. Parliamentary Papers, 1836 *Report*, p. 166, where he repeats the point made in Shee 1805, pp. xvii–xxi; Skaife 1854, pp. 35–6.

13. Skaife 1854, p. 60. Skaife is tackled by Fyfe 2000, pp. 117–33.

14. *Art Journal*, 1861, p. 145.

15. Shee 1860, vol.1, pp. viii–ix. John Millingen had argued that as the arts and sciences related to the security of the state and the dignity of the nation, they should not be 'left, like any other commodity, to find their natural price at the market, according to the degree of demand which may exist for them'. Thus the Government, concerned with public welfare, must support the fine arts by supporting academies, which are 'indispensable' for the promotion and study of culture' (Millingen 1831, preface).

16. *Art Union*, 1839, p. 66. *The Gentleman's Magazine* and the *Art Journal*, both sympathetic to the RA, used a similar critical rhetoric in the 1850s. Attacking the critics of the RA *The Gentleman's Magazine* claimed: 'The parties to the indictment are a small knot of agitators, composed chiefly

of disappointed artists and ultra liberal newspaper writers, in that advanced state of progress which recognizes the usefulness of no institution whatever which has either age or aristocratic traditions to recommend it' (*The Gentleman's Magazine*, 1859, p. 711). Five years earlier the *Art Journal* characterized attacks on the RA in terms of the activities of criminals who seek to deprive a 'solvent freeholder of his land' (*Art Journal*, 1854, p. 157).

17. Sandby 1862, vol. 1, pp. 118–28.

18. Parliamentary Papers, 1836 *Report*, p. 63. Hurlstone was friendly with the architect and publisher James Elmes, whose *Annals of the Fine Arts* adopted an aggressively anti-RA stance.

19. Barrell 1986 remains the key source.

20. He does, however, caution against the seductions of an exhibition style; see Reynolds 1959, p. 90.

21. Knowles 1830, p. 87.

22. Ibid.

23. Eagles, J., *Blackwood's Edinburgh Magazine*, October 1836, p. 553. Hazlitt and Haydon had said the same thing about the proliferation of academics in their 'An Inquiry Whether the Fine Arts are Promoted by Academies and Public Institutions', *Annals of the Fine Arts*, 1820, pp. 284–94.

24. This specific phrase occurred in pro-RA *The Gentleman's Magazine*, 1856, p. 236.

25. For an account of this process, see Trodd 1997, pp. 10–12; Trodd 2000, pp. 181–95; Rossetti, W. M., 'The Royal Academy Exhibition', *Fraser's Magazine*, 1861, p. 736; and 'Sensational Art' in Palgrave 1866, pp. 193–201.

26. Austin, A., 'The Characteristics of Modern Painting', *Temple Bar*, 1870, p. 172; Colvin, S., 'Art and Criticism', *Fortnightly Review*, 1879, p. 212. By the 1890s the RA was endlessly cited in tourism literature; see Cook 1897, pp. 344–6.

27. Statham, H. H., 'Reflections at the Royal Academy', *Fortnightly Review*, vol. 20, 1876, p. 60.

28. Morley, H. 'Pictures at the Royal Academy', *Fortnightly Review*, 1872, p. 695.

29. Moore, G. *Fortnightly Review*, January–June, 1892, p. 829.

30. I have dealt with Herkomer in Trodd 2000.

31. Laidlay 1898, p. 6. This subject is dealt with in more in detail in Trodd 1997, pp. 3–8.

32. The painter H. H. La Thangue wrote: 'Exhibition is a kind of competition or conflict'. *Universal Review* , 1889, p. 139.

33. *Blackwood's Edinburgh Magazine*, July 1885, pp. 1, 2, 5, 9, 15 and 17.

34. For a detailed account of the 1863 *Royal Commission,* see Trodd 1997, pp. 15–19.

35. Watts 1912, vol. 1, pp. 323–4.

'Fire, flatulence and fog': the decoration of Westminster Palace and the aesthetics of prudence

Paul Barlow

This is how Charles Knight's antiquarian history *London* (1841) describes the old House of Commons, destroyed by fire seven years earlier:

Of the associations connected with the House of Commons, some attach themselves to the old building or the apartment in which the representatives of the people had held their meetings for nearly three centuries prior to its destruction in 1834, but many also derive their interest from passages in the history of this branch of legislature, or peculiarities of its forms and usages, which have little or nothing to do with any particular locality. And even for the former class, the walls at least are still standing and will be preserved that echoed the eloquence of the senates of other days, and the spot which their long occupation has consecrated is to be kept separate and unappropriated to any meaner use, for the imagination to re-erect on it at will the whole structure of that dingy room, which to the unaccustomed eye, looked more like the prison than the palace of the genius of our English legislature. A strange underground cavernous air it had, indeed, with its one great table occupying half the penurious floor … and the chandeliers hung, not high, near the ceiling, but low down in mid-air, as if there had been some ground-haze, or other palpable murkiness, floating about and filling the place, which would have other-wise intercepted the light. The scene truly was apt to awaken the most awkward fancies. A mind disordered, or thrown off its balance, by the shock of the sudden, harsh, and complete *bouleversement* [collapse] of all its previous impression of the dignity and splendour of parliaments, might have been excused, looking down from that end gallery, for mistaking at first glance the assembled wisdom, speaker's wig and all, for some den of thieves, or a crew of midnight conspirators.[1]

This remarkable description begins with the emphasis on locality, custom and sentiment typical of conservative antiquarianism, devoted to sanctified spaces and practices: the preservation of time-honoured 'peculiarities' in 'forms and usages'. Such rhetoric emerges from Burkean critiques of the destructive rationalism associated with the French Revolution, its violation of accumulated relics, its dismissal of 'sentiment' and 'associations'. But as Knight's account progresses it seems to reverse its own values. The walls of

the old Commons become infected, corrupting – a fetid prison suffused with 'palpable murkiness' which disorders the mind and transforms the 'representatives of the people' into a criminal crew of conspirators. Fear of the subversive *canaille* emerging from the slums to seize power is transformed into a vision of Parliament itself, deranged and degraded by the very building it occupies.

The passage may be compared to the words of Pugin, who watched the 1834 fire, writing gleefully of the sight of the collapsing neoclassical and pseudo 'gothick' buildings, the absurd turrets of which were 'smoking like so many manufactory chimneys till the heat shivered them into a thousand pieces. The old walls stood triumphantly midst the scene of ruin.'[2] For Pugin the shoddy structure of Parliament mirrors the debased architecture of industrialism. The fire has released previously imprisoned 'old walls' (the medieval Westminster Hall) around which the modern accretions, including the murky Commons chamber, had been built. Indeed, Knight's own description had gone on to recall the destroyed chamber generating a dangerously explosive atmosphere 'composed of fire, flatulence and fogs'.

The labyrinthine, garbled, structure of the Parliament building here stands as a sign of Britain itself, as it was for other commentators. For radicals it represented the disorder within the British constitution: a confused melange of rotten boroughs and patronage networks. For MPs mindful of the murder of Perceval in 1812, its many entrances and obscure corners were too easily accessible to subversive midnight conspirators. Here again the spectre of the French Revolution haunts the legislature. Pugin's apocalyptic imagery is comparable to Carlyle's account of the destruction of the Bastille in 1789. In *The French Revolution* (1835), written a few months after the Westminster fire, Carlyle describes a clash between overwhelming force and incomprehensible, unknowable agglomerations of space and time. The Bastille, surrounded by 'Chaos', is 'a labyrinthic Mass, high-frowning there, of all ages from twenty years to four hundred and twenty'. It is impossible, even 'after infinite reading' to 'get to understand so much as the plan of the building'.[3] Carlyle's account symbolizes the struggle of a French monarchy trapped in archaism and inertia with the dynamics of a revolution which can neither understand nor engage with the institution it surrounds: inaccessible complexity engendering annihilation.

Both Carlyle and Pugin came to be preoccupied by the cultural importance of this complex of interrelated images: accretion, destruction, the medieval, the modern. Both came to be closely involved in the development of cultural institutions which emerged from the debates following the fire. Pugin's involvement with Westminster was, of course, direct. He designed the interior of the new Parliament on the model of the sanctified 'old walls'. His post-fire manifesto of medievalism, *Contrasts* (1836 and 1841), was an attempt to exam-

ine the relation between social institutions, architecture and community, containing the famous contrast of a spire-dominated medieval town with a chimney-strewn factory town. These themes were subsequently explored in Carlyle's *Past and Present* (1843) and Ruskin's *Stones of Venice* (1853).

However, this essay will not consider these canonical texts, but will instead situate the debate about the style and content of art in Westminster in the context of more popular antiquarian literature that circulated in the 1840s, of which Knight's *London* is an example. These texts, I suggest, set a particular model for envisioning British experience of history. However, this is also a tale of two cities. As I will claim, the principal model for the decorative scheme at Westminster is Louis-Philippe's reconstruction of Versailles. This French example engendered a particular kind of space for the visual definition of national citizenship, one which was both copied and transformed at Westminster.

These connections are rarely noted in the existing literature on Westminster, which tends to stress the influence of Nazarene ideas on the commissions, notably in the quasi-altar-pieces executed for the Lords chamber and the chivalric subjects from Arthurian literature painted by William Dyce for the Royal Robing Room.[4] The role of Prince Albert – chair of the Fine Art Commission set up to organize the decoration of the new Parliament building – was undoubtedly crucial here, his model being the patronage of Ludwig I of Bavaria, whose own collecting and commissioning of art was tied in with assertions of national myths, and given 'public' status by the building of museums in which to house them.

However, this aspect of the decoration of Westminster was only a part of a complex pattern of commissions. In fact, I shall argue that the design of Barry and Pugin's new building was used to construct two intersecting schemes of decoration. One follows the ceremonial functions of the house, leading from the Victoria Tower entrance through the Robing Room and the Royal Gallery (for which Maclise's battle pictures of Waterloo and Trafalgar were painted). This scheme ends in the Lords chamber, from which the monarch speaks at the opening of Parliament after having processed through the previous rooms. The second scheme, comprising thematized portrayals of historical political struggles, follows from the Westminster Hall entrance, up St Stephen's Hall to the central lobby and fans out into three separate corridors, leading to the Commons and Lords chambers, and straight ahead from the Hall. Broadly speaking these schemes correspond to the 'static' ritual/aristocratic, and the 'dynamic' historical/democratic modes of Parliamentary identity. The forms of art commissioned correspond to this difference; in subjects, style and address to the viewer.

I am not suggesting that these differences were planned in those terms, but that the pattern of governmental commissions which resulted in the final

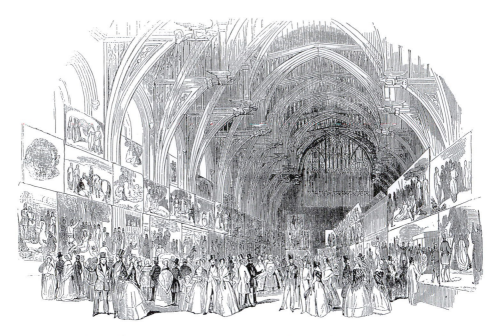

4.1 'Exhibition of Cartoons, Westminster Hall', *Illustrated London News*, 8 July 1843

scheme of decoration was articulated by the structural dynamics of the British constitution, as it attempted to assert a stable identity following the reforms of the 1830s. To some extent this can be traced to the famous 1843 cartoon competition by which Parliament acknowledged 'free competition in art' – which had been recommended by the 1835 Select Committee on Arts and Manufactures, set up to investigate the workings of Britain's art institutions with the new post-Reform Act agenda supplied by the Benthamite philosophical radicals. Free public access and open competition were bound up with claims that reform had dispelled the palpable murkiness of the old parliament and its practices. The exhibition was held in Westminster Hall – Pugin's 'old walls' – thus the model of meritocratic competitive efficiency was combined with pious devotion to national relics. The cartoons were arranged so that the left hand wall was illustrated with Spenserian, Shakespearean and Miltonic subjects, the rear with allegorical works, and the right with historical subjects arranged in chronological order (Figure 4.1).[5]

 This division reappears in the final scheme, and is allied to debates about the appropriate character of a national-popular art. The Nazarene artist Peter Cornelius, advising the Fine Art Commission, supported fresco for the decoration of Westminster, explaining that it necessitated 'large and simple forms'. The 'lower classes of the community' could not be expected to appre-

ciate 'the delicacies ... of painting in oil'. Simple forms, 'direct action' and 'in some instances, exaggerated expression' would appeal to such unsophisticated viewers.[6]

The artist and critic George Foggo also supported the use of fresco, but from a very different political position. Foggo adopted the familiar distinction between the luxury of Venetian colourism and the discipline of the Florentine drawing. For Foggo, the latter emerges from a democratic civic culture, in which self-discipline is central. The dominant value in such a culture is *prudence*, in contrast to the spectacle of expenditure characteristic of absolutisms and aristocracies such as Venice. For Foggo, the fresco medium both requires and expresses prudence and labour.[7] Attacking the 'promiscuous' energies of revolutionary crowds as much as élite displays of wealth, Foggo's critique of expenditure is characteristic of British commentary on the parallel despotisms of autocracy and the mob.

Aligning himself with Radical criticisms of the RA and of oligarchy, Foggo was active in attacks on 'corrupt' social institutions which failed fully to articulate national values. Campaigning for free entry to Westminster Abbey, the Tower and other major buildings, Foggo epitomized early Victorian attempts to constitute an inclusive national culture, which the new Westminster was, he hoped, to embody.[8] Foggo's civic vision of a national body comprising prudent, respectable, independent workers and entrepreneurs clearly differs from Cornelius's patrician conception of communication to the lower orders by those able to appreciate 'delicacies'. Foggo is contemptuous of these 'artists of Munich', who, rendered incapable of independent thought by their authoritarian government, 'imitate and copy Italian masters', then instruct freeborn Britons to do likewise.

This debate, then, is implicated in the political tensions of the early Victorian constitution. Prince Albert, advised by Cornelius, secures commissions for decorations in the Lords for Dyce and Herbert, the painters most in sympathy with the Nazarene 'artists of Munich'. However, the subjects chosen by the Commission for their paintings typically conflate history, allegory, literature and myth. The semi-historical episodes chosen – King Arthur, the youth of Henry V, the Order of the Garter – were all closely associated with literature. This is most prominent in the Arthurian Robing Room, and in the Lords chamber, where allegorical secular altar-pieces ('The Spirit of Religion') are juxtaposed with historical instances of these values ('The Baptism of Ethelbert').

Here a 'mytho-history' is created which is closely allied to the increasingly symbolic role played by monarchy itself. The chamber in which the whole of Parliament comes together for the royal speech works as an affirmation of 'universal' values instanced by the stylized Raphaelesque visual rhetoric of Nazarene art (Figure 12). Historical conflict is largely alienated from this

4.2 Ceremonial community: 'The Queen proroguing Parliament', *Illustrated Exhibitor*, 1852

space, its only significant presence being in the battle paintings decorating the processional Royal Gallery, through which the monarch passes to the Lords.

Of course, these paintings commemorate struggles against external enemies which confirm communal loyalty to the nation and its values. But this point brings us neatly to the problem of the French model for national public art mentioned above. The enemy in Maclise's pictures is Napoleonic France, victory over which had generated Britain's recent national myth, as the opponent of radical and militarist despotisms. Parliament defined itself against French political experience – the 'chaos' and the 'labyrinthic mass' described by Carlyle. Britain's National Portrait Gallery (NPG), which in part arose from debates about the decoration of the Parliament buildings, was construed by its founders as a response to wearisome and oppressive glorifications of power and violence to be found in Versailles – described by Earl Stanhope as a unrelenting succession of 'tawdry battle scenes and court pageants'.[9] When the Westminster decorations were first mooted, Louis-Philippe, who had come to power after the revolution of 1830, was extending this very sequence of paintings by creating the 'Hall of Battles' commemorating French victories from the earliest times through to the Napoleonic wars. At the end of the hall was to be a separate room in which would be depicted Louis's triumphal entry into Paris and his assumption of power in 1830. This scheme extended from the seventeenth-century paintings in the Hall of Mirrors, which celebrated Louis XIV's victories. Between these and the Hall of Battles was a room in which huge paintings asserted the military prowess and monarchical spectacle of Napoleon. These schemes were accompanied with a flurry of commissions from contemporary French artists, most famously Delacroix – though recent critical attention has focused on the figure of Horace Vernet.[10] In another part of the Palace, Louis created 'Gothic' rooms to commemorate the Crusades. These were also dominated by large narrative paintings of important battles, set in pastiche medieval panelling supported by some authentic medieval sculptures.

Critical discussion of Louis-Philippe's programme of commissions and decorations has tended to centre on the issue of the so-called 'juste milieu'. Albert Boime has claimed that Louis's régime sought a form of official art which involved a compromise between the 'extremes' of Romanticism and Classicism, and that this aesthetic compromise mirrored the régime's presentation of itself as a 'middle ground' which reconciled revolutionary and legitimist aspirations.[11] This position has been attacked by Michael Marrinan, who argues for a much more nuanced sense of both Louis's political programme and of the pictorial logic of the art which he commissioned, an art which cannot adequately be understood by the concept of 'compromise'.[12]

These issues are relevant to the Westminster decoration scheme in a number of ways. Particularly important was the fact that Louis had specifically

chosen to open Versailles as a museum – to transform a palace into a machine for the creation of a public spectacle of 'all the glories of France', in which both kingship and its popular affirmation were crucial. As a king who owed his position to revolution, Louis's long succession of corridors identified a paradoxical assertion of both rebellion and the charismatic authority of leadership.

I have spent some time considering Louis's activities because Versailles provides a particularly powerful model for the construction of a public visual culture in which 'the people' as participants in and witnesses to the spectacle of monarchy are simultaneously invoked and disavowed. The structure of the corridors is directly 'educational', as it insists on a narrative through which the viewer must pass, drawing on the developing traditions of the diorama and special exhibitions of paintings such as Gericault's *Raft of the Medusa*, at which extra material would be provided. As Marrinan says,

Spaces such as the Gallery of Battles or the Crusades Galleries provide the visitor with far more 'information' than the pictures they house: portrait busts, names and dates inscribed on wall panels, mouldings decorated with coats of arms are just some of the means used to multiply severalfold the number of specific historical references mobilised by the pictorial installation. We might say that the viewing spaces at Versailles are richly nominative; that is, everywhere articulated by repeated references to specific dates, characters and episodes that 'flesh out' the chronological parameters established by the pictures on display.[13]

It is this 'richly nominative' model with which Westminster engages, but which is adapted to resist the values which both Louis XIV and Louis-Philippe sought to stress. The integrated decorative and architectural pattern of Westminster involves just such a complex of objects, images and statuary as Marrinan describes. However, these were articulated very differently (Figure 4.3). Here, Foggo's call for a British historical art expressive of the value of prudence is important, particularly when set against the image of uncontained expenditure that is Versailles. The 'glory' celebrated at Versailles is manifest both in the extravagant grandeur of the building and in the imagery of endless military outlay – overwhelming resources of troops, equipment and energy in constant victory. Even Maclise's Waterloo and Trafalgar paintings indicate differences from this model: one concentrates on the death of its hero (Nelson), and the other on a successfully preserved alliance (Wellington meeting Blücher).

The pathos stressed here is much more apparent in the decorations leading from Westminster Hall – what I have called the 'historical/democratic' scheme. It is this that draws on the thinking expressed by Foggo and in the antiquarian histories exemplified by Knight's *London*. This scheme was articulated by two symbolic and structural features of the building: the central lobby and the remains of the 'old walls'. The four corridors from the central lobby were to

4.3 Plans of the Houses of Parliament and the Palace of Versailles

have scenes illustrating historical struggles and schisms, organized as parallel and opposed episodes facing one another across the walls. From Westminster Hall itself the corridor to the lobby was to illustrate the evolution of British constitutional rights from ancient times, reaching a point of division at the central hall. From the hall three corridors extend. Those splitting off at right angles to the Lords and Commons chambers used this architectural break to express the dominant historical rupture which formed the basis for the modern constitution – the Civil War, illustrated in parallel scenes from 'Parliamentary' and 'Royalist' points of view. The corridor leading directly on from the hall was to have three scenes on each wall depicting the contrast of barbarism with civilization, in which Empire is construed as an agency for the spread of civilized values. Thus one pair opposite one another contrasted ancient Britain sunk in barbarism with a barbaric India, civilized by Britain. The first scene depicted Agrippa routing Druids who were preparing to burn

victims in a wicker cage. The second showed a British officer putting a stop to the Indian practice of wife-burning.[14]

Here, then, history is depicted as both progressive evolution and as violent disjunction. This follows the structure of the building, emerging from the authentic relic of Westminster's primal moments, the Hall itself. Dating back in parts to 1097, the Hall, and surviving parts of the later medieval St Stephen's chapel, were fully integrated into the new building, which was designed as an extrapolation from this source. It is in this section that a direct response to Versailles can be identified. The dominant figures involved in the decision-making regarding the subjects and their interpretation were the historians Macaulay, Hallam and Stanhope – who was to be so dismissive of Louis-Philippe's Versailles. The commissioning of E. M. Ward to decorate the corridor leading to the Commons chamber is clear evidence of their dominating influence at this stage. Ward had failed to win a prize in the 1843 cartoon competition, but was known for his portrayals of British history in a style derived from Hogarth. That Hogarth's art was distinctively 'British' in character was a commonplace of contemporary criticism, but it was wholly alien to Prince Albert's system of values.

The style of the paintings executed by Ward and by C. W. Cope (who decorated the corridor to the Lords chamber) is closely allied to the antiquarian interest in national relics sanctified by the preservation of Westminster Hall. As I suggested above, full public access to national shrines was one of the aims of the critics of Britain's pre-1832 'ancien régime'. Literature such as Knight's *London* engaged with history through emphasis on the traces of the past remaining in familiar locations, the marks it had made in urban spaces, the personalities that had passed through it. *London* is organized as a series of vignettes, each describing the way historical drama – grand and small – has been enacted in the city's buildings, streets and parks. Thus Knight's account of St James's Park records festivities, riots, political violence (Figure 4.4). King Charles II's mistress, the Duchess of Cleveland,

walking one dark night across the Park from St. James's to Whitehall, was accosted and followed by three men in masks who offered her no violence, but continued to denounce her as one of the causes of the national misery, and to prophesy that she would yet die the death of Jane Shore. It was at the entry to St. James's Palace from the Park that Margaret Nicholson attempted the life of George III. In the Park the same monarch received at one time the almost idolatrous homage of his subjects, and at another was with difficulty rescued from the violence of the assembled multitude.[15]

Here, historical conflict crosses these spaces, and disparate moments confront and challenge one another. The masked men bring medieval history (the story of Jane Shore) back into their own present, itself overlaid by the oscillations of idolatry and violence in more recent times.

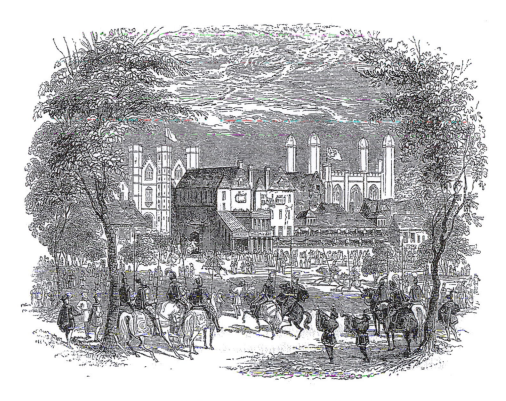

4.4 Ceremonial community: 'The Tilt-yard, St James Park in Olden Times', in Charles Knight, *London*, 1841

Likewise, contemporary guides to London's sights emphasize such preserved fragments of the past. W. R. Dick's guide to the Beauchamp Tower (part of the Tower of London) comprises a series of comments on graffiti – scratched names, verses, insignia, dates – left by various prisoners on the walls of the building. The recovery and narration of these identities, incorporated into the fabric of the building as relics, is the experience of the visit.[16]

It was H. C. Clarke, author of similar guidebooks to London museums, who printed Foggo's lecture in his booklet for the 1844 Westminster Hall fresco exhibition, but it is in Ward's and Cope's paintings that this mode of popular antiquarian history helps realize Foggo's prudential aesthetic. Throughout these paintings acts of labelling, writing and documenting are associated with historical struggles for the control of spaces. Thus in one of Cope's Civil War scenes, Speaker Lenthal kneels submissively to the figure of Charles I, who has entered the Commons chamber to arrest his opponents. But in doing so Lenthal displaces Charles from the centre of the

composition and pushes him into shadow. Meanwhile an official documents the King's intrusion into the chamber, while Cope's own signature and dating of the picture is placed between the two main figures; in the corner is another document with text also containing Cope's signature. The same device is adopted by Ward in several instances. The sleeping Argyle, shortly to be executed for participating in the 1685 rebellion against James II, drops a manuscript, readable across the plane of the image, on which he has written a prophesy of the future success of his cause, with his signature at the bottom. Ward signs nearby. On the wall behind, Argyle has scratched his name with the date '1685' beneath it. This is directly comparable to the prison inscriptions and verses described by Dick.

In these instances, then, the competition for power over space produces a *mise-en-scène* of competing points of authority, often characterized by the figures' movements through the material structures of institutions, which organize the compositional dynamic. In these images, locations are marked by the history which passes through them. It is not the spectacle of 'glory' that is affirmed, but the aggregation of historical moments within given sites, buildings and institutions. The disparate accumulation of records, inscriptions and traces of identity which characterize the relics in the Beauchamp Tower, the monuments in Westminster Abbey and other, more local buildings, becomes the principle from which a British form of historical art is developed: one which emerges from the emphasis on institutional continuity, so characteristic of British responses to the French Revolution, and which is the principle on which the rebuilding of Westminster itself was based. Here the expenditure of war is replaced by records of locations and personalities, memorials of competing values. This marking of retention and accumulation, of record keeping, and of defence, visualizes the antiquarian pleasures of prudence against French grandiosity and expenditure.

It also allows the scheme to acknowledge a history of conflict and confrontation while emphasizing the preservation of the past and its relics as accumulations of these moments. Such a history is suppressed at Versailles, which continually substitutes permanently successful leaders, constantly concealing evidence of failure and disjunction – a tendency traceable to Louis XIV's portrayals of his own wars. In contrast, the Westminster corridor schemes are preoccupied by the experience of defeat, political and military. This is connected to the overwriting of the past by the present, and the construction of the 'relic'. Of the eight scenes painted by Ward, four depicted historical personalities experiencing the defeat of their cause, two portrayed triumph, while the remaining two illustrated unresolved moments shortly before the fall of one régime and the installation of another. Cope's subjects also stress defeat, four again being directly concerned with failure or death. All the others refer implicitly to defeat, or its prospect.

This aspect of Westminster is related to its emphasis on popular involvement with history, marginal figures thrust into history's spaces, remembered like Dick's prisoners, or Knight's walkers in the park. A contrast with one of the paintings commissioned by Louis-Philippe clarifies the significance of this. Vernet's *Battle of Jena* (1836) from the Hall of Battles is the closest of these commissions in composition and theme to Ward's and Cope's work. It depicts a minor episode just before the battle commenced. Napoleon is seen riding into the space of the image. Murat rides over to the left. As a soldier in the line at the right breaks ranks to cheer the Emperor, both leaders turn their heads back towards the soldier and the viewer. A second soldier holds his pose at attention while straining his eyes towards Napoleon. The painting constructs a tension among the four characters, centring on the struggle between the rigid discipline required of the soldiers, and their desire to respond to the personal presence of the Emperor. The play is on the contradiction between two contrasts: that of charismatic leader with anonymous functionary, and that of distinct and equally significant individuals acting independently. This is connected to the fact that Napoleon – depicted in the grey greatcoat popularized by Vernet's paintings – is himself a seemingly 'anonymous' leader, moving away into the background.[17]

Vernet's stress on the identity of the private soldier marks, as Marrinan indicates, the importance of the citizen-subject in this scheme. The viewer is identified with the soldiers, catching a brief glimpse of the hero as he rides past. Napoleon's reaction emphasizes his recognition of their importance, even though he will chastise the undisciplined soldier. However, in the British paintings the spatial tension is not between independent and disciplined bodies in the social vacuum of battle, but, as we have seen, in the interaction between locations and competing identities seeking to negotiate differences within and between spaces. Thus, in Cope's *Burial of Charles I*, the ritual entrance into the church is interrupted by a Cromwellian officer who objects to the rites, confronting the officiating bishop eye to eye. In Ward's *Charles II Landing at Dover*, General Monk's ceremonial greeting of Charles is obscured by a multitude of cheering, retreating, or uncertain figures. A woman turns her back on the king, bending over an intimidated child. The child, at the centre of the composition, looks out at the viewer from between the two leaders. This intrusion of domesticity ('misbehaving' children) into the midst of the nominally important historical event self-consciously trivializes its aggrandized protagonists.

The Westminster scheme resolves itself into a fractured, discontinuous pattern of decoration, but this very discontinuity produces interacting narratives. The Nazarene frescoes and Maclise's patriotic battle paintings assert 'universal' values, but in the Corridors, the inscription and reinscription of history, tracing of identity, and intrusion of unhistorical acts into the histori-

cal moment represent history itself as multi-layered, while drawing on exist-
ing forms of public interaction with historical sites and relics, and managing
the distinction between ceremonial and legislative space. The new Westmin-
ster, open to the public as another London 'sight', is incorporated into a
structure in which popular and individual engagement with institutional
ruptures and continuities is itself sanctified.

 In dispelling the fire, flatulence and fog that had threatened to engulf the
legislature, Westminster strove to define visually the new 'Victorian' socio-
political culture of Britain. Confident progressions of stately rooms, corridors
and halls revealed multiple, overlapping claims on space with uncertain
boundaries. Later institutions pushed some of those paths further. The NPG
arose directly from Stanhope's experience on the Commission, his desire to
institutionalize through portraiture the culture of individualism. Likewise,
the V&A, though its roots were complex, developed from the concern with
national design which the new building had crystallized. Parliament's once
labyrinthine mass had cut passageways to the archipelago of modern metro-
politan art-institutions.

Notes

1. Knight 1841, vol.2, pp. 65–6.
2. Port 1976, p. 55.
3. Carlyle 1989, p. 200.
4. See Boase 1954; Port 1976; Bond 1980.
5. Clarke 1843.
6. Bond 1980, p. 29.
7. Clarke 1844, p. iv. For a detailed discussion of Foggo's theory see the introduction to this book.
8. Foggo was secretary to the National Monuments Society, which organized the campaign. See
 Foggo 1837a.
9. *Hansard*, 3 August 1859, p. 1771.
10. Marrinan 1988.
11. Boime 1980.
12. Marrinan is also critical of a largely unstated assumption in Boime's account – derived from
 Léon Rosenthal – that the alleged artistic 'mediocrity' of Couture and Vernet is somehow
 explained by their position in Louis's 'compromise' régime. See Marrinan 1994. Boime defends
 himself in the same collection.
13. Marrinan 1994, p. 121.
14. Parliamentary Papers, 1847 *Report*, XXXIII, Appendix, p. 576. This part of the scheme was never
 executed as envisaged.
15. Knight 1841, vol.1, pp. 203–4.
16. Dick 1853.
17. Marrinan 1994, p. 133.

II

Communal taste: institutional discriminations

While the essays in Part I of this book all deal with national institutions which claimed to address the totality of the public, this section deals with those institutions which in various ways 'discriminated' among that public, seeking to define a space for specific sections of creative activity (watercolour societies), neglected members of the public (female artists), or those who were seeking a place within the changing art world (the Slade, the Art Union). In this respect, these essays deal with institutions which do not claim to belong to the nation as a whole, and are not – directly at least – funded by Parliament. The institutions chosen for discussion in this Part are, of course, only a portion of those which might have been included. Specialist societies established to promote the interests of particular tradesmen were not new. Art schools of various kinds came and went. We have concentrated on these particular institutions because they reveal the tensions operating in Victorian art organizations. The claims of the major galleries and schools discussed in Part I were challenged by special-interest groups who either sought to transform those institutions or bypass them. Thus the Society of Female Artists emerges alongside continuing institutional resistance within the RA to the admission of female students, just as the Slade emerged from the perceived need to provide alternative teaching practices. Likewise, the watercolour societies were continually concerned to assert the status of their medium in the face of neglect and maginalization.

Here, then, the 'public', become competing communities – tied together by shared experience of alienation from the (real or perceived) official positions of the major institutions. Whether unified by sex, aesthetic values, or trade-practice, these institutions articulated 'communities' of cultural identity which were continually engaged in acts of discrimination: defining their community, while responding to discriminatory practices which served to maintain their own marginalization. All the authors within Part II, therefore, seek to study the dynamics of such institutions, their internal tensions. In particular they explore the connection between their construction of niche identities, and their ideological claims to represent a truer community of taste or of citizenship than had been institutionalized at the RA or NG.

The Society of Female Artists and the Song of the Sisterhood

Stephanie Brown and Sara Dodd

The history of women's struggles to establish themselves as professional artists in the Victorian period has been well rehearsed over the last twenty years or so. Many interesting points have emerged from this body of research, most notably with regard to career formation. The reasons for women's marginalization within a male-dominated art world define, by implication, the institutionalized culture of the ascendant art scene and its particular valuation of subject matter, style, technique and medium. However, the questions addressed by this essay, of how women sought to define themselves institutionally, and how this process of institutional identity was represented in critical commentary, have tended to become lost or confused with narratives of a putative feminist self-consciousness that comes into being to challenge something called 'bourgeois ideology' or 'Victorian patriarchy'. There is still a tendency among some feminist art historians to see 'Victorian' culture as a repressive rump of objectionable attitudes and institutions against which heroic opponents pit themselves. In so far as female artists achieve a genuinely feminist position, they are seen to somehow escape from their historical condition as Victorians.

This essay questions certain of the more tenuous claims made in the name of such blanket 'theory' by re-evaluating historical evidence in such a way as to connect the processes of institutionalization to contemporary debates about the nature of work, many of which emanated from the materials of Victorian political culture itself and from the discourses it sponsored. Such an approach enables us to engage with issues suppressed or ignored by the dominant accounts of women in the Victorian art world, opening up new areas for research and clarification.

Women and institutions

There is an appreciable literature which gives prominence to the barring of women from the Royal Academy Schools, Laura Herford's subterfuge in gaining entry (using only her initials),[1] and the subsequent fight, throughout the 1860s, for women to gain admission and professional status as Royal Academicians or Associate Royal Academicians. Typically, feminist historians identify this process as a struggle by women to storm the barricades of patriarchal institutions, and they align this art-world activism to battles concerning the franchise and property rights. Such issues are often projected not only into discussion of female exclusion from high art, but into debates involving the portrayal of women in art itself, the problematic question of the nude, and the perceived feminine character of 'lowly' genres such as flower painting, or 'lesser' media such as watercolour. This mix of preoccupations can lead to both productive and confused debate, but the scope of this essay allows for only one manifestation of this to be examined in sufficient detail. It will therefore be proposed that these interacting interests are entwined in consideration of female involvement within institutions, especially in the now traditional narrative of progressive 'barricade-storming'. In contrast to this story, we will argue that the class-based character of female involvement in art has been insufficiently attended to, its connection with discourses of political economy neglected.

In the literature concerned with Victorian art and its institutions, it has been customary to divide female cultural commentators, distinguishing between 'radical' and 'conservative' camps. An artist like Barbara Leigh Smith Bodichon is construed as genuinely radical, combining an interest in cultural identity with a commitment to political representation for women. Another individual cited in this context is Harriet Grote, the writer and benefactor of the Society of Female Artists, whom we shall consider shortly. Pitched against these 'oppositional' voices, a figure like Dinah Mulock, the popular novelist and writer of self-improvement texts for genteel women, is defined as conservative, unable to make the leap from supporting a limited extension of women's rights to generating a detailed feminist philosophy. This system of interpretation is implicit in recent works by Paula Gillett, Jan Marsh, Deborah Cherry and Pamela Nunn.[2] However, this distinction is not without its problems. First, it is not at all clear that there was indeed a crucial difference between radical and conservative positions, simply because both drew upon the tradition of political economy to develop a critical language explaining the social and economic advantages of giving women access to the institutional systems of the professional art world. Both factions made the division between what P. G. Hamerton called the 'feeble dilettantism' of the recreational art confected by 'young ladies' and the art produced by 'authentic'

women artists, on the basis of the social and economic utility of professional work.[3] In addition, the idea that Bodichon or her friend Anna Mary Howitt claimed a universality to their feminism beyond the threshold of middle-class culture is deeply problematic. So, for instance, we search in vain for any radical statements where they address the status of female models or other such 'drones' within Victorian patriarchy. Here Bodichon's remarks about Elizabeth Siddal, made to Bessie Parkes, a fellow 'sisterhood' feminist, are particularly revealing. In organizing a period of recuperation for the ailing Siddal, Bodichon directed Parkes to avoid all reference to the convalescent's former identity as a model, this to protect the respectability of them all.[4] In their association with middle-class culture, and in their identification with a 'self-help' ethos, Smith and her friends were as conservative as Mulock and other popular writers. Instead of being recto and verso, it is more appropriate to see radicals and conservatives as overlapping sheets, interleaved in the very claims and attitudes that mark the articulations made by women as institutional agents.[5]

This brings us to the question of what is meant by the term 'sisterhood' and how it could be expressed institutionally. In the writings of Marsh, Cherry and Nunn, the concept seems always about to become a material or social reality.[6] It would seem that 'sisterhood' is the condition to which women artists aspire, a place in which individualism is surrendered to higher values of collective identity. Beyond this, what 'sisterhood' is, or might become, or how it is to be distinguished from networking, is never at all clear. Nor is it evident why it is deemed radical rather than conservative, an authentic condition of social or institutional experience, rather than a lifestyle embraced by a certain type of bourgeois subject. It can be argued here that the 'failure' of such a 'sisterhood' to declare itself as an institutional reality has influenced the way in which the institutions formed by women have been examined within modern feminist discourses.

The Society of Female Artists

The Society of Female Artists (known as the Society of Lady Artists from 1872, when only professional artists were to be admitted, and from 1899 as the Society of Women Artists) was formed in London in 1856 and held its first exhibition in 1857. Art classes as well as exhibitions were organized under its auspices, and it seemed at first to be an important rival to contemporary male-dominated exhibiting societies and institutions. A nomadic institution – it opened at 315 Oxford Street, moved to the Egyptian Hall, Piccadilly in 1858, the Haymarket in 1859, Pall Mall in 1862, and ended up at the Gallery of the Society of British Artists, Suffolk Street in 1896 – the SFA

has been treated as something of an embarrassment by recent commentators for whom it is insufficiently ideological or radical.[7] However, it could be argued that in its concern with the productive value of work associated with the 'professional woman', it provided an entirely orthodox model of political economy.

Because its archives were lost in the Second World War, very little is known about the self-definition of an institution described as 'partly philanthropic and partly artistic' by the *Art Journal*.[8] Founded by Harriet Grote, the wife of George Grote the MP, the SFA embodied many of the principles and ideas she had accumulated in dealings with the Philosophic Radicals of the 1830s. Harriet Grote is an intriguing figure, though surprisingly, the relationship between her 'feminism' and the political and economic culture of radicalism has been ignored by art historians. However, even a brief account of her interests indicates something of the complex of ideas working through the SFA.

Grote, far more than her husband, was a great political networker and classic publicist for the radical cause in the 1830s. By the 1850s, though, her interests seem to have become identified with the workings of her salon.[9] This localization of radicalism enabled her to marshal considerable powers of patronage for particular concerns, one of which was the condition of women who aspired to professional status. The formation of the SFA emerged from quite specific debates about the problematic condition of unmarried middle-class women within what was seen to be an unaccommodating labour market. On the basis of her writings about economic and social matters, it seems reasonable to suggest that Grote saw the SFA as a vehicle of utility, which would be socially and economically valuable through demonstrating that women could enter a profession and contribute to the circulation of goods and services. Indeed, Grote's engagement with this subject emerged from her interest in the relation between demographic forces and economic powers – the claim made by Jameson, Mulock and others that a 'surplus' of 800,000 unmarried women would be a burden on national resources.[10]

We have suggested that Grote's radicalism or feminism loops back to issues concerning the productive power of the social body, rather than any real identification with communitarian ideals one might associate with the 'sisterhood' claims made by recent commentators. This reading is confirmed when we examine her writings, though the nature of this essay limits discussion to two representative works, *The Case of the Poor against the Rich fairly considered by a mutual friend* (1850) and *On Art, Ancient and Modern* (1855), both of which were reprinted in her *Collected Papers* (1862).

The Case of the Poor is a most illuminating document. In its identification of the internal logic of political economy with laws of social and natural life its totalizing vision exceeds the mechanical purity associated with Gradgrindian

economics. Her essay seems to be the fantasy of economic reductionism imagined (and parodied) by Dickens, Carlyle or Ruskin. She makes many of the standard points within the discourse of political economy: that charity is of no value in the problem of poverty; that any form of co-operation be-tween workers blocks the laws that regulate profits and wages; that the state should minimize its involvement with the poor, the labour market and em-ployment contracts; that nothing must impinge on the 'law of property.' Her great fear is the operation of practices that are 'unproductive'. Anything which blocks the 'accumulation of capital', which is destined to 'reproduce wealth' must be annihilated. Capital, 'set to work', constantly reproduces itself and makes the social body strong and healthy.[11] Politics, then, is the art of ensuring that capital is accumulated more quickly than the population increases.

Opposing the sentiments of the 'humanity preachers' Grote proclaims that: ' … no one need die of hunger in England. But he who would eat the bread of others must eat it in the workhouse … [Poverty] can only be eradi-cated, if at all, by a new course of provident and self-denying conduct on the part of our working people.' The problem of pauperism, she concludes, is checked by the 'natural law' of 'death from poverty'.[12] Such matters shaped the way in which Grote approached the institutional identity of the SFA, and it is clear from these ideas that her claim on the SFA derived from an interest in population, productivity and self-help. That is, women would become 'citizen' artists when their work was allowed to contribute to the generation of capital and the logic of consumption.[13]

On Art, Ancient and Modern links economic and cultural values, reading the history of art as the development of the progressive power of commerce. As the arts began to distance themselves from the controlling power of the Church, the diversity of styles and subjects indicated new expressive freedoms created in and through the liberal arrangement of artists with patrons. The fascination of wealth with art led to 'the multiplication of objects of curios-ity' – a social vision of culture that looked out into the world for its inspiration instead of turning back into a 'meditative' realm of 'pious ecstasies and eloquent agonies'. Now the civilizing qualities of commerce generate the 'rich products of the easel', and modern achievements 'surpass, in most respects, those of the previous period'. Economic expansion and cultural freedom produce a popular art speaking to a mass market of consumers through 'homely forms of sympathy – domestic incidents and everyday interests'. The 'teeming abundance' of artists reaches out to address 'every variety of taste'.[14]

This emphasis on the 'homely forms' of modern art working through the laws of supply and demand benefited the institutional identity of the SFA for obvious reasons. First, the work it exhibited could be associated with the

'femininity' of many contemporary genre subjects displayed at the RA
Annual Exhibition. Second, it provided the context for contemporary com-
mentators to see that the SFA was organized on the basis of extending the
principles of political economy to the collective practices of women artists.
Thus the claims on professionalism emerged in a language about productive
value and economic rationality. It was believed that the SFA would open a
'new field for the emulation of the female student', and establish a 'wider
channel of industrial occupation, thereby relieving part of the strain now
bearing heavily on the few other profitable avocations open to educated
women'.[15] This point was echoed by the *Spectator* when it claimed, ' … the
new exhibition will afford to professional ladies an opportunity both of
showing their competency and of selling the pictures and drawings that
they may produce'.[16]

By seeking to disconnect women art producers from dilettantism, the
emphasis was placed on employment, training and access to exhibition spaces.
If this focus on commercial value was a way of demonstrating that the SFA
was an authentic institution rather than a pointless display space, it also
suggested that women were legitimate producers within a public economy
of wealth generation. Professionals whose status was recognized by the
market, their labour was 'profitable' because it was not 'wasted' energy
spent on private leisure activities.

Needless to say, the conditions under which the SFA entered the market,
and the institutional claims this entailed, did elicit cautious comment from
some sectors of the press. The *Illustrated London News* wanted to know how
women could maintain their 'rights' by withdrawing 'from the association
and competition with their brother artists'.[17] The female press, such as it
was, also began to revise its initial enthusiastic support very soon after the
first exhibitions.[18] Some women activists had felt let down, and many had
begun to feel that to contribute to separatist institutions was to renege on
their original challenge to meet men on their own ground, in this case the
exclusivist male art institution.[19] A consistent criticism in the art press, how-
ever, was of the poor standard of work in general and the lack of technical
skill in particular. A review of the 1866 exhibition, using familiar terms of
reference, damns with faint praise the 'attempts at figure-painting, a depart-
ment it is always perilous to enter without studied preparation',[20] and
condemns 'that want of completeness and thoroughness which, in woman's
work especially, so constantly stands in the way of absolute success'. The
patronizing tone of such reviews is easy to condemn. Equally, it is easy to
pluck out negative comments on particular exhibits as evidence of a desire
on the part of male critics to denigrate the project as a whole. However, the
evidence does suggest that artists who stayed within the traditional areas of
female artistic accomplishment are given gentler treatment in the gendered

language of eighteenth-century 'sensibility' suited to their sex. One woman's work, 'though amazingly slight, is delightful in its concord of grey greens, and has a manner truly artistic'. In another 'the colour is fervent yet delicate, and a sense of poetry is made to suffuse the scene'. The reviewer's 'kindly' conclusion, however, is that 'the enterprise is not to be measured wholly by an Art standard, it is also to be esteemed as a social aspiration ... as one among many ways, all but too few, whereby woman may find a vocation, and by work not uncongenial to a lady make a livelihood or add to the resources of a household'.[21] Elsewhere the *Englishwoman's Review* claimed that the SFA Annual Exhibition supplies 'the public with what the public likes – i.e. cheap pictures'.[22] When the language of political economy is adopted, SFA exhibitions are perceived as an effective shop-window for the products of female labour consistent with genteel class-identity. The gendered language is part of this discourse, a sign of the distinctive marketing role of the exhibition which uses 'femininity' as its claim on the consumer.

Ruskin: feminism's Anti-Christ?

This establishes a useful context for considering the case of Ruskin, the convenient Victorian punch-bag in some feminist discourse.[23] Ruskin's doctrines of sublime and authentic observation of nature had been seen as revolutionary in the middle of the century, challenging as they did the accepted academic principles of History Painting, with its emphasis on classical models and its organization around the study of the nude. This is important because discussion of the position of women artists has – then as now – homed in on the question of the nude. As has often been pointed out, one of the main barriers to female admission to art training, especially at the RA, was the impropriety of access to the male nude, especially in male company. The nude was traditionally considered an essential ingredient of the training required to aspire to the still dominant genre of historical figurative painting in oils. If women could not get the training, it has been argued, they could not hope to aspire to a fitting depiction of 'high' subjects. The noblest subjects and the most elevated method of representing them were therefore denied to women. In the words of Pamela Nunn, 'without life study, the Victorian female artist was confined to those genres which were held in low esteem because they discussed inanimate vegetable or animal matter'.[24]

Ruskin's influence is pertinent here. His rhetoric and his advice concerning drawing ran counter to this institutional logic, and his own practice as an artist conformed to 'feminine' conventions. Ruskin didn't produce finished, exhibited works for sale; he didn't draw from the nude, but instead

drew architectural details, submissively copied the works of great masters, or sketched bird's feathers. This practice was justified by his theoretical writing as being intellectually, morally, and aesthetically superior to traditional academic methods. For Ruskin, the nude was irrelevant, access to it unimportant. But the entryist techniques of Laura Herford implied the existence of a stable hierarchy of art embodied in institutions, to which access must be obtained at all costs. Ruskin, meanwhile, cultivated non-art-institutional networks, for example in extending his own belief in disinterested amateur observation by encouraging this in the girls he wrote to at Winnington School.

Watercolour had been seen as less important than oils since the formation of the RA, but Ruskin's support for the fluidity and spontaneity afforded by watercolours, following his admiration for Turner's effects in both media, meant that the technique traditionally associated with women amateurs had begun to gain status. Manuals such as Ruskin's own *The Elements of Drawing* (1857) were added to the more traditional drawing books, such as *Ackermann's New Drawing Book of Light and Shadow* (1809). Copying alone, for which many of the earlier manuals were castigated later in the century, was not enough for those of Ruskin's persuasion, of course. F. Edward Hulme, author of *Art Instruction In England* (1882) looked back to the days when for 'our mothers … drawing was a mere accomplishment … the blind copying of drawings … as mechanical and senseless an operation as can well be imagined', and lamented that this still lingered in 'some ladies' schools', as opposed to what he called 'real art power'.[25] Although, as Hulme notes, copying was still in operation towards the end of the century, by then women and girls were also allowed to pursue that element of the sublime so revered by Ruskin. Ruskin's opposition to blinkered 'copying' is suggested by Elizabeth Wordsworth, principal of Lady Margaret Hall, Oxford, in an anecdote describing how she and her sister were taught his 'principles', with 'studies of … white arum lilies and other things' as opposed to what they had done at school, where,

we copied blacklead pencil drawings on Bristol board, we did sketches with ready-made sunset and moonlight 'effects' of pink and grey respectively, which looked really imposing when touched up with Chinese white by the master's steady hand … and we filled pages on pages with 'touches', as they were called, done copybook fashion. The master did a little scribble in the top left-hand corner, which was supposed to be typical of the foliage of oak, birch, elm, willow, etc. and we repeated it (non passibus equis) over and over again! Well might Ruskin inveigh against such methods as these.[26]

By the time of Wordsworth's recollection, Ruskin's methods had overtaken those of the copyists. However, even Ruskin was supposed to have dismissed a drawing with a crusty 'My dear young lady, how can you with

your HB pencil and your bit of india-rubber hope to portray the moon in all her glory?'[27] In the more public arena and professional sphere, this is reminiscent of his reaction to Anna Mary Howitt's ambitious history painting, *Boadicea Brooding Over Her Wrongs* (which had been rejected by the RA), in a letter written to her after its acceptance at the 1856 Crystal Palace exhibition: 'What do you know about Boadicea? Leave such subjects alone and paint me a pheasant's wing.'[28] Clearly this is an example of Ruskin's naturalistic aesthetic which sought not only to invert the hierarchy of genres described by Nunn, but also – as we know from his advice to established artists – to assert the moral authority of nature, its motifs and forms. Knowing Ruskin's notorious pomposity, we also know his intention was unlikely to have been critically demeaning. His distinction between *aesthesis* and *theoria* was not a distinction between the genders and their capacity to make authentic art. Indeed Ruskin's 'pheasant's wing' is a metaphor in an anti-luxury discourse, one which suggests the 'modesty' of such imagery is not indicative of smallness of talent, but something virtuous, a form of integrity which seeks to transcend the pictorial rhetorics of commercial culture and its 'exhibition pictures'; and, in this sense, his is a claim about the collective experience of art that continues the Hazlittean criticism of institutional painting.[29]

Women's activities working within or around institutions take on a particular significance in the light of the alternative values represented by Ruskinian aesthetic preoccupations. For example, the Old Watercolour Society, established in 1804, and the New Watercolour Society of 1832, equally anxious about enhancing their professional status, had excluded women as amateurish in their range of skills, forcing aspiring women to form the SFA. Nevertheless, many women, like Howitt with her *Boadicea*, still felt it worthwhile to try their luck at the RA for the chance of exhibiting their more ambitious works. Such instances demonstrate that amongst female artists there was a reluctance to embrace the potential of a Ruskinian alternative, and a readiness to pursue their aspirations through established institutions whose academic practices and prejudices seemed designed to exclude them.

The Female School of Art

We suggested that the SFA was central to the process of developing an institutional logic for the display and purchase of art by women, emerging, as it did, at a moment when the issue of the employment of single women was becoming a topic of discussion in the cultural press. In its association with utility rather than art theory the SFA was similar to the Female School of Art, which opened in 1842 in order to enhance the design quality of domestic manufactures and support students from 'the middle class to ob-

tain an honourable and profitable employment'.[30] It is certainly the case that both organizations were broadly aligned to a reformist discourse which suggested that the social conditions of disadvantaged groups could be improved by access to education, and that this process of amelioration would have the economic advantage of supporting the manufacturing sector.

Given a government grant until 1859, the FSA had emerged from the debates about the reform of commercial art in the 1830s. Pupils were trained to become industrial designers and teachers, but not professional painters. By the early 1850s, when Henry Cole was developing and directing affairs at the new Department of Practical Art, the FSA was obliged to introduce *laissez-faire* principles. Student numbers were expanded; tuition fees were increased; staff numbers were reduced. Cole's interest in income-generating practices required the FSA to adjust the composition of the student population to include middle-class amateurs, all of whom paid higher fees. This blurring of the boundaries between work and recreation, between industry and leisure, was not unique to the FSA: later in the century the Slade faced a similar problem in the relationship between revenue gathering and institutional standards.[31] Cole's edict resulted in the FSA losing the monies received from the state, as what had begun as a means of providing cheap training and employment for the artisan class was perceived as becoming a finishing school for more genteel young ladies who aspired to the fine arts. What should be noted is that the FSA and the SFA responded to similar irreconcilable interests. The institutional logic of both was complicated by the contradictory interests of three client groups: artists seeking to enter, or enhance their position within, the profession; middle-class art-workers seeking to maximize their employment interests by gaining access to training and exhibition networks; and amateurs producing art as a form of hobby or leisure activity.

The FSA, however, sought to combat the accusations of amateurishness, having broken away from its origins in the Government Schools of Design and, after a period of transition at Gower Street, by 1860 it had newly established itself in Queen Square (Figure 5.1), in premises exclusively for women.[32] Louise Gann, who had initially been trained, then served as an assistant, at the FSA, and was now its Superintendent, organized a lively campaign to continue the School as it was, raising funds and petitioning influential members of the Establishment.[33] A committee was formed, subscriptions were collected, and eventually, in 1862, the School became the Royal Female School of Art under the patronage of the Queen. Three years earlier, when Jessie Boucherett had founded the Society for the Promotion of Employment for Women, an article appeared in the *Art Journal* on 'Art Employment for Females'[34] stressing the practical training that 'young ladies educated at the Government Schools of Design' could acquire so as to gain

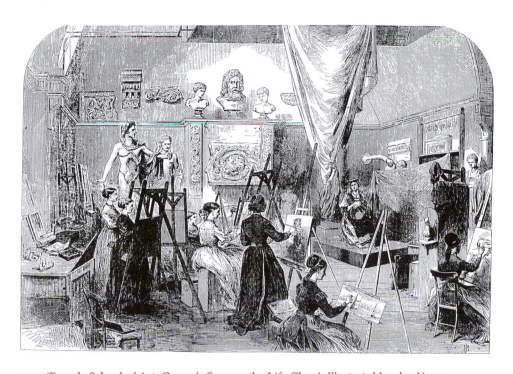

5.1 'Female School of Art, Queen's Square: the Life Class', *Illustrated London News*, 20 June 1868

employment in a 'wide field for this class of females'. This was what the Female School of Art under Gann had moved away from though, and her pleas for the School's preservation in the same journal in 1860 were introduced by the editor expressing the hope that 'the difficulty may be met by the co-operation of all who desire to promote Art, and especially those who advocate every means of procuring employment for educated women'.[35] Educated women, rather than the artisan class alone, had become a focus of attention in the FSA. Gann constantly reiterates the need for 'providing honourable and remunerative employment for educated women', losing no opportunities to point out that 'should the Gower Street School be closed, one of the most useful institutions for the professional education of women would be lost to the public'.[36]

 Instead of dealing with the SFA or the FSA in terms of their inability to form and develop a 'sisterhood' of feminist artists, we should see them as institutions that faced different problems and issues. If the SFA deployed networking techniques to present women artists before a public of consumers, this was because it worked to address the status of work performed by women artists. Issues of social or institutional coherence should not be col-

lapsed into judgements about the merits of the work displayed at its exhibition. Because the SFA was an instrument of utility, founded to extend the principle of economic independence to middle-class women, it should be seen as a practical exercise in self-help rather than a feeble attempt at feminist art politics. Rather than searching for the mythic purity of a 'sisterhood' discourse, we should see Victorian women artists and cultural agents in terms of relatively stable and conformist attitudes to institutional representation and articulation. Both 'conservatives' and 'radicals' were more interested in the entrepreneurial opportunities afforded by the commercialization of modern culture than in embracing a fellowship discourse that included middle-class and working-class women. It should not surprise us, then, that the SFA and the FSA were shaped for the market, organized to constitute entry points into commercial culture at the same time that they asserted a claim on professional identity.

Notes

1. See Cherry 1995, pp. 53–4.

2. See Gillett 1990, pp. 133–91; and the essays by Marsh, Cherry and Nunn in Orr 1995, pp. 33–48, 49–69 and 107–24. As will become apparent when we discuss the ideas of Harriet Grote, both 'egalitarian feminists' and supporters of 'bourgeois femininity' (these are Cherry's terms) used identical concepts to justify the social value of the professional woman. Muloch's productivist definition of labour is as radical as the most egalitarian Victorian feminist. She writes of women's art and literature: 'we must learn to rate ourselves at no ideal and picturesque value, but simply as *labourers* – fair and honest competitors in the field of the world; and our wares as mere merchandise' (Mulock 1858, p. 49).

3. Hamerton 1873, p. 349.

4. Herstein 1985, p. 100.

5. Cherry 1995, pp. 52–3, distinguishes Bodichon and Howitt from the bulk of the SFA by claiming that they were 'egalitarian feminists' who 'countered prevailing ideals of femininity'. However true this may be, it is obvious that Cherry, like Marsh and Nunn, wants this progressive 'egalitarian feminism' to be ideologically untarnished by those more 'problematic' aspects of Victorian intellectual culture which also attacked traditional ideals. This generates blockages and confusions in her argument. Cherry separates out these progressive values by asserting that distinct 'discourses' operate in Bodichon's work. Her 'feminist politics of landscape' is untainted by the fact that her North African views 'were produced within the growing industries of tourism, itself a component of the discourses of imperialism and orientalism generated around this French colony' (p. 57). It is precisely the *relationship* between Victorian feminism and imperialism that is evaded here. Although Cherry does not mention it, Bodichon's husband held that the 'progressivism' of the 'fair races' obliges them to conquer the 'black, brown and yellow races' in the name of 'universal brotherhood' (see Bodichon 1859, pp. 5–6).

6. Marsh (in Orr 1995, p. 42) associates Bodichon with the search for sisterhood, though it remained elusive in institutional frameworks. Thus Bodichon's promotion of 'mutual aid' is realized in the Portfolio Society, which acted 'in some degree as a substitute for the unrealised Art Sisterhood'. In fact the Portfolio Society included male members.

7. For Marsh (Orr 1995, p. 42), the SFA failed 'to play an active role in respect of artistic sisterhood, [nor did it provide] a site of mutual support where strategies of collective and individual advancement could be developed'. For Cherry (ibid., p. 55), the SFA was 'similar to egalitarian feminist groups, although it lacked their focused objectives'.

8. *Art Journal*, 1869, p. 421.

9. Thomas 1979, p. 416.
10. See Thomas 1967, p. 209.
11. Grote 1850, pp. 15–17.
12. Ibid., p. 20.
13. The review of the 1858 SFA Exhibition by the *English Woman's Journal* (which was established by Bodichon and supported by Grote) contains the following passage: 'Everything which, in the present needs of society at large, helps raise the energy, concentrate the ambition, and support the social relations and professional status of working women, is a great step in advance ... This Society may be made a noble means of *self-help*' (p. 206).
14. Grote 1862, pp. 196–200.
15. *English Woman's Journal*, 1858, p. 205.
16. *Spectator*, 1857, p. 496.
17. *Illustrated London News*, 1858, p. 351.
18. *English Woman's Journal*, May 1858, pp. 205–8 (Bessie Rayner Parkes on SFA).
19. *English Woman's Journal*, March 1859, p. 53.
20. *Art Journal*, 1866, p. 56.
21. Ibid., p. 56.
22. *Englishwoman's Review*, April 1868, p. 467.
23. This dates from Kate Millet's *Sexual Politics* (1970), which unfavourably compared *Sesame and Lilies* with J. S. Mill's *Subjection of Women*.
24. Nunn 1995, p. 145.
25. Cited in Alexander and Sellars 1995, p. 39.
26. Battiscombe 1978, p. 269.
27. Ibid., p. 268.
28. Cited in Lee 1955, p. 217.
29. See the introduction to this volume.
30. Gillett 1990, p. 141.
31. See the essay in this volume by Emma Chambers (Chapter 6).
32. It had been displaced from the salubrious environs of Somerset House to rooms above a soap factory in the Strand in 1848.
33. Dodd 1995, pp. 187–200.
34. *Art Journal*, December 1859, p. 378.
35. *Art Journal*, February 1860, p. 61.
36. Ibid.

The cultivation of mind and hand: teaching art at the Slade School of Fine Art 1868–92

Emma Chambers

In 1868 Felix Slade bequeathed £45,000 to found professorships in Fine Art at the universities of Oxford, Cambridge and London. Slade also stipulated that this money should be used to fund six scholarships for art students at University College. Therefore the University devised an element of practical training to augment the theoretical teaching provided by the professorship, and this created the impetus to establish what became the Slade School of Fine Art. The Slade was set up as a school of 'high art' and became renowned for its emphasis on life drawing, enshrined in the curriculum and the lectures on art theory delivered by Edward Poynter, the first Slade Professor. Poynter's lectures have generally been used as source material to describe the teaching system at the School and Poynter has been given sole credit for the establishment of the curriculum.[1] However, although he was undoubtedly an influential, if now largely forgotten, figure in art education comparable with contemporaries such as Charles Eastlake and Frederic Leighton, credit should also be given to the University Council for their role in shaping the ideology of the School and its curriculum.[2] Equally important to the way that the Slade functioned as an institution was the interplay between its official theoretical stance, as documented in the published curriculum and Poynter's lectures, and the day-to-day practice in the School. Letters and committee reports reveal how the numbers, gender and proficiency of students, and the physical spaces of the School shaped the way that the official programme was delivered. It is this interplay that I want to examine as a means of showing the complexity of an environment where the interests of art, ideology and education were competing elements within a training culture.[3]

On receiving news of the Slade bequest the Council of University College established a Slade Committee headed by Edwin Wilkins Field to formulate a plan to set up the School.[4] In May 1868 Field sent a private circular contain-

ing proposals for establishing the School and a draft curriculum to a carefully chosen selection of artists, requesting their help and advice. Field's proposed curriculum was influenced by the French system of art education that he had observed on a visit in 1847–48 and emphasized the primacy of life drawing, but it also suggested that the students should draw from live animals and study comparative anatomy.[5] It was also proposed that the practical classes should be complemented by lectures delivered by specialists from other university departments on geology, vegetable physiology, the laws of clouds and the atmosphere, the laws of optics, colours and the chemical qualities of pigments, all of which were clearly linked to the University's tradition of practical scientific enquiry. Field's plan envisaged an extraordinarily wide range of studies for students and indicates how important it was from the very first that the new school should be constituted as an academic department within the University.

Art education had been under intensive scrutiny as recently as 1863 when the Royal Commission on the RA investigated its schools as part of its remit. The importance of art education to the production of a truly national art is evident from the report of the Royal Commission, which clearly signalled that it was in its role as an educational institution that the claims of the RA to represent art as a professional practice rested as an educational institution.[6] It is clear from the responses of several of Field's correspondents to the circular that the RA was not fulfilling its self-appointed role as the National Academy of Art, and many saw the Slade Bequest as a chance to create 'a real National school of Fine Art to which a purely national and free Exhibition might be added', benefiting from its institutional connection with the University.[7] This would ensure that it would be safe from such accusations of operating a clique to advance the commercial interests of its members, as had compromised the claims of the RA to represent national art.[8] The Royal Commission on the RA had stressed that the quality of art produced by a country was dependent not only on educational practices, but also on the level of taste among its patrons.[9] This view was echoed by many of Field's correspondents who saw the provision of University Professorships by the Slade bequest as a chance to elevate general taste for the benefit of artists who were at present limited by the demands of the market for portraiture and small-scale domestic works.[10]

There was a split between those of Field's correspondents who endorsed his proposals to widen the curriculum as an opportunity to 'train an efficient body of men with technical knowledge and *cultivated intellects*',[11] and those who insisted that the traditional programme of study was perfectly adequate and that 'Art is not a science and there is no general law or system for its study.'[12] This issue of whether art could be taught systematically and what skills an art school should teach its students was at the heart of the debate around the early years of the Slade.

Although the Slade was envisaged as a national academy where art education would be elevated by a wide-ranging theoretical curriculum and removed from the commercial imperatives of the market-place, the Slade bequest did not provide for the day-to-day expenses of running the School, which would have to be funded by charging fees. The majority of Field's correspondents were in favour of fees set at a level which would keep entry relatively exclusive, although it was acknowledged that this would result in a large number of amateur artists enrolling.[13] Equally, the pre-eminence of the free Royal Academy schools was seen as an impediment to attracting professional artists.[14] This necessity to negotiate a balance between amateur and professional students generated a tension between the identity of the Slade as both public academy and private art school from the first.

An amended version of Field's original circular, incorporating the views of his correspondents and sections added by the University Council outlining how the teaching in the art school should reflect the ideology of the University, was sent out in February 1870. The Council's stated intention was to establish a school where professional artists could be taught 'all subjects auxiliary to art ... more completely and scientifically ... than could be done in an isolated school', giving them a thorough general education which would enable them to 'obtain that position in society which, for the sake of the influence of Art it is most desirable that they should fill'. In addition it was believed that the School would enrich the education of students in other departments.[15]

Furthermore, the Council intended that the founding principles of the University were to be reflected both in the Slade's admission policies and in the way that art was to be taught in the School:

University College was founded, and has been rigidly conducted on the principle of affording aid towards the education of all classes and denominations without any distinction and favouritism whatever. That principle must govern its teaching in Art as well as all its other teaching. The Council desire to offer such instruction as is the common need of every artist, to whatever school or mode of thought and treatment he may incline, ... The aim of such instruction will be to inform the minds and help the knowledge, and not to warp the special and characteristic feelings; to deal with the intellect rather than the imagination. ... The function of the teacher should be directed and confined to ensure the most intelligent and scientific study of nature in all those of its different aspects with which art has to deal.[16]

This passage is notable for its adaptation of Utilitarian philosophy with its commitment to freedom of opinion and equality of opportunity to art education through a teaching system which would foster an environment where students would be free to choose their own method of working, and teaching would develop their intellects rather than restrain their imaginations. It was the difficult task of Edward Poynter the first Slade Professor to translate

all these ideas into a working curriculum which provided students both with an understanding of art theory and scientific subjects related to art and with the mastery of manual skills.[17]

Poynter was already a successful associate of the RA when he was appointed by the University Council in May 1871. Monumental works such as *Israel in Egypt* (1867), with its carefully researched costumes and backgrounds, had gained him a reputation as an educated academic painter in the classical tradition of Leighton, with whom his paintings and career in art administration are often compared. He seems to have been appointed by the council precisely because of this public profile and commitment to high art, in addition to his proven prowess as a lecturer and experience in art education.[18] His ideas on art education were compatible with those of the University Council insofar as he endorsed the French system of art education and believed that 'it is quite as important for an artist to cultivate his mind as his hand'.[19] His principles of art education were outlined in the successive lectures that began each academic year at the Slade. These were intended to give students broad aesthetic principles which should inform the skills and manual dexterity which they would acquire in their daily work in the classes.

The educational processes of the Slade as an institution hinge on the constant tension between the theory of art education and its provision at classroom level. This tension emerges from a close examination of the relationship between the theoretical framework provided by the lectures and the printed curriculum, the day-to-day classroom practice, and the difficulties of fitting a systematic training into the physical spaces of the School which are documented in committee minutes and Poynter's letters. Indeed the way that the lectures were designed to work in tandem with the more fragmented discourse of daily teaching is evident from Poynter's stated purpose in delivering them which was 'to systematize and classify, as far as possible, the instruction which is, for various reasons, necessarily imparted in a somewhat desultory manner'.[20]

Despite Poynter's reputation for introducing a radical new curriculum at the Slade, in fact the aesthetic theory which he outlined in his lectures was based on the familiar precept that the role of the artist was to select what is beautiful from nature and omit what is not, by constant study from the life model guided by the precedents of the art of Classical Greece and Renaissance Italy.[21] The living model would also enable the artist to master the technical competences in representing the human figure necessary to produce 'high art', thus providing him with a basic artistic vocabulary in which to express his ideas. Poynter was convinced of the importance of tradition in art and endorsed the classic academic concept of the interpretative copy where students reworked classic subject matters and compositions, claiming

that in art 'the only possible development was in the power of expression', contrasting this with the progressive search for new discoveries in science.[22]

Poynter's first lecture as Slade Professor was entitled *Systems of Art Education*. Here he positioned the Slade in relation to other art schools in London, aligning it with the RA as a school 'for the study of high art'with an emphasis on the study of the living model.[23] He went on to give an account of the French system of art education as practised at the *Ecole des Beaux Arts* and private *ateliers* where students studied from the antique only long enough to acquire a facility with the pencil before moving on to study from the life model, with the master visiting twice a week to correct their work. This gave them 'knowledge of all the technical and practical details of their profession … that is the knowledge of their craft at their fingers' ends before they began to paint pictures'. He contrasted this with the English system where students who became impatient with the long period spent drawing from the antique, were more interested in commercial gain than mastering their art, and painted pictures for exhibition before they had sufficient technical competence, thus generating 'helpless errors in drawing, … obvious difficulties and struggles in dealing with the material'.[24]

Poynter's aim was to create a school of high art by removing the students' work from the demands of the market; he wanted to achieve this by dealing with the technical and practical details of mastering the ingredients of art practice as well as an intellectual understanding of its theoretical basis. It was clearly important to Poynter that students should be aware of the theory underpinning their practical classes from the first, and a passage of theoretical explication based on this first lecture to the Slade emphasizing the importance of study from the living model prefaced the printed syllabus.[25]

These ideas were implemented at classroom level by replacing a separate initial course of study from the antique (followed by study from the living model) with a General Course in which students could study simultaneously from the the antique, the nude model and the draped model as soon as the Professor judged them competent.[26] Thus, despite the common perception of the Slade as a radical educational institution, the curriculum that Poynter established relied solidly on the traditional components of the academic curriculum, and its primary innovation lay in the increased importance given to the Life over the Antique School and the abandonment of the idea of progression from one to the other by a series of compulsory stages which was enshrined in the RA and South Kensington systems. From the beginning the School catered for both amateurs and professionals with the General Course which aimed to be a rigorous and comprehensive training system set up for those who wanted to study art as a profession, and a part-time course for amateurs.[27] Despite this mix of students, Poynter's lecture emphasized that 'unremitting labour and attention' was required from all the students,

stipulating that he could not teach them to draw and paint but promising that his guidance would ensure that they would not waste their energies on the 'study of what is useless or prejudicial'.[28] But hard work, careful observation and the acquisition of manual skill was to be balanced by the use of the imagination 'for the study of nature is not the end of art but merely a means of enabling you to express your ideas'.[29]

Subsequent lectures were even more precise on the exact knowledges and competences that Poynter expected students to acquire through his system, so *The Training of Art Students* which opened the third session of the Slade in October 1873 systematically broke down his theory of the study of nature into precise divisions such as form, tone, colour and composition, defining them and stating the means by which students would acquire skill in rendering them.[30] In addition, although Poynter required accuracy and detail in drawing, he also emphasized that the student should be able to draw with 'certainty and celerity' in order to capture movement and short poses.[31] Poynter's aim was to provide the student with a set of skills and basic grammar of art which would facilitate 'a development of his natural gifts' and 'such a habit of good work that the carrying out of his ideas shall be in no way hampered by the difficulties of execution'.[32] Therefore, despite the very structured nature of the curriculum and the clear guidance on method and procedure given in the lectures, Poynter's system did not include the prescriptive exercises characteristic of the South Kensington system, rather drawing on a University tradition of independent thought and echoing the Council's definition of art education as a framework within which the student expresses his thoughts.

In order to gain a sense of how Poynter's mixture of theoretical and practical instruction might work at the level of classroom teaching, however, it is necessary to return to the Slade Committee Report of 6 May 1871, where Poynter's appointment and proposals for the School were first debated. Here a long discussion occurred as to how the students should be taught. Responding to Poynter's proposal that he should attend 'not less than once a week, instructing each pupil in turn',[33] leaving the day-to-day management of classes to his assistant, the Committee agreed that 'the study of art does not require … constant supervision & direct instruction of the students by the Teacher', and that Poynter's role should be:

to examine and criticize the productions of the Students at certain intervals of time, ordinarily once a week; leaving the daily superintendence of the Students, and the management of the routine of the School to competent subordinates. The Professor's chief duty in fact is to direct the general course of study, by arranging its several parts in their natural order, by selecting such objects of study as are suitable for students in their various stages of progress, and by expounding and illustrating the leading principles to be observed by them.[34]

Poynter's primary responsibility was to provide a framework within which the students could understand their daily practical work, and at the urging of the Slade Committee who were closely involved in monitoring the course of instruction offered by the School he expanded the curriculum in 1872–73 to include new courses of lectures in Anatomy, Perspective, and Archaeology delivered by academics from the relevant college departments.[35] Poynter also set up a Fine Art Library containing photographs from Michelangelo's *Sistine Ceiling* and volumes of prints. He was explicit about the use he expected the students to make of these resources: 'These prints will be of great use in forming your style, and should be much consulted for the study of composition.'[36]

The 1872–73 syllabus contained comprehensive regulations for the Slade Scholarships for the first time, these emphasized the commitment of the University to ensuring artists had a rounded education by including both an examination in general knowledge, including English Language, English History, Greek and Roman History, Ancient and Modern Geography, elementary arithmetic and a foreign language, and the execution of various competition works in drawing, painting and sculpture to be prescribed by the Slade Professor.[37] An official scheme of prizes was also included in this prospectus with prize categories including painting and drawing from the life, painting and drawing from an antique figure and composition from a set subject, with the amounts devoted to different prizes clearly reflecting the hierarchy of teaching priorities: Painting and Drawing from the Life were awarded £10 and £5 respectively; Painting and Drawing from the Antique £3 and £2; and Composition £2.[38] Poynter's lecture *The Value of Prizes* is also instructive in understanding what he hoped to achieve by means of the prize system, as not only spurring the students on 'to their best efforts' but also enabling the master 'to show in a practical manner the style of work which he considers the best for a student to pursue'.[39] Together with the examples in the library these prize-winning works provided a framework of approved practice within which the students were expected to work.

Between 1872 and 1875 Poynter progressively developed the theoretical elements of the curriculum by incorporating lectures on architecture and building up the library,[40] but simultaneously his theoretical framework for the School was watered down by the practicalities of teaching large numbers of students, many of them beginners, who did not come equipped with the necessary skills to study from the life model immediately. In 1873–74 a new rule was added to the curriculum which required every student on entering the School 'to make a drawing from an Antique figure as a test for passing into the life school'. To make the initial execution of a satisfactory drawing from the antique a pre-condition for entering the Life School marked a

significant ideological shift from Poynter's attempt to move away from the antique as a sign of technical competence and as a progressive step in the move towards life drawing, and was probably also a pragmatic way of providing elementary instruction for the less proficient students, and controlling numbers in the Life Room.

The tension between the demands of theory and provision in art education is clear from the accounts which Poynter gave of the overcrowding in the School which compromised the effective operation of the curriculum. Having complained to the Slade Committee in October 1873 about problems with overcrowding in the School and the effect that this was having on his teaching,[41] in May 1874 he again wrote to the membership on the need for more space. This letter demonstrates that, despite the division of the School into two Life Studios, an Antique Studio and a Library, reflecting the components of the curriculum, students were enduring cramped conditions and having to work in non-designated spaces such as Poynter's own studio and dressing room; and the Life Room and Library had to be regularly cleared and rearranged to accommodate the lectures, resulting in the breaking down of the systematic delivery of the curriculum through designated spaces.[42] The space problems at the Slade and the resulting incursion of the practical on the intellectual were further complicated by the need to teach students in different areas according to both gender and ability. Female students worked only from the draped life model, necessitating the separation of these classes from those where the nude model sat, and beginners also required different tuition.[43]

At the end of the first Slade session Poynter reflected on the success of the 122 students, many of them beginners, whose progress had been 'generally satisfactory, & in some cases very remarkable'.[44] However, the interplay between amateur and professional students and the perceptions of non-seriousness which female students had to overcome was also clear from the figures which Poynter provided in his letter. Students on the full-time General Course were considered to be more serious and Poynter remarked that, although female students outnumbered the male students by 61 to 44, the numbers on the general course were 25 male to 12 female. He stated 'these details are not of much importance, but they serve to show that although the ladies are in the majority the number of men devoting their whole time to the study of art is more than double that of the ladies'.[45] Equally when Poynter wrote to the College about overcrowding in 1874 he observed that the omission of the 'morning class for ladies only' had resulted in 'a more serious set of students attending more regularly'.[46] The University's liberal admission policies had ensured that the Slade was the first English art school where female artists were able to gain access to professional training including study from the life model, unavailable elsewhere at this period, however,

their presence at the School was also seen as destabilizing its professional identity. Nevertheless, it is clear from the records that, despite the persistent view among the teaching staff that female students were far less serious than the men, many of them were among the best students, winning a significant proportion of prizes and scholarships.[47] There was a constant tension between the aspiration of the Slade to provide a rigorous curriculum which produced professional artists and its large intake of amateurs on the part-time course which helped to keep the School financially successful. Over the course of Poynter's Professorship the balance between part-time and full-time students shifted with 70 students on the General Course and 43 on the Partial Course in 1874.[48] However, the market for art education was becoming increasingly diverse and competitive and the interplay between attracting students and delivering an effective and rigorous training in both manual skills and art theory was increasingly an issue; one that reached crisis point under the Professorship of Alphonse Legros who succeeded Poynter as Slade Professor in 1876 following the latter's appointment to the directorship of the South Kensington Schools in August 1875.

Poynter's appointment to South Kensington did not terminate his influence at the Slade, since he had played a significant role in ensuring the appointment of Legros who had already deputized for Poynter at the School since February 1876, taking his class teaching while Poynter continued to give lectures.[49] Poynter described Legros's teaching methods as a 'truly remarkable gift of drawing and painting in the presence of the students for their instruction [which] more than compensates them for his difficulty in expressing himself in English',[50] and he was also praised for his 'severe and distinct method' which 'wd direct the student rather to the power of mastering form than to trivial methods of execution'.[51] His own art was also considered to be exemplary possessing 'high qualities as a draughtsman & painter & ... noble and elevated style'.[52] Thus Legros was thought capable of providing a complete technical system in addition to an example of high art practice for the students to emulate. However, over the course of his Professorship it becomes clear that his lack of language skills compromised the role of the lecture system in providing an intellectual framework for students to contextualize the technical skills provided by class teaching.

Under Legros's guidance professorial lectures were abandoned and the curriculum shifted further towards a more traditional emphasis on drawing from the antique as a preliminary to study from the life model.[53] Extending provision by widening the range of media, Legros introduced etching classes in 1877 and sculpture classes in 1880. The lecture programme continued to offer sessions on anatomy, perspective and archaeology, with additional lectures on the chemistry of materials, the applied arts and history of art.[54] However, despite the assumption of the Council that Legros would do most

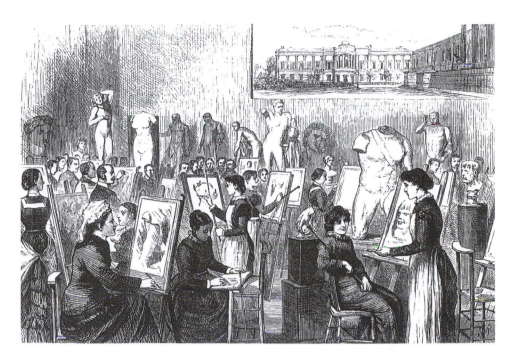

6.1 'Mixed Antique Class at the Slade', *Illustrated London News*, February 1881

of his teaching by demonstration, in fact his procedure was similar to Poynter's, as a letter he wrote in 1878 affirms:

It is well known in Schools of Art that the students in them learn a great many of the earlier steps in their pursuits, such as manual processes, handling etc. whether in Drawing, Painting, or Sculpture, from one another, from those especially rather more advanced than themselves in their studies, either by instruction given in a friendly way, or from having their more advanced work constantly before them, & seeing them work … frequently even more is taught the younger students in this manner than by the Professor himself, who in teaching the more general principles of art, is often of necessity apt to dwell less on the smaller details of execution which nonetheless must be mastered by artists in their early course of study.[55]

The problem with this form of teaching, which was based on the French *atelier* model, was that Legros failed to back it up with the professorial lectures and verbal criticism that had grounded the students' practical experience under Poynter.

A building extension in 1880 had reduced the problems of overcrowding in the School, and an illustration of the Life Room of the building published in the *Graphic* in 1881 shows a spacious and well ordered room (very different from the chaos evoked by Poynter's accounts of the use of the School's physical space) with predominantly female students confidently tackling life drawing

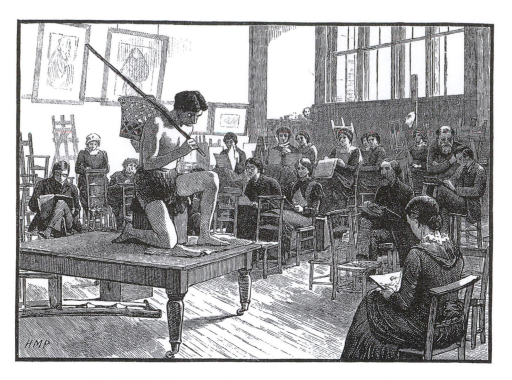

6.2 'The Life Class: Women at Work', *Magazine of Art*, June 1883

without an instructor in sight. By the mid-1880s, however, the Slade was struggling to attract the numbers of students that it had in its early days. The initial success of the School was partly dependent on its uniqueness and particularly in the opportunities it offered to women artists, but by the 1880s a number of new private art schools were offering similar tuition to the Slade for cheaper fees. In April 1883 the Council attributed falling numbers to lower fees at the St John's Wood School and the Female School of Art.[56] Questions were also raised about the discipline and teaching at the Slade, the Committee observing that 'the amount of supervision by Mr Legros and Mr Slinger seems very limited'.[57] In June 1883 a long article about the Slade appeared in the *Magazine of Art* written by Charlotte Weeks, who had studied at the Slade under Poynter. The article gave a detailed account of the 'intelligent system of instruction' established by Poynter to which Legros was considered to have added a valuable culture of practical tuition and demonstration, thus legitimating the shift away from theory that had occurred under his Professorship. Legros was described 'going from easel to easel' to correct the students' work 'sometimes pausing to complete a study' and painting complete study heads in an hour and a half in front of the students in the Life Class, Weeks observ-

ing that 'the watchers probably learnt more in that silent lesson than during three times the amount of verbal instruction'.[58] One of the accompanying illustrations shows the Life Class with a bearded figure (almost certainly intended to represent Legros) bending over a student's work (Figure 6.2). Coming two months after the unfavourable Committee Report, it seems likely that this article was a publicity offensive on behalf of the School intended to attract students by presenting a favourable picture of teaching at the Slade and emphasizing the rigorous tuition and careful supervision – precisely those areas which had been the focus of concern in the Report. Despite the positive picture of teaching at the School presented in the article, Legros did not provide enough of the routine instruction and correction of work expected of the Professor to satisfy either the Council or the student body as a whole, but clearly inspired talented individuals. William Rothenstein, who was at the Slade in the late 1880s, later described Legros's painting demonstrations as 'the most inspiring method of teaching', but criticized the long hours spent in the Antique Room and Legros's 'laconic and somewhat bleak' comments on the students' work.[59] The Council's concerns about Legros's teaching methods persisted throughout his Professorship reaching crisis point in 1892 when his appointment was again up for renewal.

The Slade Committee consulted Poynter and Sidney Colvin of the British Museum for views on student numbers, discipline and teaching at the Slade under Legros. The Committee's first concern was the fall in student numbers and Legros's response to Colvin's enquiries was to attribute this to competition from other schools and suggest that the fees should be revised so that it was cheaper for students to attend for a whole session than termly 'to attract as large a proportion as possible of continuous and regular scholars'.[60] Despite the income that was generated by the part-time students, the perceived necessity of attracting serious students to maintain the Slade's position as a school of 'high art' for professionals was clear from Poynter's and Colvin's responses to the Slade Committee. Colvin concluded from his conversations with past students that: 'the more serious the student, the better satisfied he or she is with the teaching received, while complaints are apt to come from those who want to dabble or to learn by royal roads … the teaching at the Slade School contrasts very favourably with that at most others for severity and thoroughness of method.'[61] The assumption was that serious students should be able to learn independently, Poynter observing that 'some students have very mistaken ideas … & think that a master shd be always standing over them or be always in the school', adding that 'such complaints are generally from the young ladies'.[62] Here he again contrasted serious students with dilettantish amateurs with a clearly gendered emphasis.

Poynter also considered that one of the most important functions of the Professor was to provide education by example, praising Legros's 'scholarly

appreciation of the works of the great masters' and his 'profound knowledge of the qualities that are necessary for the production of a great work'. He dismissed the Council's concern about the limited number of lectures delivered by Legros and emphasized the importance of class teaching, stating in contradiction to the views expressed in his earlier lectures that: 'the first object is that the students should learn to draw and to paint.'[63] He also attributed the problems with falling student numbers to competition from other art schools, comparing the standard of training provided by them with the 'serious study so indispensible & yet so irksome to students' at the Slade.[64] In Poynter's and Colvin's views the School was failing to compete precisely because it was committed to providing a serious professional education.

The questions raised about Legros's teaching reveal the problems of selling art education in a market economy, and the students' expectations about what they should receive for their fees. The aim of the School to provide a rigorous, intellectual, university-based art education which allowed the students to develop their talents independently within the structures of lectures and class teaching was at odds with the need to attract sufficient numbers of paying students some of whose expectations of art education were very different. In other words, this is a conflict between the Slade's identity as professional academy or private art school. This conflict is exemplified by a letter of complaint to the University from a Mr Bishop whose daughter was studying at the Slade. He wrote: 'She appears to me to get hardly any teaching at all … I cannot let her go on as at present as I am sure she is losing all heart and I am certain it is not *her fault.* ' He was, however, satisfied with the tuition she had received in the modelling class as 'the gentleman there *shows* where she is wrong & what to do'.[65] It is clear that students increasingly expected a one-to-one direct teaching of manual skills which the Slade was failing to provide. Following a conversation with the students, the Committee's report was disapproving of Legros's régime and recommended that full-time student fees should be reduced to take account of competition from other schools, also that Legros should be appointed only for a further year and reminded of his duties to 'give "his personal attention to the studies and artistic 'works' of the students".' Not surprisingly this led to his resignation.[66]

Aside from the issues of competence in which the Committee were interested, this episode is a fascinating document of the changing expectations of students, the shifting balance between the day-to-day practice of teaching technical competence as opposed to imparting aesthetic theory by lecture in art education, and the increasing competition for paying art students in an art world where art education had become a commercial commodity and art schools were obliged to cater to the market. This was a far cry from the National Academy in a University location envisaged by the original plans

for the School in 1868. The early history of the Slade documents a constant struggle between theory and provision in an institution that, from its foundation, was made to carry the burden of remedying many of the perceived inadequacies in British art and art education. This conflict was articulated in the tension between pedagogic claims for a commercially disinterested high art curriculum and those commercial imperatives associated with developing markets for art education.

Notes

1. See Charles Aitken (1926), 'The Slade School of Fine Art', *Apollo*, 3(13) January; John Fothergill, *The Slade*, London, 1907; Andrew Forge, 'The Slade', *Motif*, 4, 1960; Macdonald 1970, pp. 269–83.

2. Martin Postle examines the role of the University in setting up the school in 'Samuel Palmer and the Slade: Artists and Amateurs in Association', *Apollo*, 1991, 133, p. 350, and Postle 1995a.

3. See Chaplin, Stephen (1997), 'A Slade School Reader: A Compendium of Documents 1868–1975' (unpublished; UCL Library MS Add. 400), for a methodological approach which highlights the importance of using different levels of archival evidence to construct a more nuanced understanding of the workings of the School.

4. See Postle 1995a for earlier attempts to found a Department of Fine Art at UCL and details of Field's visit to France in 1847–48 to assess the French system of art education for this purpose (pp. 129–30), and for biographical information about Field (pp. 130–31 and 223).

5. Postle 1995a, pp. 156–64.

6. Trodd 1997.

7. John Linnell to Field, 29 August 1868 and Samuel Palmer to Field, 7 September 1868 (Postle 1995, pp. 169 and 174).

8. See Trodd 1997 for the accusations of commercialism levelled at the RA.

9. Trodd 1997, p. 19.

10. W. Y. Yeates Hurlstone to Field, 25 October 1868 (Postle 1995a/b, p. 180).

11. William Riviere to Field, 1 January 1869 (ibid., p. 189).

12. Edward Armitage to Field, 27 August 1868 (ibid., p. 168).

13. W. C. Smith to Field, 19 October 1868 (ibid., p. 178). Postle compares the 7gns for an eleven-week term charged by the Slade with the £4 for a five-month session at South Kensington which also offered discounts to artisans (ibid., p. 145).

14. Laura Herford to Field, n.d. (ibid., p. 209).

15. University College London, Slade School of Fine Art, Circular for Assistance and Advice (Proof), n.d. [*c.* February 1870], p. 1 (UCL Library, College Collection BA 27).

16. Ibid.

17. Poynter's initial response to the consultation process was that it 'contains observations enough to set up a dozen schools of art on a dozen different principles' (Poynter to the college, 11 July 1871, (College Correspondence) UCL Library).

18. Poynter had been responsible for awarding the medals at South Kensington since 1867 and had lectured at the college in 1869 (Poynter 1880, p. 1).

19. Ibid., p. 31.

20. Ibid., p. 135.

21. See Chaplin 1997, p. 36, on Poynter's sources.

22. Poynter 1880, p. 64.

23. Ibid, pp. 95–6.

24. Ibid., pp. 100–101.

25. *College Calendar* 1871–72.

26. Female students were not allowed to study from the nude model, only from the draped living model and although they could do so with the male students a separate 'ladies only' class for this was also available.

27. Poynter 1880, pp. 110–11.

28. Ibid., pp. 112–13. See Chaplin 1997, p. 38, on the conflict between diligence and expressiveness in Poynter's lectures and art education generally.

29. Ibid., p. 121.

30. Ibid., p. 139.

31. Ibid., p. 187.

32. Ibid., p. 198.

33. 'Report of Slade Committee to be presented to the Council May 6th 1871', University of London, Appendix to Council Minutes 1867–78, (49), UCL Records Office.

34. Ibid.

35. Council Minutes, 2 December 1871.

36. Poynter 1880, p. 130.

37. The syllabus of 1871–72 had outlined brief requirements for the Slade Scholarships but had not included a general examination (*College Calendar*, 1871–72).

38. Ibid. and Slade Committee Report, 4 May 1872.

39. Poynter 1880, p. 173.

40. 1873–74 saw the adoption of lectures on architecture.

41. Poynter to the college, 31 October 1873 (College Correspondence), UCL Library.

42. Poynter to the college, 15 May 1874 (College Correspondence). The Council were unable to provide additional space and instead passed a resolution on 4 July 1874 limiting student numbers (Poynter to the college, 16 October 1874).

43. Two of Poynter's main requests were a separate room for teaching beginners and an extension to the Antique School where beginners were also taught (Poynter to the college, 15 May 1874 (College Correspondence)).

44. Poynter to the college, 6 July 1872 (College Correspondence).

45. Ibid.

46. Poynter to the College, 15 May 1874 (College Correspondence).

47. College Calendars.

48. Poynter to the college, 16 October 1874 (College Correspondence).

49. Poynter to Robson, 17 February 1876 (College Correspondence).

50. Poynter quoted in 'Report of the Committee on appointments for Professorship of Fine Art read and adopted by the Council July 8 1876', *Appendix to Council Minutes* (151).

51. F. W. Burton (Director of the National Gallery) quoted in ibid.

52. Poynter quoted in ibid.

53. In the printed syllabus for 1880–81 Poynter's introductory paragraphs to the courses of study were deleted and replaced with 'All students (except those especially exempted by the Professor) will, on entering the schools, be required to draw from the Antique until judged sufficiently advanced to draw from the life' (*College Calendar*, 1880–81, p. 91).

54. Chemistry of Materials lectures were held between 1880 and 1890, Applied Art between 1889–94 and History of Art in the 1890–91 session.

55. Legros to the college, 12 November 1878 (College Correspondence).

56. 'Report of the Slade Committee on the Reference from Council of March 10 & April 14 1883' (UCL Library, AM/C/114).

57. Ibid.

58. Weeks 1883, p. 326.

59. Rothenstein 1931, pp. 24–5.

60. Sidney Colvin to Erichsen, 30 March 1892 (College Correspondence).

61. Ibid.

62. Poynter to Erichsen, 30 March 1892 (College Correspondence).

63. Ibid.

64. Ibid.

65. Mr Bishop to the college, 31 May 1892 (College Correspondence); emphasis in the original.

66. AM/C/273 Report of Slade Committee Met on July 1 1892. Laid Before Committee and Adopted July 2 1892, UCL Library.

An art suited to the 'English middle classes'?: the watercolour societies in the Victorian period

Greg Smith

The identification of watercolour painting as particularly suited to the 'English middle classes' was widespread when John Ruskin published his *Notes on Samuel Prout and William Hunt* in 1880.[1] What this meant, however, was the subject of much debate. For some writers, the medium, and specifically its association with the portrayal of the English landscape and with a modestly priced commodity, was the laudable expression of positive bourgeois values which united a faction of artists and their audience. For others, though, the domestic scale of works, their parochial subject matter, and the modest ambitions of practitioners were evidence of the pernicious effect of an art market dominated by a philistine middle-class taste. According to the former point of view, the watercolour societies were estimable since they provided an attractive market for reliable goods, acted as the guardian of a glorious national tradition, and promoted the status of an independent profession. For critics of the latter persuasion, they were seen as evidence of a deadening effect on creativity typical of self-serving trading bodies masquerading as disinterested public institutions. Despite the differences, however, there was a consensus during the last quarter of the century that the activities of the watercolour societies, and, by extension, the medium itself, epitomized a set of social and political values of which class was an important aspect.

The associations surrounding the medium and its practitioners at the outset of the Victorian period were, however, markedly different. Exhibitions were frequently described as thronged with fashionable visitors; the Society of Painters in Water Colours and its members, in particular, were portrayed as having triumphed over the petty prejudices of the Royal Academy, and the art of painting in watercolours was characterized as progressing year by year to new artistic levels. Watercolour was confidently proclaimed as 'that branch of British art which most astonishes and humiliates foreigners', and the 'pleasant rooms' of the societies were its congenial home.[2] This

shift in perception of the watercolour societies, and the medium itself, followed a common trajectory by which a fashionable commodity, fuelled by stylistic innovations, achieves a level of popularity which ultimately undermines its function as a marker of elevated taste to gain, in turn, a new identity as a signifier of what Bourdieu has termed 'middle-brow' taste.[3] To explain how this came about we need, I suggest, to balance analysis of the broad shifts in the discursive realm with an account of the professional project of the watercolour societies themselves, the Society of Painters in Water Colours (SPWC; founded in 1804), and the New Society of Painters in Water Colours (founded 1832). In particular, we must examine the role played by institutions in promoting a specific notion of professional identity, in encouraging the association of the medium with national pride, and in creating a distinctive arena for the selling and viewing of works.[4]

Public bodies and private interests: problems in promoting professional identity

The emergence of a professional ideology for art, based, notionally at least, on the ideal of disinterested public service, was a crucial element in the development of the Victorian art system. The role played by the watercolour societies was both significant, and, given their often heated discussions about how to reconcile public interests with public duties, typical of the problems of promoting a professional ideal when practitioners were involved in the production and sale of commodities, rather than the provision of services.

The specific problem at the outset of the period was that, despite the success of their exhibitions, the two watercolour societies were often criticized for betraying the principles of free trade and competition. The SPWC, in particular, was attacked for confining access to their exhibitions solely to thirty members and twenty-six associates.[5] For one reviewer, writing in 1831, 'the paltry, mercenary workings of its members' underline the 'notorious farce and falsehood … that Academies and Institutions, professedly "for the promotion of the best interests of the Fine Arts", are anything … but monopolies for the promotion of the selfish interests of the few that constitute them.'[6] The New Society operated on the 'more enlightened and encouraging principle' of open membership, but it was to prove a short-lived corrective.[7] Pressure on space encouraged the leading artists to restrict the right to exhibit to a limited membership as early as 1834, and exhibition reviews continued to object to the exclusivity of the societies. The *Art Union* summed up a common view in 1839 when it complained that since the 'age of monopoly is gone … Art, which, above all things, exists by liberality, should not be the last to relinquish the small advantages obtained by the narrow policy of exclusiveness.'[8]

Opposition to the monopolistic tendencies of the societies was not just ideological, however. In 1834 *Arnold's Magazine of the Fine Arts* spelt out the practical dangers of confining exhibitions to a small number of members. The greed of the watercolourists, it argued, was particularly 'short-sighted' since the 'overwhelming numbers' of works 'neutralize its general excellence ... imparting to the *ensemble* ... an air of sameness.'[9] As more supportive critics pointed out, a restricted membership can ensure an exhibition of manageable proportions and one which, though lacking 'novelty and experiment', avoids 'the lower stratum of mediocrity.'[10] However, for those who saw the exhibitions as spoilt by a tedious monotony the implications of the societies' closed policy for their professional project were highly problematic. The productivity of artists such as Copley Fielding who showed almost seventeen hundred works, with an average of thirty-six exhibits a year, suggested to many critics that watercolourists were frankly engaged in the manufacture of art. The *Art Journal*, for instance, complained that the watercolourists had 'gone to Birmingham and Manchester and had learnt from manufactures and political economists how to suit the market, and make the supply equal the demand.'[11] Even the generally sympathetic Ruskin characterized the SPWC as a sort of 'Fortnum and Mason' supplying a 'kind of Potted Art, of an agreeable flavour.'[12] The implication was that bodies which prioritized their private interests as trading institutions undermined the highest aspirations of their members.

Comments such as these from the late 1850s and 1860s reflected a growing pressure on the societies, and art institutions in general, to adopt a more disinterested public role and to amalgamate in the interest of professional unity. Such comments prompted the formulation of a coherent defence of the division of interests within the artistic domain. According to T.C. Hofland, for instance, the proliferation of watercolour exhibitions was actually a healthy example of the free market principle whereby 'one society would prevent another from becoming a monopoly.'[13] This, Hofland continued, ensures 'that emulation and that striving ... which ... advance[s] the fine arts'.[14] Sir Charles Eastlake, the President of the RA, used the same argument in his evidence to the 1863 Royal Commission, suggesting that 'the interests of public taste' were best served 'if the arts were subdivided under different establishments.'[15] Moreover, he proceeded, the *ad hoc* nature of the arts system 'accords with the English love of liberty and independence'.[16] This was exactly what the two watercolour societies wished to hear. Both institutions may have complained of the 'want of liberal feeling on the part of the Academy' and, specifically, its requirement that members of other bodies must resign before becoming candidates for academic recognition, but they were even more concerned with suggestions that a reformed RA might welcome back watercolourists on equal terms.[17] Frederick Tayler of the SPWC

argued that the promise of 'the honours of the Royal Academy' could never compensate for 'any sacrifice of our independence and individuality', and the societies were relieved when the Commission acceded, albeit reluctantly, to their contentions.

The societies may have been in agreement about not contemplating a union with the RA, but they were increasingly divided over the advisability of combining to form a single representative body. The first sign of a split came in 1858 during discussions about the provision of accommodation for artistic bodies at Burlington House. This offered a potential solution to the problem of a lack of exhibition space, but, as the New Society pointed out in a letter to the SPWC, their claim on public premises would be stronger if they were seen to be 'representing Water Colour Art *generally*'.[18] The SPWC reacted coolly and resisted further suggestions made by the Royal Commissioners. Tayler cited practical reasons and argued that since the New Society 'would not be willing to admit the[ir] great inferiority ... a fusion could not fairly take place'.[19] At this stage the SPWC believed that overtures from the New Society represented a desperate move from an inferior rival, rather than a disinterested desire to promote a unified profession. Moreover, failure to attract government support was not in itself a great disaster for the SPWC since it reconfirmed its status as a private body whose responsibilities lay strictly to its own members.

The debate over the relative merits of independent competing societies and a unified body intensified following the proposal in 1879 by the Grosvenor Gallery to organize a watercolour exhibition and to invite members of both institutions to participate. The SPWC interpreted the new exhibition as a 'direct attack upon the interests of the Society' and they discussed ways of blocking any collaboration.[20] In contrast, the New Society, now called the Institute of Painters in Water Colours, argued that this new challenge vindicated its policy. Under the dynamic leadership of James Linton, they set up a private company to build an impressive set of galleries in Piccadilly with sufficient space to accommodate a representative display of watercolours, thus obviating the need to restrict membership. The Institute invited the SPWC to join, but again they refused to contemplate a merger which threatened their identity.[21] This was interpreted by at least one paper as disturbing evidence that the 'condition of Water-colour art in England is that of a house divided against itself', and there were numerous calls for a body to 'authoratively represent the state and progress of our national art'.[22] Criticism of the SPWC for clinging on to the principle of a closed exhibition reached a crescendo after it was granted a royal warrant in June 1881, when it became the Royal Watercolour Society (RWS). As the press pointed out, public recognition brought new responsibilities and the fact that the RWS had no teaching function and confined its charitable function to its own

limited membership was no longer acceptable. The members convened committees to 'consider the steps to be taken to maintain the Society in its present position, as the Head of the Water Colour-Art in England', but the institution lacked both the leadership and the resolve to react decisively to the challenge to its hegemony and public criticism of its activities.[23]

The consequences for the watercolour profession of the public divisions in the early 1880s and competition between the societies throughout the period can be overstated, though. The RWS still had its core supporters for whom its continued independence, particularly financial, was evidence of an *ad hoc* art system which none the less worked. Moreover, the efforts of the Institute, culminating in the building of spacious new galleries, extensive exhibitions, and the provision of teaching for the public, spoke of a successful alternative strategy. Professional infighting based on the conflict between the private interests of an élite and the needs of an ever expanding number of practitioners within the watercolour domain was a characteristic aspect of the art system, however much an ideal of disinterested competition might hold sway. Moreover, the fact that the watercolour societies could be characterized at various times as monopolistic and self-serving did not necessarily undermine the positive associations of the medium which were established on their walls. Contentious aspects of their professional project meant little as long as the societies' exhibitions continued to embody a valued English tradition which contributed to the national school.

Representing the English art of watercolours

Throughout the nineteenth century the watercolour societies sought different ways of encouraging the view that the work of contemporary artists was an estimable continuation of a great national tradition. The Institute, for instance, organized two small historical exhibitions in 1870 and 1871 whilst the SPWC responded by proposing to arrange an exhibition which would illustrate their role in raising the practice to 'its present European distinction'.[24] The Institute also used the opening of its new galleries in 1883 to lay claim to be the true guardian of the English tradition. It placed busts of the great heroes of watercolour practice on the facade facing Piccadilly. In addition to statues of Paul Sandby, John Robert Cozens, Thomas Girtin and J. M. W. Turner, it rather pointedly added David Cox, Peter De Wint, George Barret and William Hunt who had been members of the SPWC. To celebrate the opening, the Institute also organized an elaborate 'Masque of Painters' which depicted the great schools of art in a series of *tableaus*. The display culminated in the British school in which painting 'in watery hues', the 'home-growth of art', was given pride of place.[25] This was also one of the

main themes of John Lewis Roget's monumental *History of the 'Old Water-Colour Society'* [1891] which placed a flattering account of the Society and its members in the context of a comprehensive survey of the medium. Roget emphasized the importance of the Society's role in 'the progress ... of a truly national art' and created a complimentary image of contemporary professional status predicated on a continuity with the past.[26]

The motivation behind the societies' involvement in displays of historical and contemporary watercolours in the national and international exhibitions in the mid-century had been much the same; the results, however, had been more gratifying. The presidents of the two societies superintended the arrangements for watercolours at the 1855 Exhibition Universelle in Paris and were delighted by the flattering attention shown by the French and Belgian governments, as well as by much favourable comment on the continuing strength of the English school. The societies were less directly involved in the 1857 Manchester Art Treasures show, but again there were complimentary suggestions that contemporary artists were worthy heirs of the great masters of the art.[27] The strength of the art, it was widely agreed, stemmed from a continuing commitment to nature and, specifically, to the English landscape, with each exhibition providing the urban viewer with a portrait of the country: 'our coasts, and copses, and cornfields, our lakes and mountains'.[28] Commenting on the reasons for the success of the English school of watercolours, the handbook to the 1862 International Exhibition held in London claimed that it reflected social advances. Watercolourists benefited, it argued, from the higher 'proportion of the more educated and wealthy classes in England ... providing not only an infinite number of patrons, but of amateur followers of the new art'.[29] However, the 1862 International Exhibition also marked an unwanted watershed for the profession. The presidents of the societies found themselves excluded from the arrangements for the exhibition and, more worryingly, the official publications rejected the view that present practice was a laudable progression from the past. The catalogue followed an extensive eulogy of Turner and praise for the earlier masters with a very cursory coverage of contemporary artists together with the suggestion that modern practice had gone beyond the 'natural ... limits of the material' and was characterized by 'too much picture-manufacturing'.[30] The glorious heritage of English practice could, for the first time, be damaging, as well as beneficial, to contemporary artists.

The growing number of critics of contemporary watercolours in the 1850s and 1860s were primarily concerned that changes in practice betrayed what the *Art Journal* termed the 'pure, unsophisticated English watercolour method' of the older generation of artists such as David Cox.[31] For such critics, the growing popularity of watercolours, as measured by the proliferation of watercolour exhibitions, was anathema to the true progress of the art.[32]

According to Ruskin, increased demand resulted in works characterized by the use of 'glaring colours, and blotted and dashed forms' designed to 'appeal to the insensitiveness and pretence of the public'.[33] Ruskin also identified a concurrent danger for a profession which, at various times, had sought to establish its status in competition with oils. In Chapter 7 of *The Cestus of Aglaia* [1865], titled 'The Limits of Materials', he used watercolour as an example of the larger principle that 'whatever material we use, the virtues of that material are to be exhibited, and its defects freely admitted'.[34] There was, he argued no 'merit in a water colour to have the "force of oil"', and he urged artists to display that 'peculiar delicacy, paleness and transparency belonging' to the medium.[35] Moreover, the issue went beyond the niceties of aesthetic theory, as a number of high-profile defections of watercolourists suggested; the independent identity of the profession was itself threatened by practices which blurred the distinction between media.

The collapse of the notion of watercolour as a progressive art took another turn in the 1870s and 1880s when a new generation of critics attacked artists for a wilful refusal to look beyond their own traditions. Whether artists followed the Ruskinian recipe for reform and looked back to earlier simpler styles, or merely remained faithful to the more detailed manner of the 1860s, they were equally culpable, according to this point of view, of allowing the art to stagnate. For much of the century the association of watercolour and Englishness had been unequivocally positive, but now even this was coming under suspicion. For the first time, references to foreign watercolourists were not simply introduced to show the superiority of the English school; a series of commercial shows of French and Dutch artists were represented as a challenge to a complacent profession. Moreover, the increasing attention paid to Impressionism added further grounds on which to attack watercolourists for their inability to reform their work in line with foreign developments. The *Art Journal* summed up decades of growing criticism in 1895, claiming that the watercolour exhibitions continued as though 'Barbizon has yet to be discovered, the Dutchmen have painted in vain, the Impressionists worked to no purpose'.[36]

The modernist agenda of many watercolour studies means such an antipathy to the watercolour societies on the grounds of their irredeemably conservative nature has become a truism. However, this misses the point that the increasing fragmentation of the art world, which saw the emergence of new bodies such as the Grosvenor Gallery and the growth of commercial dealers specializing in watercolours, meant that the survival of the RWS and the Royal Institute depended on the establishment of a viable alternative identity. In practice, this meant abandoning the progressivist mission to a new faction of artists who, though they may have used watercolours, were defined by other criteria, and taking advantage, instead, of a new set of

nationalist readings for the medium. The RWS, in particular, was character-ized as a welcome guardian of national tradition by a conservative faction of the press in the 1880s and 1890s. According to *The Times*, it was notable for 'carrying on the continuity of one branch of our national culture', in contrast to oil painters who 'have been blown about by every wind of doctrine', thus keeping 'at least one stream of English art pure and wholesome'.[37] The source of these disturbing influences was spelt out in the *Architect* where the exhibi-tion was praised for the lack 'of foreign influence ... at a time when ... many clever young artists are persuading themselves that Impressionism is the only form of art'.[38] It is essential the RWS 'remains the temple of the national art *par excellence* – an art English-born and English-bred', such arguments went, because without it the very image of our 'native scenery' would be 'blurred'.[39] According to this view, the art of 'water-colour painting' is not just English by association with the work of its greatest masters, but is perfectly 'suited to express the evanescent beauties of our skies and windy seas and fields'.[40] The continuing dominance of landscape subjects at the exhibitions, and of English scenes in particular, reinforced the claims of the watercolour societies to patriotic praise.

Buying and viewing at the watercolour societies

Whatever the successes and failures of the societies in promoting the status of the medium and its practitioners, it was their role in organizing exhibi-tions which performed the dual function of a public spectacle and a market that contributed most to the association of watercolour with middle-class taste. There was no question, however, of the societies seeking to concentrate their efforts on one faction of their potential audience. Both the SPWC and the New Society went to great lengths to cultivate royal and aristocratic patronage and they introduced many of the rituals undertaken by the RA even before acquiring their Royal Charters in 1881 and 1883. Moreover, although the societies had been unsuccessful in their efforts to relocate within grand public premises in the 1860s, they tacitly admitted that they aspired to the standards of public display set by the RA, and this was underlined by the general stipulation that works should be surrounded by gold frames. Moreover, the SPWC was also keen not to be seen to be competing in terms of cost with oils. For instance, it introduced a minimum price of seven guineas for exhibits, and up until 1857 the society paid out a sizable propor-tion of its profits in premiums to encourage members to produce larger and more complex pieces. Despite the best efforts of the societies, however, the medium was always associated to a lesser or greater degree with a series of problematic qualities such as the domestic, the feminine, and the ephemeral,

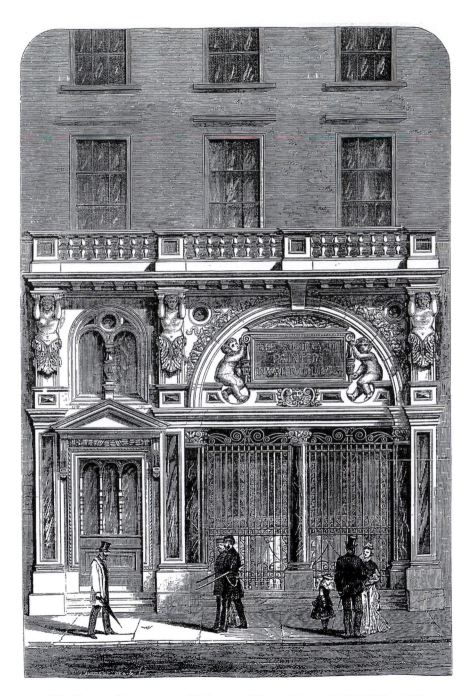

7.1 'The House of the Society of Painters in Water-Colours, Pall Mall East', *The Builder*, 24 April 1875

and with a conservative stratum of society, which had the potential to un-dermine the highest aspirations of the profession.

The association of watercolour, and the exhibitions in particular, with the domestic, stemmed from a combination of factors. The small size of the RWS's home in Pall Mall and that of the Institute prior to 1884 meant that, although works were crowded on the walls, the number of exhibits were comparatively low. The use of screens reinforced the domestic feel of the exhibitions and this was strengthened by the comparatively small scale of the majority of works. Although the practical limitations to the size of water-colours had been removed, the economics of production meant that larger works could be produced with less labour and more profit in oils. It was, however, the continuing shift in the function of the watercolour, from an object for private perusal to an important element in domestic decoration, which was of the greatest significance. The shift may have been equally characteristic of the large country houses, but writers like Ruskin tended to identify it with the 'suburban villa' and the 'moderate-sized breakfast-par-lour'.[41] For Ruskin this spoke of a proper humility, but, more commonly, discussions of the domestic scale of watercolours saw it as evidence of the profession's failings. According to the *Daily Chronicle* in 1880, a 'too frequent submissiveness to the requirements of the drawing-room' reflects a 'disincli-nation to search for anything nobler than prettiness' to the detriment of 'manly art'.[42] Critics of watercolours, particularly in contrast with oils, had often employed pejorative gendered terms, but the growing numbers of women who showed with the societies reinforced the negative association of the medium with the feminine and the domestic.

The use of watercolours as a key element in domestic decoration also contributed to a damaging association of the medium with the ephemeral. The evanescent quality of many watercolour pigments had been a worry for practitioners throughout the century, but the issue came to a head in the mid-1880s in a manner which threatened both their professional integrity and the market for watercolours. The catalyst for the very public debate was a letter sent by J. C. Robinson to *The Times* in March 1886 which accused the South Kensington Museum of displaying a collection of watercolours in light conditions which rendered them 'more or less irrevocably injured'.[43] The further testimony of the chemist A. H. Church suggested that the water-colourists themselves were guilty of employing materials known to be fugitive. The challenge was taken up by the president of the Royal Institute, James Linton. He angrily denied that the works had been significantly dam-aged, claiming that many were monochrome anyway, argued that others had actually been deepened in tone by exposure, and suggested that in other cases it was chemical reactions which had caused the problem rather than light.[44] Linton also organized an Exhibition of Water Colour Drawings by

Deceased Masters which contained a large number of immaculately pre-
served works as a counter to the 'reckless insult ... levelled promiscuously
against the whole body of an honourable profession'.[45] Watercolourists were
better served, however, by the setting up of a Committee to Investigate the
Action of Light on Water Colours. Its report, published in 1888, largely
exonerated the South Kensington Museum and provided artists with sound
advice on which pigments to avoid, though it is questionable whether it
entirely allayed the fears of consumers.[46]

Worries about the reliability of the commodity were particularly unwel-
come given that the market for watercolours was in decline in the 1880s
following a high in the previous decade.[47] In the case of the RWS, the 'seri-
ous falling off in the number of visitors and consequently of purchasers'
was, according to the members, caused by the 'remoteness of the Gallery
from the Art Centre'.[48] With the foundation of the Grosvenor Gallery and the
move of the RA, the fashionable centre had shifted west; the decision of the
RWS not to join the Institute in Piccadilly or move from Pall Mall therefore
marked it out as content to remain on the periphery and willing to accept
smaller crowds.[49] Comments about the audience for the Society's exhibitions
continued to talk of its respectability, but there was now also a mocking tone
to many reviews. The *Court Journal*, for example, commented on the prepon-
derance of 'grey-bearded, white-haired frequenters' in an exhibition which
was full of works redolent of 'crochet antimacassers and glass-covered wax
flowers in the room of a widow lady who has known brighter days'.[50] The
RWS, wrote another, caters for a 'section of the public' for whom 'dullness
has apparently a vast attraction', providing the 'picture-seer of the highest
moral repute' with works which are reassuringly conventional in treatment
and bland in subject.[51]

However, the refusal of the societies, and the RWS in particular, to pander
to fashionable taste was welcomed by many others; the fact that there was
little of the 'press and rush of "smart people" that surges in the rooms of
other galleries' allowed for a more civilized ritual, it was agreed.[52] 'What
was especially noticeable', the *Pall Mall Gazette* continued, was the 'old-time'
feel of the place where 'the vast majority of the visitors came not so much to
be seen as to see; for they clustered around the pictures, seeming as if they
really liked them'.[53] According to this view, declining crowds may not be a
bad thing if they encourage sales and promote the exhibition as a respectable
meeting of 'picture-painters, picture-lovers, and picture-buyers'.[54] The close
relationship between the artist and audience was, according to the *Ath-
enaeum*, a result of the nature of watercolour practice which saves the 'amateur
from that painful consciousness of impossibility in rivalry' with the profes-
sional.[55] The audience was thus made up of 'shrewd, competent, poetical
lovers of Nature, who have themselves wielded the pencil or coloured in the

open air' and can therefore 'criticize or … sympathize' with authority.[56] For one faction of the press, therefore, the societies embodied a distinctive and laudable relationship between artist and audience who met on equal ground and expressed mutual respect

The RWS did not issue a manifesto or publish its aims, but it was happy to be seen to oppose the modern, the fashionable, and the rarefied. In the catalogue for the 1896/7 winter exhibition it included a piece by Harry Quilter which looked back to the golden era of the 1860s 'before the birth of the new criticism' when 'Painters and buyers … were not ashamed of their mutual transactions'.[57] According to Quilter, the RWS was the last home of artists who were content to 'see a little of the beauty and significance of the world, to love it, and embody it in [their] pictures; to paint them as well as [they] can, and sell them as quickly as possible for what they are humbly worth, and then to go away and paint some more'.[58] Quilter's notion of the society as a haven for an art governed by bourgeois commercial values has much in common with Ruskin's description in *Notes on Prout and Hunt* of its early days as a golden era suited to the solid taste of the middle classes. Neither writer tells us anything about the actual composition and values of the audience, but they do illustrate the continuing capacity of the activities of the watercolour societies and the work of their members to embody middle-class values. The combination of the strength of the native tradition, an inertia inherent in the workings of closed institutions, and the need in a fragmented art world to establish a distinctive identity, ensured that positive as well as negative associations continued to evolve.

Notes

1. Ruskin 1903–12, vol. 14, pp. 369–452.
2. Taylor 1857, pp. 20 and 3.
3. Bourdieu 1993, pp. 125–31.
4. I would like to thank Judy Dixey, Simon Fenwick and Alison Roe of the Royal Watercolour Society at the Bankside Gallery for their help and hospitality.
5. Society of Painters in Water Colours, *Laws, Regulations, etc.*, London, 1848 and 1861.
6. Anonymous cutting, mounted in *Catalogues of the Society of Painters in Water Colours*, National Art Library, Victoria & Albert Museum, London.
7. Ibid.
8. *Art Union*, May 1839, p. 72.
9. *Arnold's Magazine of the Fine Arts*, vol.vi, 1834, p. 151.
10. *Daily News*, 15 April 1893.
11. Newall 1987, p. 27.
12. Ruskin, 1903–12, vol. 14, p. 122.
13. Parliamentary Papers, 1836 *Report*, vol.ii, p. 107.

14. Ibid.

15. Parliamentary Papers, 1863 *Report*, p. 24.

16. Ibid.

17. Evidence of Frederick Tayler, ibid., p. 401.

18. RWS, *Minutes*, 23 August 1858.

19. Ibid., 29 July 1863.

20. Ibid., 5 August 1879.

21. Ibid., 16 May 1881. The Institute merged instead with the Dudley Gallery.

22. *Standard*, 4 December 1880; *The Academy*, 3 May 1884.

23. RWS, *Minutes*, 7 June 1881.

24. Ibid., 24 April 1871. It was, however, opposed by those who feared that it would reduce their sales.

25. Gosse 1885, p. 11.

26. Roget 1891, vol.1, p. 2. Roget's text was based on the research of the secretary of the Society Joseph John Jenkins.

27. *Art Journal*, November 1857, pp. 344–5.

28. Taylor, p. 30.

29. Palgrave 1862, p. 63.

30. International Exhibition (1862), *Official Catalogue of the Fine Art Department*, p. 48, London.

31. *Art Journal*, October 1862, p. 199.

32. The founding of the Dudley Gallery coincided with the introduction by both existing societies of winter shows of sketches.

33. Ruskin, 1903–12, vol. 14, p. 127.

34. Ruskin 1903–12, vol. 14, p. 135.

35. Ibid.

36. *Art Journal*, May 1895, p. 159.

37. *Times*, 13 April 1881.

38. The *Architect*, 22 April 1887, p. 222.

39. *Daily Telegraph*, 30 November 1889; *The Times*, 25 November 1882.

40. *Daily News*, 25 November 1882.

41. Ruskin, 1903–12, vol. 14, p. 374.

42. *Daily Chronicle*, 27 April 1880.

43. *The Times*, 11 March 1886.

44. Ibid., 18 March 1886.

45. *Catalogue of the Exhibition of Water Colour Drawings by Deceased Masters of the British School*, (1886), London, p. vi.

46. The report was conducted by W.J. Russell and W. Abney and was presented to the Science and Art Department of the Committee of Council on Education in 1888. Critics at the time rightly attacked it for its complacent, if not biased, conclusions.

47. See RSW, *Sales Statistics 1862–1881*, Bankside Gallery, London. Sales at the summer exhibition plummeted from £9,968 in 1877 to £4,894 in 1881.

48. RWS, *Minutes*, 3 August 1881.

49. The attendance figures dropped from 9,925 in 1885 to 4,993 in 1901.

50. *Court Journal*, 7 December 1895.

51. *Morning Leader*, 7 May 1894.

52. *Pall Mall Gazette*, 29 April 1889.

53. Ibid.

54. Ibid.

55. *Athenaeum*, 2 May 1857, p. 571.

56. Ibid.

57. Harry Quilter, 'Some Memories and a Moral', in RWS, *Catalogue of the Winter Exhibition of Sketches*, London, 1896/7, p. xxii.

58. Ibid., p. xxiii.

'The advantages of combination': the Art Union of London and state regulation in the 1840s

Duncan Forbes

Art, cheap and good.[1]

How is it possible to create a current of patronage of Art on a standard of taste and judgment, to which all men will defer?[2]

The people had now approved themselves to be not the despoilers, but the protectors of Art; and why? Because they were permitted to participate in the gratification derived from Art.[3]

Now, according to the same papers, a Mr. Taunton has manufactured an umbrella – 'the handle of which is *of ivory, and represents a bust of Prince Albert*. A sundial and a compass are beneath this, with a *thermometer*; a *telescope* is inserted in the stick. There is also a *microscope!* The tube or stick is of pure silver – the telescopic portion of silver gilt; as is the *ferule* and *microscope*; the umbrella is of royal purple silk, the *extensors* of silver, the tassels, *et cetera*, of gold bullion, and the whole inclosed in a red morocco case, lined with crimson velvet.' Here are tempting prizes for an Art-Union![4]

In April 1844 the two Honorary Secretaries of the Art Union of London received a letter from the Lords of the Treasury informing them that their organization was illegal: unless it ceased its operations immediately each of its 14,000 or so subscribers was liable to a £500 penalty under the terms of the 1802 Lottery Act.[5] Similar warnings had been despatched to the other 'provincial' (national) art unions, as well as a handful of distribution schemes run for private profit. The Treasury's intervention, sluggish and unwilling, had been forced by the more urgent petitioning of a group of London's engravers, publishers and printsellers, worried about the Art Union's ruinous effects on their businesses, particularly its adoption in 1842 of the electrotype. As one of their number testified in the subsequent Select Committee hearing, this new reproductive technology would so increase the circulation of engravings that it threatened to reduce their status to that of 'everlasting flowers'.[6]

This chapter examines the impact of the Treasury's actions on the Art Union of London and the disputes engendered by increased government 'interference' in the selling and distribution of the fine arts. Whether for or against the operation of the art unions, most critics agreed that the appearance of mass membership patronage bodies marked a fundamental shift in the development of British art. For some – usually those of utilitarian training – this appeared simply as a clash of cultures: the routing of the acquisitive culture of the 'few' by a more appropriately modern form of patronage relations grounded in the purchasing power of the 'many'.[7] For others – the *Spectator* and *Athenaeum* especially – art unions heralded only the vulgarization of art, whose 'best results can be but an irresponsible indulgence of individual whim and caprice'.[8] The extensive public row over the functioning of art unions was expressive of conflicts and contradictions generated by the growing accumulative and compulsive power of British capitalism. What happens to high art when élite patronage is seemingly overtaken by a corporate counterpart founded on accelerating bourgeois wealth? Might not the newly-won gift of artistic consumption granted to the *ingénu* prizeholder diminish national taste? Would such extravagant interference cause supply to exceed demand and cheapen the value of artistic work? In what form was government regulation of the fine arts legitimate in a commercial nation whose freedoms, for many, had long been defined by the absence of state control? And what exactly – in that brutally class-conscious phrase – were the 'advantages of combination' when it came to defining the future of public taste?[9]

By the time of the Treasury shutdown, and in the wake of the worst recession of the nineteenth century, the Art Union of London's economic and cultural power was extensive. In 1843 it raised £12,334 from its guinea subscription with prizeholders purchasing 234 paintings from the five major London exhibitions (over £3,100 was spent at the Royal Academy alone). An estimated 200,000 visitors attended the annual exhibition of the prizeholders' choices and the organization's committee was confidently forecasting a settled income of £20,000 a year. Across Britain an estimated £48,000 was being raised annually by the 'official' art unions, with a growing number of private speculations exploiting the resounding popularity of the lottery mechanism. As several commentators noted, there was a 'mania' for art unions, and it bore striking resemblance to that altogether more fraudulent speculative frenzy: the railways.

For the social improvers and bourgeois radicals who formed the core of the Art Union of London's active support, its success proved that 'the precipitate adoption of some new-fangled German theory' was after all appropriate for the world of English art.[10] 'In a commercial country', argued the historical painter George Foggo, 'almost everything requires to be done

by individuals or by combinations of individuals', and he was by no means alone in elevating the freedoms to be won for art within civil society over the pretensions of the British state.[11] Many of the Art Union of London's friends, viewing its history through a Benthamic optic, perceived it as the culmination of efforts during the eighteenth century to force greater autonomy from a congealed aristocratic culture, working against the monopolization of patronal power. For the engraver John Pye, the Art Union was an institution freed by its commercial functions from the intrusion of, and reliance on, the state and its governing classes, symbolized most potently by the Crown's connection with the Royal Academy. The Academy's establishment had 'converted the republic of art into an aristocracy' inevitably antagonistic to merit. Only now with the founding of the Art Union of London could this situation be reversed, its object 'the acquisition of national dignity and other public advantages by spreading amongst the people at large a taste for art' (Figure 8.1).[12] Painting was to be a tool for public improvement, rather than a symptom of private wealth, and the Art Union could quickly rejuvenate the moral tradition in English art inaugurated by Hogarth. Publicly, the Art Union of London described its members as 'fellow-workers with Government', but it also retained a deep suspicion about the ability of government to regulate the fine arts. At a time when the state appeared to be arrogating to itself the promotion of the nation's collective cultural life, the Art Union of London continued to defend its core utilitarian ideals: self-governance, self-interest and economic independence for artist and patron alike.[13]

From the founding of the Art Union of London in 1837, the extent to which pursuing these values compromised communal aspects of national artistic progress generated considerable public controversy. One of the more fissile topics was the organization's system of awarding prizes: the allotting to the individual prizewinner a sum of money to be spent on any work of art in the capital's exhibitions. As George Godwin, the Art Union of London's long-standing Honorary Secretary, repeatedly argued, this was the organization's 'fundamental principle', separating it decisively from the systems of the other national art unions (Edinburgh and Dublin) where committees of amateur experts selected the works to be offered as prizes. Individual choice prevented 'jobbing' on the part of any committee, encouraged responsibility in the prizeholder, was better suited to the open character of the London art market, and ensured a maximal return of pleasure for the individual subscriber. Its moral benefits were evident, leading the prizeholder:

to inquire into the subject, and to take the opinion of friends: he goes into picture-galleries where, perhaps, he had never been before, and his art education is commenced. Even if an indifferent picture be chosen in some few cases, to the exclusion of a better, the error is soon pointed out to him by his friends, his judgement is improved, and he learns to admire justly. Every man is the centre of a circle;

8.1 'The Art Union of London prize drawing in 1843', *Illustrated London News*, 29
April 1843

the knowledge that he gains spreads throughout that circle, and thus the general
improvement is advanced.[14]

What is evident here and elsewhere in the Art Union of London's published
statements is how the utilitarian commitment to self-instruction tends to
erase consideration of the traditional values of high culture: reverence for
accepted standards of taste becomes secondary to the social experience of
formulating artistic judgement. As I shall argue, this promoted a profound
ambivalence within the organization about the objects of its patronage, al-
though Godwin and his colleagues – in the face of extensive provocation –
never wavered from their bias towards encouraging the active formation of

individual taste. More than almost any other feature, this commitment to the mechanism of individual choice, understood by its defenders as promoting moral self-regulation and the forces of economic individualism, reveals the organization's role in mediating the beliefs and practices of what its leaders recognized as a specific class. As the radical MP Thomas Wyse argued at a meeting called by artists in December 1842 to defend the practices of the Art Union of London, the 'outward formulary' encouraged by 'exclusive cultivation' must be abandoned to be replaced by the 'real inward knowledge' of an educated middle class.[15] High culture, in order to sustain itself, must be remade by the bourgeoisie in its own image. The social 'benefits' of such a process were outlined by Godwin in the 1851 Annual Report:

Opening works of mind to the contemplation of the people will be found a powerful means of lessening such moral and intellectual difference as there may be between the upper and lower orders, not by injuring one, but by improving the other. An acquaintance with works of art gives dignity and self-esteem to the operative, a matter of no slight value as regards the stability of society, besides making him a better workman; and furnishes him with a delight, independent of position, calculated to purify and exalt.[16]

We should not forget that this was written at the tail end of fifteen years of intensified struggle on the part of the working class.[17]

From the early 1840s, arguments against the 'London system' received a vigorous airing in Parliament and the press. At their core lay the contention that individual patronage undermined the communal imperatives of a national high culture, sabotaging its progress through a haphazard amalgam of ill-informed choice. Stewart Blacker, the Honorary Secretary of the Royal Irish Art Union, argued that artists should 'paint for a superior class of men', rather than the 'popular taste', proposing committees comprised of 'well-selected men, influential, independent, and competent from known taste, education, and attention to a particular department'. This alone would ensure that 'some uniform principle' – described later as 'ideality' – governed the encouragement of high art. For Blacker, committee expertise consisted in the ability to command the market, frustrating the attempts of artists to force manufactured paintings on an unsuspecting public. Patronage could then be properly directed towards the 'original and painstaking artist'.[18] Others proposed that the authority derived from selection by committee would best further an artist's reputation and create the economic certainty needed to stimulate the highest examples of art. For William Etty, the London system, coupled to distribution by lot, served only to entrench art objects within a cycle of speculation, with those 'rather needy' reselling and raffling their prizes in order to retrieve 'what the picture will produce'.[19]

For many of its critics, the Art Union of London's system of choice cancelled out any of the advantages residing in combination, artificially placing

actors in a market whose autonomy and lack of cultural competence threatened to diminish the status of art. As the *North British Review* argued in its analysis of the competing 'Scotch and English systems':

If the chief, if not the sole object of corporate interference, be to raise art above the prevailing taste, and by this means to drag the public taste up after it, it seems difficult to imagine how this is to be effected, unless a purer and severer criticism is brought into play than that of the very taste which is thus raised. To found Art-Unions for the elevation of taste, and then to entrust the existing taste with the duty of determining the class of works to be encouraged, is to suppose this taste to be at once capable and incapable, low and high.[20]

To what extent this 'corporate interference' constituted an assault on the immutable laws of supply and demand was a constant topic of interest, explaining the lengthy investigation of the social relations of art union production that is such a defining feature of the 1844–45 Select Committee inquiry. In 1837 the *London and Westminster Review* had argued that '*the interests of taste in art and those of commerce are identical*', reflecting a confidence in the benefits of cultural commodification that was seldom to be stated so definitively again.[21] During the 1844 hearing, George Godwin's confused and contradictory answers under a barrage of questions from the sympathetic, but equally uncertain, radical MP William Ewart, reveals the difficulties faced in accounting for the differential nature of artistic labour and its impact in the market. Taste and the qualitative assessments it implied could evidently not be so easily explained by the rigid exchange-ratios of political economy. The *North British Review* attempted to resolve the contradictions of art and commerce by arguing that 'the principle involved in Art-Unions was independent of the ordinary laws of trade':

The chief object aimed at by the subscribers was not to secure an adequate return for their money, but to obtain the benefits which artistic taste and knowledge are supposed to confer on a community, without involving individuals in any sensible pecuniary loss … The sum was paid, not for the commodity simply but for the [ethos], the whole habit and mode of being, on the part both of the artist and the public, as the result of which the commodity was produced.[22]

As the *Review* went on to propose, the function of art as communal property justified the interference of both selection committee and government alike. In the realm of art at least, common action should defeat the play of competing self-interest.

Godwin's unflinching opposition to the determination of public taste by a benevolent rotating hierarchy of aesthetes reveals how the formal political antagonisms of 1832 continued to be fought out at the level of social and cultural practice. From the late 1830s, and in particular with his editorship of *The Builder* from 1844, Godwin devoted his life to voluntary and commercial activities that would rein in the worst social consequences of, and thus

perpetuate, *laissez-faire*.[23] Again, his commitment to overcoming internal division and realizing the social and cultural hegemony of the bourgeoisie is often made explicit. '[T]hinking only of ourselves', he wrote in a tract of 1854, 'we must, if we are wise, look to the health, the well-being, and the advancement of those beneath and around us, if it be but for the effect neglect of these may have on our own health, well-being, and advancement'.[24] The vital ameliorative function of art – a 'social bridge of no ordinary size and strength' – would best be safeguarded by the autonomy of bourgeois taste and the self-activity of what were usually referred to as the operative classes, the former better able to stimulate the 'striving upwards' of the latter than any amount of patrician regulation.[25] More so than the other national art unions, the activities of the Art Union of London were framed by a conscious solution to the contradictions of social 'reform' in a period of helter-skelter commercial expansion.

This tendency towards a deterministic equation of social class and aesthetic capacity inevitably generated difficulties for Godwin when justifying the patronage activities of the Art Union. Quoting from Archer Shee's *Outlines of a Plan for the National Encouragement of Historical Painting in the United Kingdom*, an Art Union of London subcommittee noted in 1842 that 'we should always keep in view, that to excite the genius of our countrymen to great and noble efforts is the only object, that can make our interference with the arts of our country at all judicious'.[26] Throughout his period as Honorary Secretary (from 1840 to 1868), Godwin utilized a highly generalized exhortatory rhetoric in the organization's annual reports, directing artists and patrons towards what were described *inter alia* as the 'highest departments', 'ideality', 'universal and general nature' and works 'which speak to the mind rather than to the eye'. Once again, the vagueness of aesthetic prescription is matched only by the certainty of social outcome:

Money spent in the production of really great works for universal contemplation … is but put out to use, and will return a glorious interest. Counteracting the absorbing love of gain and the pursuit of mean pleasures, the language of such works goes straight to the hearts of all, giving higher motives for exertion, and purer enjoyments: arousing dormant energies, and dignifying the character of man.[27]

There can be no clearer (or more telling) expression – published in 1848 – of Godwin's concern to arrogate to the Art Union a specious cultural universalism in the face of social fragmentation and political conflict.

Inevitably the commitment to an idealizing art clashed with the Art Union of London's 'fundamental principle' and the bulk of prizes chosen by individuals were landscapes or domestic figure subjects. For Copley Fielding, the Art Union had 'no visible effects on high art', and for this reason he preferred the patronage of church and government to art unions.[28] In his testimony Clarkson Stanfield agreed, arguing that art unions have only

'hitherto bought pictures of a middling class'.[29] Henry Graves maintained that art unions encouraged mediocrity and he called for the formation of what was in effect a government art lottery in order to regulate public taste more aggressively.[30] John Burnet proposed that art union committees might best be appointed and superintended by government.[31] For these and other witnesses, the Art Union of London's comparative autonomy within civil society meant that it had in practice already failed, or was unable by its very constitution, to represent adequately a more highly evolved tributary of national taste.

Caught by the desire to patronize high art and the need to maintain a mass membership organization, the Art Union of London's managers were sometimes compelled to admit the difficulties of their enterprise. At the 1840 General Meeting, in response to the charge that the committee devoted too much income to works of high prices, Benjamin Bond Cabbell confessed to 'the necessity of having smaller prizes, in order to secure subscribers from the middling classes'.[32] By 1846, and under mounting pressure to justify its activities, Godwin argued that the Art Union's 'number of probable advantages should bear a sufficient proportion to the number of subscribers' and to that extent the committee 'cannot admit that none but high-priced works should be encouraged'.[33] The following year he suggested that under the individual choice system 'all classes of art-works find a market', a situation unlikely to occur under the 'bias' and 'personal favouritism' of a committee.[34] Godwin's logic never quite embraced the arguments of those who perceived the Art Union as a manifestation of market-driven popular taste, an organization, according to *The Topic*, which in its inability to promote high art spoke 'very intelligibly the national bias'.[35] But, for many, the Art Union's adoption of only one modest regulative mechanism in the form of the annual exhibition of the prizeholders' choices meant that it ceded far too much authority to what the MP William Escott, described as the 'depravity of modern taste'.[36]

There are many other lesser points of dispute that fuelled debate over the work of the art unions: the evils of the lottery mechanism; the encouragement of design and manufacture; the protectionist policy of restricting Art Union of London patronage to British art. Each in its own way reveals the difficulties faced by the Art Union's managers in formulating and defending universal values against the asymmetries of competitive economic advance. However, after the system of allotting prizes, it was the status of art union engravings that came under the severest critical scrutiny. By the 1840s prints were being despatched throughout the British empire and had become what one contributor to the Select Committee hearing described as 'the common circulation and currency of art'.[37] The invention of the electrotype, offering potentially an infinite number of prints from an original plate, raised ques-

tions about the status of high art within commodity culture; again, it was the ability of the Art Union of London to represent adequately an ill-defined standard of taste that troubled its critics. With the practice of engraving becoming more equivalent to the status of petty commodity production, the art unions' adoption of the electrotype was perceived by some as further reducing the value of creative work, this time by their monopolistic intervention in what had once been a prestigious luxury market.

Arguments against the art unions' use of engravings were numerous: that the number reproduced resulted inevitably in uneven quality; that mass distribution diminished their status as luxury commodities and reduced public appreciation; that the economies of scale created by art unions gave them an unfair advantage over the individual producer; that art union engravings had little or no resale value; that they were destroying the market for guinea prints; that art unions circulated engravings in order only to advertise their cause; that the engravings were of an insufficiently elevated character; and that the electrotype in particular robbed the engraver of the just reward for his labour.[38] Repeatedly art unions were attacked for their 'artificial' intervention in the market: fewer engravers would be needed to work on a diminishing number of plates; assistants would be laid off, the necessary division of labour disrupted and the influence of the publisher diminished. As one complainant argued, the trade should be left to the 'application of talent and capital in the usual way'.[39] However, not all engravers were opposed to the art unions' mass distribution of prints: a counter-petition had been raised by some sections of the trade in defence of the art unions and the witnesses to the Select Committee hearings were divided over the effects of the electrotype. For some, it would result not in unfair competition, but in a necessary restructuring of the market. Furthermore, the electrotype had so little effect on the engraving of old masters that it would in no way damage the circulation of high art. The art unions also promised to free the engraver from reliance on publishers' capital, offering greater personal reward and global renown.[40]

The close dissection of the relations of production in the engraving trade – especially the concern to determine the economic value of an art union print – was a pronounced aspect of the 1844–45 Select Committee hearings. In part this was a way of establishing that the art unions could be justifiably exempted from the Lottery Acts: if subscribers received a full return for their guinea subscriptions then the speculative character of the membership transaction was perceived to be diminished. But the level of scrutiny also reveals an intense anxiety about the mass production and circulation of art objects in a market economy which appeared even to its most committed supporters to be evidently traducing the 'value' of art. For George Godwin and his colleagues, the commodification of art was an incontestable benefit: no longer

should it be available as a luxury item to a wealthy few. But the dilemma, as the 1846 Report phrased it, was how to make 'cheap art GOOD'.[41] As far as art union prints were concerned, the solution lay – as the Select Committee Report emphasized – in the function of the organizations' committees. Once again, the contradictions of art in a commercial society were to be contained by some form of representative, regulatory élite.

The parliamentary Select Committee's long and cautiously argued Report was eventually published in August 1845, and under the direction of its supportive chairman, Thomas Wyse, it pronounced in favour of the work of art unions generally, and in a more qualified appraisal endorsed the activities of the Art Union of London. Working within the framework of a well-established radical agenda on the fine arts, the general strategy was twofold: first, to emphasize that art unions held no undue influence on the operations of the market or on the determination of public taste; and second, to recommend mild administrative procedures which, sanctioned by a specific Act of Parliament, would be regulated by a new government department 'specifically charged with the interests of Art'.[42] Symptomatic of a general trend in legislative action across this period, the Report attempted to negotiate a workable relationship between the communal imperatives of national artistic progress and the forces of economic liberalism. As one section argued, art unions 'may lead and regulate', but they 'cannot persist in altogether counteracting' what were described as 'the recognized predilections of the public'.[43]

Central to the Report was the argument that art unions were unlikely to 'produce an excess of supply over demand in the present and probably future circumstances of the country', a conclusion sustained by the contention of several witnesses that Britain was experiencing a rising standard of public taste.[44] In the context of expanding régimes of consumption, concerns about the art unions' monopolistic practices could easily be dismissed:

Similar complaints to those we now hear of the effect of Art Unions have been expressed of the monopoly crushing all private enterprise, &c., consequent on improvements in machinery, in the applications of steam printing, &c. But this is the tendency of the age, or rather of human industry. Whatever may be its evils, they are more than compensated by its advantages.[45]

One of the advantages of industrial modernity was 'cheapness', a factor to be 'looked on as not only of good omen, but as the actively operating cause to produce the end of which all seem equally desirous'. As in Italy or Greece, the growing familiarity of the British people with art will lead to escalating levels of public taste: 'a choicer and more fastidious spirit will arise, and a corresponding effort to meet or guide it.'[46]

However, when it came to the question of the quality of art union productions, the Report's confidence began to falter. It was 'very doubtful how, under present circumstances, High Art can be best encouraged':

The public at large is not educated to High Art, and in the public at large, on the plan of the London Art Union, the choice lies. Whatever may be its existing taste, that taste will show itself. It may, indeed, be questioned whether the Art Unions, as at present constituted, can so effectually encourage High Art (however desirable) as either the Government or the Church, in whose hands such function generally lies.[47]

Even more so than the Art Union of London's published statements, the Report betrays a remarkable ambivalence about the object of art union patronage, paying lip-service to academic hierarchy, but also recommending in the most generalized way the encouragement of landscape, seascape and genre painting. In a climate of poor artistic education 'the choice will fall on productions, not only out of the pale of High Art, but in most instances antagonist to it'. As public bodies, it is inevitably 'the temper and wishes of the nation' that art unions must reflect, combining 'great central power and means, with an infusion of popular opinion and feeling'.[48] However, elsewhere the Report argues that this feeling must be directed to 'higher motives and purposes', and in its most significant intervention it recommended the committee system over that of individual choice, arguing that this would result 'in a better class of production, and a more certain criterion for the producer'.[49] The constant oscillation between the popular, market-driven determination of public taste and a desire for some form of limited regulation was to be resolved by instituting the committee system. However, distinctly apologetic when it came to recommending any form of regulatory procedure, the Report also stated that it would not be 'peremptorily insisting on its adoption'.[50]

It is perhaps significant that, despite its timidity, the Select Committee sought in its recommendations to replicate an equivalence of its own representative function for the management of the Art Union of London. As the state during this period was increasingly forced towards interventionist measures in order to ensure the stability of *laissez-faire*, so the fine arts – now deeply embedded in the private realm of economic competition – required regulation in order to protect their communal purpose. How, and to what extent, this could successfully be achieved within the realm of civil society was the issue confronted by the Art Union of London and its critics, and the Select Committee inquiry sought to stiffen the organization's regulatory arsenal, bolstering its commitment to high culture and bringing it under the surveillance and supervision of central government. The inquiry and subsequent legislation can be understood within the context of the state's massive arrogation of cultural functions to itself during this period in an effort to represent itself as the guardian of a general interest that was fast being eroded by the fragmentation of civil society.[51] As the Report and Minutes of Evidence reveal, the superintending of the art unions was part of a larger process of interpenetrating legislative action, encompassing the teaching,

display and moral effects of art and design, as well as their contribution to the competitive strength of the British economy.

The passage of Thomas Wyse's Art Union Bill proved troublesome, opposed first by leading representatives of government and then, once enacted, sabotaged by the Art Union of London's refusal to abide by the Board of Trade's regulations. Both Sir Robert Peel and the Chancellor of the Exchequer, Henry Goulburn, spoke against the Bill in Parliament, arguing that it constituted an unprincipled exception to the Lottery Acts and would do little to encourage the development of High Art.[52] Only a few weeks after the abolition of the Corn Laws, Peel's opposition offered further tempting targets for sections of the press suspicious of any principle that failed to fall directly from the pens of Smith or McCulloch:

> It is quite certain that the spirit of speculation partakes of a gambling principle, and that the very enterprise which has made us the nation we are arises from an impulse to indulge in risks which must sometimes prove ruinous ... It is quite impossible to suppose that the Premier and the Chancellor of the Exchequer can really look with alarm on the possible moral depreciation caused by Art Unions when they have for so long philosophically contemplated the appalling mass of fraud generated by railway speculation ... Why they should reverse their principles when the liberal Arts and not trade are concerned it is difficult to imagine. The Arts and all intellectual pursuits have ever been treated in a strange manner by commercial states.[53]

It was of course precisely the reality of economic risk that made the unitary and unifying expression supposedly embodied by the fine arts so enticing for British élites.

With the collapse of Peel's administration, the Art Union Bill moved quickly to receive Royal Assent and by December 1846 the Art Union of London had been incorporated by Royal Charter. However, government confusion over which department should regulate the activities of the art unions meant that the system of individual choice continued to operate and it was only in October 1847 that the Board of Trade moved to implement the Act's recommendations. An extended correspondence ensued, with the Art Union of London stubbornly refusing to accept the Board of Trade's limited proposals: the graduated introduction of some form of committee selection (with prizeholders retaining the opportunity of choice from the collection selected); the abandonment of the annual distribution of modern engravings (to be replaced by the occasional commissioning of 'superior' works, whose proofs could then be distributed as prizes); and the setting aside of 10 per cent of income for the purchase of works for public exhibition.[54] Godwin, soon labelled the 'Cobden of the Combination', offered tenacious opposition, articulating a principled stance against state interference and a pragmatic concern that the implementation of the proposals would lead to a fall in membership. It was only in July 1848, after extensive petitioning by

London's artists, that the Board of Trade agreed to withdraw its regulations. The intervention of twenty-four Royal Academicians in support of the Art Union of London – the first time its corporate support had been publicly stated – appears to have been significant in encouraging the Board of Trade's reversal of policy.[55]

It is tempting, as it often was for contemporaries fired up by other debates, to view this whole episode solely in terms of fundamental antagonisms fought out between liberal individualism and the patrician intervention of a government still dominated by representatives of the aristocracy and gentry. Utilizing modern advertising and accounting techniques, art unions instigated a vision of a common cultural interest defined through the 'free' association of individuals rather than the high-handed imposition of traditional élites. Certainly, the Art Union of London was comparatively autonomous from, and also in extensive conflict with, representatives of the state, its role in fostering an exemplary national culture more contested than many other mediating institutions in British artistic life. But like other organizations in civil society the Art Union of London was also dependent on, and often working parallel to, state agencies in its practices and articulations: it is clear from the account above that disparate class factions were able to generate mutually supportive projects, not least in the intensified effort during the 1840s to promote art as a non-class alternative to the powerful particularist ideologies of a threatening working class. Both the state's increasing attempts to regulate and monopolize high culture, embodied in the workings of the Select Committee procedures, and the Art Union's efforts to mobilize a series of unifying cultural universalisms served to entrench an internally divided capitalist class as the embodiment of a general or common interest. Disagreement over who exactly should have the power to regulate and represent the fine arts did little to undermine the bourgeoisie's wider commitment to high culture as a site of social reconciliation.[56] For Godwin and his opponents, 'Art' proved a potent weapon in denying the salience of working-class claims to cultural and material difference.

As the intensity of the disputes recounted here reveals, the Art Union of London's impact on English art during the 1840s was felt to be dramatic – its size, apparently democratic constitution and harnessing of new technologies marking it out as a distinctively modern form of patronage relations. However, the rapid expansion of the London art market, burgeoning middle-class audiences and the multiple engagements of the state in the fine arts meant that by the 1850s the art unions were no longer perceived – even by their supporters – to be so central to the well-being of British art. By 1866, and the next Select Committee inquiry into their operations, the attitude of most of those involved was distinctly hostile and the art unions were persistently disparaged in comparison with the more comprehensively integrated activi-

ties of the Department of Science and Art. As the Report argued, the influence of the art unions in improving public taste had been 'very slight', and the moral effect of some of them – especially the shilling organizations that began to appear in the late 1850s – 'very bad'.[57] Although the Art Union of London remained successful until well into the 1880s (it was eventually wound up in 1912), George Godwin's commitment to the aesthetic agency of the autonomous, self-regulating individual became increasingly subjugated to the twin imperatives of commercial expansion and the moral legislation of a parasitic state.

Notes

1. Slogan of the National Art Union, quoted in the *Art Union Journal*, November 1842, p. 285.

2. John Pye, recorded in *Report* 1842, p. 22.

3. Thomas Wyse, MP, addressing the eighth General Meeting of the Art Union of London, *Art-Union Journal*, September 1844, p. 282.

4. *Athenaeum*, 31 December 1842, p. 1140.

5. Art Union of London Committee, Minutes, 16 April 1844 (British Library MS 38868). Standard histories of the Art Union of London include King 1964 and King 1985.

6. Mary Parkes, in Parliamentary Papers, 1845 *Report* (612), VII, qu. 4566.

7. This was an often-repeated argument in the Art Union of London's own documents. See, *Annual Report*, 1843, p. 4.

8. *Athenaeum*, 21 August 1841, p. 643.

9. The phrase was first used in connection with art unions in Parliamentary Papers, 1836 *Report*, (568), IX, p. viii. For the evolution and significance of the combination laws, see Rule 1988.

10. Thomas Wyse, in *Report* 1842, p. 6.

11. Parliamentary Papers, 1845 *Report*, qu. 4662.

12. Art Union of London, Minutes, 4 June 1844 (BL MS 38868).

13. For the evolution of utilitarian discourses in connection with the fine arts, see Hemingway 1993.

14. Art Union of London, Annual Report, 1846, p. 14.

15. *Report* 1842, p. 29.

16. Ibid., p. 10.

17. Saville 1994.

18. Parliamentary Papers, 1845 *Report*, qus. 1336, 1337, 1344 and 1365.

19. Ibid., qu. 2140.

20. *North British Review*, February 1857, p. 513.

21. *London and Westminster* Review, July 1837, p. 121.

22. *North British* Review, February 1857, p. 513.

23. For an account of Godwin's career, see Anthony King's introduction to Godwin 1972, pp. 7–26.

24. Godwin 1854, pp. 12–13.

25. Godwin 1972, p. 18.

26. Art Union of London (1842), 'Report … Sub-Committee Appointed to Consider the Future Prospects and the Most Efficient Mode of Working the Enlarged Means of the Association', London: n.p., p. 8. Shee's text was first published in 1809.

27. Art Union of London, *Annual Report*, 1848, p. 16.
28. Ibid., qus. 2280; 2341.
29. Ibid., qu. 2366.
30. Parliamentary Papers, 1845 *Report,* qu. 2995.
31. Ibid., qu. 3572.
32. *Probe*, 1 May 1840.
33. Art Union of London, *Annual Report*, 1846, p. 13.
34. Ibid., *Annual Report*, 1847, p. 5.
35. *The Topic*, 4 July 1846, p. 8.
36. Parliamentary Papers, 1845 *Report*, qu. 288.
37. Ibid., qu. 1005.
38. See in particular the 1845 *Report* testimonies of James Fahey, C. E. Wagstaff, Henry Graves, Thomas Uwins, William Finden, Mary Parkes, Henry Leggatt, John Pye and H. T. Ryall.
39. C. E. Wagstaff, Parliamentary Papers, 1845 *Report*, qu. 2632.
40. See in particular the 1845 *Report* testimonies of H. C. Shenton, John Burnet and W. H. Macqueen.
41. Parliamentary Papers, 1845 *Report*, p. 13.
42. Ibid., p. 29.
43. Ibid., p. 32.
44. Ibid., p. 19.
45. Ibid., pp. 1–22.
46. Ibid., pp. 25–6.
47. Ibid., p. 3.
48. Ibid., pp. 32–3.
49. Ibid., pp. 38–9.
50. Ibid., p. 38.
51. Corrigan and Sayer 1985; Pearson 1982.
52. *Hansard*, 3rd series, vol. 88, cols. 187–96.
53. *The Topic*, 4 July 1846, p. 3.
54. The passage of this dispute can be tracked in the Art Union of London 1848, 'The Art-Union of London and the Board of Trade. Correspondence Relative to the Proposed Interference with the Society's Plan', London: np.
55. *Art Union Journal*, August 1848, p. 251.
56. Lloyd and Thomas 1998.
57. Parliamentary Papers, 1866 *Report*, 332, VII, p. iv.

III

Contradicting tastes: public art, the mass and
the modern

Part III has been entitled 'Contradicting tastes' in order to indicate the increasingly fissiparous relationship between the national claims of the institutions discussed in Part I and the special interests or radical aspirations articulated by groups discussed in Part II. The aesthetic debates of the later nineteenth century were intertwined in shifting and often problematic ways with the social functions increasingly ascribed to art. The 'gospel of art' advocated by the reformers who set up the Whitechapel Art Gallery implied that art was not simply to be accessible to the nation's citizenry, or articulate its values, but that it should actively intervene within marginalized or victimized communities in order to help *constitute* such a national culture. Much the same can be said of the National Portrait Gallery, which – though a state institution like the RA – was bound up with the dynamics of a national culture stressing individual entrepreneurial activity and increasingly populist politics. Likewise the V&A had a specifically active role to play in transforming public taste and national manufactures. Each of these institutions is defined by its dynamic, interventionist character. Even the Tate, becoming an 'alternative' form of National Gallery, is constituted by the perceived neglect of modern British art at the NG. All of the institutions discussed in this section, then, see themselves as *modern*: intervening in a dynamic and unstable social realm in which taste, community and nation are all sites of struggle. The modernities sought by the Whitechapel, the NPG, the V&A and the Tate were all distinct and mutually contradictory. That the Whitechapel and the Tate were themselves later transformed into prime institutional proponents of Modernism is no coincidence, though the full institutional history of that transformation lies beyond the scope of this book. Instead we seek to map the contradicting processes at work in late-Victorian culture, and to identify the increasing complexity of inter-institutional connections and tensions as the nineteenth century moved towards its close.

The National Portrait Gallery and its constituencies, 1858–96

Lara Perry

Tucked in alongside the National Gallery in a modest but solid nineteenth-century building facing St Martin's Church, the National Portrait Gallery (NPG) enjoys a central position in London and in English national life.[1] But it was not always so: the NPG did not settle in St Martin's Place until some forty years after it was founded. The Gallery opened in a private home in Westminster (1858); then became one element in the grand exhibitionary enterprise which was South Kensington (1869); was subsequently spun off to the South Kensington satellite museum at Bethnal Green (1885); and finally moved to its permanent quarters on St Martin's Place in 1896. The dramatic changes to the Portrait Gallery's location and exhibiting practices during the course of the nineteenth century were responses to the fraught process of negotiating and establishing its cultural, as well as geographical, position. Its physical location was more than a metaphor for the Portrait Gallery's role in the governing cultures of London: its moves around the metropolis, and the debate that accompanied each move, reveal some of the changing assumptions about the NPG's intended audience, and about its intended functions within national life.

The National in the Portrait Gallery's name invites attention because it represents much more than its status as a state-funded institution: it represents the NPG's effort to define the nation itself. The Portrait Gallery's collection was initially conceived of as a repository of historical (rather than artistic) documents, and it was imagined that its collection of portraits would illustrate and delineate a history of the nation. Lord Palmerston, recommending the Portrait Gallery to the House of Commons, suggested that this was particularly suitable as a national project since a series of portraits would illustrate the distinctive continuity of English history: he pointed out that 'owing to our own happy exemption from intestine disturbances [i.e. revolution] … there existed [in England] a greater number of historical

portraits than any other nation of Europe would be found to possess'.[2] Representing national history through portraiture was also perceived as a gesture to 'national' taste and sensibilities: the English were understood by contemporaries to have a peculiar affinity for portraits because of their supposed preference for empirical exactness over what was constructed as a continental propensity for idealization or ornamentation.[3] Formed in relation to an assertion of Englishness, and against Frenchness, historical portraiture was seen to have national significance: the collection of the NPG was understood to literally embody a national history and ethos.

The national history and ethos that the NPG's collection embodied was not much contested during the nineteenth century. There seems to have been a general, if not absolute, consensus amongst those responsible for the collection (the vast majority of whom were well-educated aristocrats and politicians) about who deserved inclusion in this hall of national heroes and heroines.[4] If some of their choices now strike us as unexpected, the administrators of the Gallery were building the collection within the context of a historiographical literature which helped to define the set of people who figured in its national history: for instance, the remarkable choice of the now-forgotten Elizabeth Hamilton, Duchess of Grammont as the first female sitter in the collection can be explained with reference to her exemplary character as it was drawn in *The Memoirs of the Comte de Grammont*, a widely-read account of the court of Charles II written by one of its courtiers, the Countess's brother Anthony Hamilton. The NPG embodied a national history which was, by today's standards, limited, but which drew on a set of already accepted sources and conventions of historiographical representation that made its content as a national history relatively uncontested.

If the content of its representation of national history was rarely a matter for contest, the history of the Portrait Gallery's locations suggest that there was a great deal more conflict over defining the nation to which its collection would be accessible. The objective of the NPG was in part to preserve the nation's legacy of portraits; but education and instruction also featured significantly in its rationale.[5] Whom the NPG was intended to educate was never clearly expressed, but the instructive purposes of the NPG can be made more explicit by investigating the relationship constructed between the Gallery and its audience through location, architecture, and hang. Although there seems never to have been any question of the Portrait Gallery being located outside London (reflecting the Gallery's allegiance to the political tradition of London as the national capital), each of the four neighbourhoods which the Portrait Gallery occupied represented very different aspects of metropolitan life and culture. The history of its moves around London can be read as a history of changing and contested proposi-

tions about who would, and who should, have access to the objects housed in the Gallery and to the knowledge that those objects represented.

The founding of the NPG should be placed in the context of the debates around citizenship and suffrage which resulted in the suffrage reforms of 1832 and 1867.[6] Both of those reforms created new classes of citizen-voters to be incorporated into the governing cultures, and the early history of the Portrait Gallery can be understood as a response to a perceived need to educate these new classes of citizen-voters in national history. As the century wore on and the trajectory (if not the final outcome) of the suffrage reforms was resolved, another aspect of the collection became the focus for its presentation. Increasingly, the NPG sought to build a collection of peculiarly British artworks which would appeal to artists and aesthetes, who were themselves in the process of becoming a more defined professional group. It was an aesthetic, rather than political citizenry, which was being cultivated by the NPG when it moved into the building on St Martin's Place.

The links between political life and the NPG's functions were clearly evident in its first decade, when the collection was shown in a context which strongly suggested its connection to Parliament and what was still the relatively intimate world of national politics. The original site of the NPG was not intended for a public gallery, but was two floors of a residential house at 29 Great George Street in Westminster, initially let by the Office of the Works for the Gallery's offices and storage.

These functions were soon afterwards extended to include housing the Secretary and Keeper, George Scharf, and eventually to exhibiting the collection (Figure 9.1); the rooms were open to visitors who produced a ticket, which was available free from certain printsellers, during the afternoon daylight hours on three days of the week. The opening of the NPG in Great George Street was somewhat impromptu, but there were deep connections between the Gallery's first Westminster location, its 'public' and its intended function in national life.

A close neighbour to both Westminster Abbey and the new Palace of Westminster, together with these institutions the NPG celebrated the antiquity of English Government, Crown and Parliament. Although it had been recently rebuilt after fire, the Palace of Westminster had been designed to retain and evoke its historical past. A gallery of national portraits which *were* actual antiquities responded to the same impulse to valorise English Parliament as an ancient institution.[7] The 'national' of the Portrait Gallery was therefore physically and notionally linked to that of Parliament and Westminster: that 'national' was still the prerogative of a very select group, notably a select male group. Peopled mainly by the gentry, peers and their relations, the habitués of Westminster would have found the exhibitionary practices of the NPG (like those of the early National Gallery) familiar from their extra-

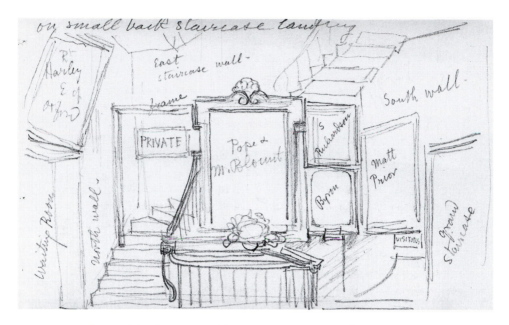

9.1 George Scharf Jun., pencil drawing of the small landing in the National Portrait Gallery's rooms at 29 Great George Street in 1866.

parliamentary social lives, in which visiting houses and looking at their portrait collections was an accepted form of tourism as well as social inter-course. (Think, for instance, of Elizabeth Bennett and her party touring the houses and portrait collections of Derbyshire in Jane Austen's *Pride and Prejudice*.) The national life invested in and represented by Westminster remained that of a relatively small but especially privileged group domi-nated by the gentry and aristocracy; the early Portrait Gallery catered to that constituency, and echoed the forms of their privileged lives.

Without underestimating the liberality of creating a public gallery in the middle of Westminster, the persistence of élite forms of exhibition at Great George Street is worth emphasizing because of how those forms were altered as the NPG moved within London, and its relation to its public changed. The location and limited opening hours of the Portrait Gallery when it exhibited at Great George Street meant that it catered primarily to a leisured class, making exceptions in order to accommodate visitors who were obliged to be at work during the week. Saturday, one of the three opening days and a customary half-holiday, was a day when the working classes might well have visited the Gallery; specific efforts were made to attract the attendance of the working classes by opening the Portrait Gallery specially over the whole of the three-day holiday at Easter. The limited opening hours were blamed by the Trustees

on the limits of the building, who insisted that 'the free admission of the public will be one of their first objects whenever an adequate Gallery can be provided by the Government', an assertion which was probably in part genuine and in part a strategic lobby for a new and larger gallery.[8]

In the second half of the century, the development of Whitehall as an imperial capital was squeezing the NPG out of Westminster when it urgently required new space to house a rapidly growing collection. During this time, the South Kensington estate of the 1851 Commissioners was under development, and the National Gallery and NPG were invited to participate in its great exhibitionary enterprise. The controversial proposal to relocate the National Gallery to the estate in south-west London was Prince Albert's, and objectors used a language saturated in class division when they complained not only of the removal of the National Gallery to what were then suburbs, but also to the perceived 'lowering' of the fine arts that would result from their association with the South Kensington Museum and Schools' collection of industrial design and manufacture.[9] The National Gallery successfully defended its position at Trafalgar Square, but while the Trustees of the Portrait Gallery made similar objections to the proposal to move it to South Kensington, the government insisted that it relocate to the estate. The government's distribution of these resources seems linked to the different social functions of the two national galleries, and the different audiences they were meant to address.

The Trustees' decision to move the NPG to South Kensington was taken, after several years of negotiation and delay, during the same period that the 1867 Reform Act was debated and ultimately passed. As a result of this reform, the electorate was nearly doubled, to include almost half of the adult male population including working men. The constituency of voters and those with concerns and interests in Westminster and its 'nation' therefore also nearly doubled, and perhaps more importantly, took on a new character: the parliamentary 'nation' was not defined by property, but by a form of patriarchal masculinity.[10] A whole new element of the (male) population was eligible for, indeed urgently required, instruction in the history, values and mores of formal (that is, parliamentary) national life, and South Kensington – a development which sought to provide rational recreation for the middle and working classes – appeared to be the place to do it.

The NPG was offered the ground and first floors of the south wing of the rather elegant Italianate quadrangle surrounding the gardens of the Royal Horticultural Society, the other wings being at the disposal of the South Kensington Museum.[11] Exhibiting in this more spacious and more popular location created an opportunity to address and educate a larger and broader audience, and the Portrait Gallery's exhibiting practices were changed to reflect its new relationship with the 'public'. Admissions hours and policies

were altered to be consistent with those of the South Kensington Museum, which nearly doubled the number of hours that the Portrait Gallery was open, and, in contrast to the jumbled arrangement of the collection at Great George Street, at South Kensington the portraits were arranged in an orderly, chronological hang. The chronological order of the portraits placed both the portraits and the viewer under a disciplinary régime: signs hung over the portraits marked out each of the different periods, and the visitors were directed through the gallery in historical sequence. The Portrait Gallery was constituted as a physical analogue of a chronological narrative of English history, an arrangement which more clearly and directly evoked the events of English history referred to by the portraits and sitters. The instructive aspects of the Portrait Gallery's collection were emphasized for the larger and broader audience who visited the South Kensington estate.

The generous opening hours and straightforward presentation of the collection at South Kensington exemplified the free access to the collection which had been a constant refrain in the expressed intentions of the NPG's administration. Although its collection and collecting principles were founded in élite property and practices, the presence of the working man – particularly the newly enfranchised working man (and unenfranchised working woman) – within its audience was accepted and indeed encouraged throughout the early history of the NPG. The collection's multiple purposes, and the various classes of its audience, peaceably co-existed until 1885 when, as the result of a fire in the South Kensington building, the NPG was ordered to move to the Bethnal Green Museum (now the Museum of Childhood) in London's East End (Figure 9.2). The move to this relatively isolated location represented a shift towards addressing a more specific audience; but it was seen as a shift in the wrong direction.

The Bethnal Green Museum was, like its contemporaries the Whitechapel and South London art galleries, a philanthropic institution.[12] The iron and glass 'Brompton Boiler' (a term of abuse for the cheap and temporary structures which originally housed the South Kensington Museum) was erected and opened as a branch of the South Kensington Museum on the Bethnal Green 'Poor's Land' in 1876, as a means of extending the benefits of the collections to the deprived inhabitants of the East End. The founding in the later nineteenth-century of philanthropic museums and galleries, which had exhibition practices and aims directed solely at the working classes, had the ironically excluding effect of dividing and specializing art education for specific populations. Locating the NPG in a primarily working-class neighbourhood, in an institution developed for a working-class audience, put it beyond the limits of the Portrait Gallery's 'public'.

Although educational and philanthropic aims were always notionally part of the Portrait Gallery's programme, the collection was seen to be wasted in

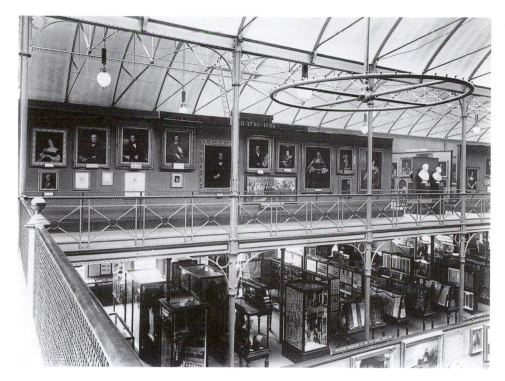

9.2 Anonymous, photograph of the National Portrait Gallery installed at the Bethnal Green Museum (1885–94).

Bethnal Green. There seems to have been little dispute over the usefulness of the Bethnal Green Museum itself, but the museum authorities expressed scepticism that the local population could benefit from the collection of the NPG. This was usually articulated as the Bethnal Greeners' inability to 'digest' works of art, which were too sophisticated for easy comprehension. In draft notes for a letter or speech, George Scharf, the Portrait Gallery's Director, used that metaphor explicitly: 'lighter and more varied food would probably suit the frequenters of galleries in outlying districts', he wrote, 'portraits are not in themselves popular and require a great amount of ready knowledge and previous study. They are solid and heavy of digestion.'[13] As the 'temporary' residence of the NPG at the Bethnal Green Museum extended to years, its Trustees began to agitate vociferously in press and Parliament for a new, permanent and centrally located gallery.

The protest against exhibiting the NPG at the Bethnal Green Museum forced a hitherto implicit premise about the Portrait Gallery's intended 'public' into the open. The public was not an undifferentiated body, but were divided into primary, secondary, and tertiary constituencies. The audience at Bethnal Green,

apparently a prime target for the political and visual education which the
NPG offered as a 'public' institution, was not its primary audience; it was all
very well to include the working classes, but not at the expense of the Gal-
lery's other constituencies, for whom the journey to Bethnal Green and its
rudimentary museum was inconvenient and uninviting.[14] Its final move in
1896 to its present, purpose-built gallery was (in this narrative) a resolution of
what had been vexing questions of who would be addressed, and how, by the
NPG. The location, architecture, and general presentation of the new gallery
allied it neither with parliamentary politics nor manufacturing education, but
with London's institutions of fine art practice and exhibition.

As it was reconceived between 1889 when the offer was made and 1896
when the new building opened, the NPG was designed to principally serve
a constituency of artists and connoisseurs. A philanthropist, W. H. Alexander,
a collector of Asian antiquities who was promptly offered a position on the
Gallery's Board, provided the funds for the new building. The primary
condition of his offer to build the Gallery was that the government provide
the site, which was to be located within a one-and-half-mile radius of St
James's Street (a geography which, not incidentally, had clubland as its
centre). This range was generous but its exclusions are significant: the South
Kensington Estate falls just on its perimeter, and its eastern limit falls roughly
at Blackfriars Bridge, excluding the City and anything further east. Barring
the possibility of Waterloo, the new NPG was as a matter of policy to be
situated within the genteel enterprises of the West End. The government
sealed the Portrait Gallery's fate as an élite exhibiting institution when it
offered the plot north and east of the National Gallery, and made it a neigh-
bour not only of the National Gallery, but also the Royal Academy, the Slade
School, and the art dealers and commercial galleries on New Bond Street.

How the NPG was going to relate, architecturally and programmatically,
to its neighbours was recognised as problematic. Ewan Christian, the archi-
tect commissioned by Alexander to design the new NPG, resolved the
architectural problem of its juxtaposition with the National Gallery by creat-
ing an elevation which effected a seamless transition from the neo-classical
National Gallery to a distinctive Florentine entrance to the NPG. The Por-
trait Gallery's Florentine frontage was and is more modern in feel than the
National's Gallery's stodgy row of columns; it still, however, represents a
decision to work within the artistically revered European traditions of archi-
tecture, rather than to affect a more recognizably indigenous style that would
have suited, for instance, while the Gallery was located in Westminster. But
the links that were formed between these neighbouring institutions existed
on more levels than architecture and geography.

The active Trustees of the later nineteenth-century Portrait Gallery were
frequently practising artists and their patrons, and the geographical location

and physical arrangement of the Gallery were importantly connected to their conception of how the Gallery should function. Their interest was in portraiture as a form of fine art, and their critical appreciation of portraiture was often undertaken and expressed in an aesthetic framework.[15] Art students, as well as the 'busy man' of the West End, were frequently cited at this point as important constituents for the Gallery to serve.[16] The Trustees' interest in portraiture as an art form was negotiated with the original and more functional view of the Portrait Gallery as a collection of historical documents; after some debate the Trustees rejected the Director's initial proposal that the Gallery should be arranged to show the 'best' portraits together, and determined that the hang should continue to be in a historically instructive, chronological order. This concession to its special educative purposes was one of just a few differences which distinguished the NPG from a more conventional art collection.

Back within the orbit of the students of the Royal Academy, the historians reading in the British Library, the Antiquaries and the visitors to the National Gallery, the NPG was again available to the constituency of visitors for whom it intended primarily to cater. At the end of the century the Portrait Gallery addressed itself firstly to a cultural/social/artistic class, rather than a group distinguished, as at Westminster and South Kensington, primarily by its relation to suffrage, or, as at Bethnal Green, an audience characterized (from the museum administrators' perspective) by their lack of formal education and capacity to appreciate the finer things. These shifts in the NPG's objects and addresses were contingent on events like suffrage reform or the development of London as an imperial capital, which were obviously linked to the question of 'nation' with which the Portrait Gallery was involved, but also with apparently peripheral kinds of historical change, such as the emergence of a specialist language with which to describe and assess works of art. Thus, as it ever was, the qualities which assemble to make a 'nation' are not obvious.

Nor are they stable. The two 'governing cultures' involved in the NPG – its administrators and the audience which it sought to inform – changed both in character and interests over the course of its nineteenth-century relocations. The changing constituencies of its audience confirms that the Portrait Gallery responded to changing notions of the 'nation' it was founded to develop. But if the NPG's notion of the nation was subject to change, it was subject to change only within limits. The 'governing culture' cultivated by the NPG was located firmly within the male middle classes, an audience which its location and buildings were ideally (if not always in practice) designed to attract. The collection of the NPG was always premised on the point that there was a historical national élite; its exhibition reinforced that point by orienting its address to a privileged constituency.

Notes

This essay is a shortened version of a chapter from my unpublished thesis, 'Facing Femininities: Women in the National Portrait Gallery 1856–1899' (DPhil, University of York, 1998), which interested readers may wish to consult for an expanded argument and detailed references. Most of the documentation for this essay is held by the National Portrait Gallery, London, and I am pleased to have an opportunity to thank the Gallery's staff for their helpful and interested assistance. I also gratefully acknowledge the financial support of The Social Sciences and Humanities Research Council of Canada, and the Association of Commonwealth Universities, during the completion of the research.

1. The 'national' represented by the National Portrait Gallery had pretensions to Britishness (it was referred to by the founding Trustee as 'the principal national collection' of the British Isles), but National Portrait Galleries were also founded in Scotland and Ireland in the nineteenth century, so the designation English is most appropriate. For a broad survey of the relationship between questions of nation and the founding and development of art galleries in London see, Taylor 1999; a brief passage on the NPG appears on pp. 92–9.

2. *Hansard*, 3rd series, V, 142, col. 1114.

3. Barlow 1994, pp. 517–45, deals in detail with the impulses behind the founding of the NPG. Bermingham 1994, pp. 77–101, also deals interestingly with the idealized/particular dichotomy in early nineteenth-century English aesthetics.

4. The Trustees of the NPG, numbering about a dozen at any time, were nominated by the Prime Minister and appointed by the Treasury. They seem to have had a sufficiently common culture to come to agreement on the contents of the collection; of the eighty-nine Trustees who were appointed during the nineteenth century, many carried titles and most were active politicians and/or historians. Some Trustees were appointed from the art world; their influence on the history of the Portrait Gallery is discussed below.

5. The concluding chapter of Pointon 1993 examines the founding of the NPG as the institutionali- zation of an eighteenth-century collecting culture, a move to save its treasures 'from the housekeeper's room'. It is clear from the speeches made in Parliament to promote the funding of the Portrait Gallery that it was also understood to have value as a means of public instruction and edification.

6. Standard histories of the Reform Acts can be consulted in Wetherell 1995, pp. 411–36, and Smith 1996.

7. See Port 1976; also Barlow 1994.

8. Second Annual Report of the Trustees, NPG, London.

9. A useful overview of government building during this period, including buildings for the national collections, is Port 1995. Pointon 1994 surveys the art galleries more specifically. The most pungent readings on the question of where the National Gallery would be located are the parliamentary papers: see for example Parliamentary Papers, 1857 *Report*, Session 2, vol. 24, 2261, and 1863 *Report*, vol. 26, 3205.

10. This argument has been made by Hall 1992 and 1994. See also McClelland 1996.

11. This building, now destroyed, is documented in the *Survey of London* 1975, vol. 38. George Scharf, the Portrait Gallery's Director, extensively sketched the interiors and arrangement of its rooms.

12. The early history of the Bethnal Green Museum is recounted in Robinson and Chessyre 1986, pp. 5–9. On the South London Gallery, see Waterfield 1994; and on the Whitechapel Gallery, Koven 1994.

13. George Scharf, undated notes following those dated 7 April 1889, bound in Vol. 3, Science and Art Department and Bethnal Green 1865–99, NPG, London. This volume also contains a report from the South Kensington Museum dated 30 August 1889 in which the author states that 'those who are best acquainted with the people' of Bethnal Green did not believe that they were 'elevated by the contemplation of these portraits'.

14. Henry James wrote in his diary of his journey to the Bethnal Green Museum that it was 'a long one, and leads you through an endless labyrinth of ever murkier and dingier alleyways and slums'. The distance of Bethnal Green from the centre of London, and its lack of amenities, was a constant subject of complaint in the protest against the Portrait Gallery's stay there.

15. The Chair of the Board of Trustees between 1876 and 1894 was the second Viscount Hardinge, a draughtsman and watercolourist who also sat on the Board of Trustees of the National Gallery. His colleagues included the Presidents of the Royal Academy Sir Frederic Leighton and Sir John Everett Millais, and Sir Coutts-Lindsay, the artist and founder of the Grosvenor Gallery. The language and values that they brought to the assessment of portraits for the Gallery was increasingly specialized in terms of aesthetic description, a trend which can be related to their status as arts professionals, and which parallels the history of art criticism traced by Prettejohn 1997.

16. In a letter to the Office of the Works dated 16 July 1885, Scharf suggested that the Portrait Gallery should be available to 'real art students', distinguishing them perhaps from mere spectators, or perhaps from the students from the South Kensington schools; Vol. I, Science and Art Department and Bethnal Green 1865–99, NPG, London. The phrase 'busy man' was used to describe the audience for the Portrait Gallery in 'The New National Portrait Gallery', *Illustrated London News*, 11 April 1896, 108:452.

Consuming empire?: the South Kensington Museum and its spectacles

Paul Barlow and Shelagh Wilson

We will begin with a vignette far removed from London, and from the urban industrial culture that engendered the South Kensington Museum – later renamed the Victoria and Albert Museum (V&A).[1] Some time in the early 1860s Josephine Bowes, Countess of Montalbo, with her husband John, decided to set up the 'Bowes Museum' in County Durham. Building a gigantic house on the model of a French chateau, they brought together a vast and disparate collection of bibelots, costume, art and curiosities. Among such items as a stuffed two-headed sheep and uneaten dried bread from the siege of Paris, are to be found cases full of china, an elaborate mechanical swan, and paintings by Goya, El Greco and other artists – both contemporary and historical. This grand edifice was located outside the small town of Barnard Castle, too far from the nearest manufacturing centre of Newcastle to be visited by those whose 'taste' might be improved by it.

Since its opening the Bowes Museum has been a problematic institution. Its location and architecture seem to imply lordly assertion. It incarnates conspicuous aristocractic display of cultural and financial prowess. As John Bowes had lost his claim to an Earldom because of his illegitimacy, and his wife was an ex-Variety actress whose own 'title' had been purchased for her, this need to declare so excessively their lordship over Barnard Castle is understandable, at least psychologically.[2] Josephine's extravagant, apparently chaotic, shopping for objects produces an image of *expenditure*, of profusion which both invokes and destabilizes the aristocratic identity she claims. However, the fact that the house was always intended to be a museum, not a residence, reconfigures her acts of purchase. As Sarah Kane explains in her definitive account of the Bowes' activities,

Destined for a public museum, Josephine's *object d'art* lost their status as bibelots and became instead specimens of material culture, examples of the industrial arts of past ages ... She is certain to have been aware of the debates surrounding the

formation of industrial arts museums … in England, where calls from as early as 1836 to make art available to manufacturing workers eventually resulted in 1857 in the opening of the South Kensington Museum. Indeed, there are parallels between Josephine's acquisition policy and that pursued by the South Kensington Museum, both general similarities in the range of purchases made and specific instances of identical purchases being made from the same source.[3]

The dual identity of the Bowes Museum: as an assertion of newly-minted 'tradition' (the Bowes' family seat) and as a design museum (justified by its function to improve taste, to codify designs, to educate manufacturers), is apparently aberrant. To perform the latter function it would have to be close to manufacturing, to urban-industrial activity. It would need to drop its aristocratic distance from such realms, its fantasy of purchasing-power existing independently from manufacture. And yet, as Kane indicates, the Bowes Museum in fact follows closely the purchasing practices of South Kensington, it mirrors its institutional identity.

In what follows we will attempt to examine some aspects of the complex, apparently contradictory, identity of the V&A, and explore the ways in which this identity overlaps with those of other contemporary institutions, most notably the British Museum and National Gallery. In doing so we hope to bring out some of the paradoxes implicit in the South Kensington project, paradoxes which slip into confusions in instances such as the Bowes Museum.

In many ways the V&A is the most thoroughly 'Victorian' of all the institutions covered in this book. It emerged from the debates of the 1830s and 1840s about the relationship between art and manufacture. It was, of course, financed from the profits of the Great Exhibition of 1851, the talismanic moment of High Capitalist display – the transformation of the methods and products of industry into objects of cultural contemplation. In this respect its status as a museum was always ambiguous. Emerging from the 1835 Select Committee of Arts and Manufactures, the Schools of Design and the Museum of Manufactures (the basis for what became the V&A) were specifically construed as government-sponsored agents for the improvement of manufactures in Britain, following increasing anxiety about the perceived superiority of French design. This utilitarian aspect of the museum sets it apart from those other galleries which sprang up at various points during the century. While performative rhetoric was certainly used elsewhere, this tended to take the form of claims that moral and aesthetic 'improvement' might be effected by the gallery. This internal transformation of visitors was by definition unprovable. The V&A, in contrast, was to provide definable improvements in manufactures which would measurably affect British economic performance. That this claim persisted is evidenced in texts such as Moncure Conway's *Travels in South Kensington*, published in 1882, in which Conway quotes French politicians, dismayed at the success of the V&A,

while deploying statistics to demonstrate the triumph of South Kensington as an agent of design education.

Empires of design

This notion that the V&A stood at the centre of a system of training, organized on Liberal-Utilitarian principles, in which art is evaluated in economistic terms may be set against that aspect of the museum, as it developed, which has something of the apparently profuse, unconstrained character of the Bowes Museum. Conway's 'travels' within the museum are described by him in euphoric terms. For Conway, the V&A is a site in which the accumulated cultural experience of the world is condensed. Far from being an institution with a delimited function which can be assessed and adjudged, Conway's museum is experienced by him as a storehouse of a vast array of objects which call forth an infinity of potential associations. Referring to a foreign visitor who had asked how a similar museum could be established in his own country, Conway's answer is that it will 'grow by itself' once the initial impetus is provided. The V&A has the capacity to generate its own voracious appetite for objects, an appetite which can always find room for more, as new wings are added, new aspects of the collection devised.

As Tim Barringer has argued, Conway experiences the museum as a condensed image of the British Empire, ever expanding, with efficiency and economic progress as its message.[4] This central logic allows the V&A to consume the world: to re-present it as spectacle and as potential commodity. Indeed, this oscillation between the V&A's functions as a museum, displaying objects as a means to communicate knowledge, and its purpose to 'improve taste' for commodities – to make objects desirable – is an ambivalence as important to the Victorian V&A is it is to the institution today. Thus Conway lists the gifts that have been made to the museum by various benefactors. The list is emphatically arbitrary: Elizabeth Ellison donated 'watercolour drawings'; Professor Ella, 'volumes of music'; Mrs Wollaston, 'drawings of mosaics'; Mr Davis 'a collection of coral'; Mr Barker, 'Venetian furniture of a boudoir'.[5]

The V&A's collection of paintings and prints is of particular note here. The 1857 Sheepshanks donation is the most important such bequest. This comprised works by recent British artists – Mulready, Danby, Leslie and others – and was envisaged as the nucleus for a national collection of British art, an idea revived later at the Tate Gallery. That Sheepshanks allied himself with the specifically 'modern' identity of the V&A rather than the values of the National Gallery is important. An earlier gift to the nation of modern British art had been given to the National Gallery, but had been consigned to its

'most unsatisfactory rooms'.[6] In this instance, then, the V&A reveals its potential to consume not merely objects, but the distinctive identities of other galleries and museums. That potential, at least as regards the National Gallery, is most evident in the V&A's possession of Raphael's 'Cartoons' from the Royal Collection. Technically these might be described as examples of design, as they were made to be translated into tapestries, but they epitomized High Art to artists working within the civic-humanist academic tradition. Frederic Leighton's continuing faith in this Raphaelesque aesthetic is evidenced in his two frescoes of the *Arts of Industry* (Figures 0.6, 0.7), which he painted for the V&A itself as an expression of its values.

The commercial-imperial identity which the V&A proclaims, then, extends to the régimes of display which operate in other cultural institutions. Indeed, this is one of the dominant characteristics of the institution, evidenced in the ways in which objects came to form part of its collection. For example, a portrait of Queen Elizabeth was offered to the V&A as an example of the history of costume, before going to the National Portrait Gallery.[7] Indeed in the mid-1860s three massive exhibitions narrating British history through portraits were held at the V&A, a far larger display than any mounted at the NPG itself. However, the institution which was most obviously threatened in this respect by the voracity of the V&A was the British Museum. Some time after the appropriation of the East India Company by the Crown, its collection of Indian artefacts was incorporated within South Kensington, though retaining a separate identity as the 'India collection'. Chinese and Japanese items were also collected. The V&A also acquired a large number of Western sculptures, including important Renaissance and medieval works, threatening the BM's status as guardian of the Classical Western tradition.

All these acquisitions may be said to *overwhelm* the cultural logic by which collections were separated. However, the V&A also generated the possibility of other kinds of collection, of which the most notable, if rarely discussed, are those which illustrated the use of natural materials, especially the Animal Products and Food collections. After the original 'Brompton Boilers' (the temporary buildings in which the V&A was first housed) were replaced, they were reconstructed in Bethnal Green, the working-class district in the East End of London, far from the West End location of the main museum. It was here that these collections were displayed from 1872, initially along with the Wallace Collection of paintings.[8] For some years the NPG was also housed in the same building, elevated above the animals on the first floor. It is important that these collections were held outside the V&A's main site, and that they were displayed in a manner which so clearly activated the cultural inheritance of hierarchies so characteristic of the academic codification of aesthetic experience. If Leighton's frescoes of the *Arts of Industry* indicated the continuing relevance of academic claims to universalizing civic

values expressed through history painting, the Food Museum recalls the rationale for placing still life in the lowest category among the genres of art, a point to which we will return.

This problem of cultural hierarchies is central to the mission of the V&A and to the examination of its apparently chaotic inclusiveness. We have described the multiple character of the museum as 'imperialist'. By this we do not simply mean that the V&A articulated or justified the activities and cultural hierarchies of the British Empire – for example in its Indian and Oriental displays – although attempts have been made to demonstrate that this is in fact the case. Thus Partha Mitter, writing in 1997, predictably states that, 'the India Collection of the V&A served as a perfect tool for construct- ing cultural difference and reinforcing racial hierarchy'.[9] Likewise, Tim Barringer argues that: 'The decorations [of the Oriental Courts] served to enhance the "otherness" of the objects by creating an oriental ambience and also demonstrated the ways in which Indian, Japanese and Islamic decora- tion could serve as source materials for contemporary British design.'[10]

The problem of the status of non-Classical cultural relics in national col- lections is certainly important. The British Museum was also engaging in debates about the expansion of the ethnographic and historical function of its collection. Even by 1857, Antonio Panizzi, the museum's influential li- brarian, was objecting to the presence of worthless curiosities: 'It does not seem right that such valuable space should be taken up by Esquimaux dresses, canoes and hideous feather idols, broken flints and so on.'[11] While Panizzi's contempt for such items is allied to assumptions that they are 'folk' objects, and their collection in the tradition of Cabinets of Curiosities, the status of the items included at the V&A was less easy to define.

Mitter, writing with Craig Clunas, discussing the 'Imperial collections' of the museum argues that cultural hierarchies worked to maintain the status of the West in relation to the East as: 'With nineteenth-century public muse- ums applying taxonomies of fine and applied arts to all artistic traditions, non-western sculpture and painting were classified as decorative arts, which further confirmed their ethnographic, rather than aesthetic, status.'[12]

There are several problems with this assertion. The role of decorative art within an hierarchy of the aesthetic by definition contradicts the claim that 'decorative' identity is 'ethnographic rather than aesthetic'. While Panizzi's 'broken flints' are clearly ethnographic, comparable items were not dis- played in the V&A.[13] Likewise, Mitter and Clunas fail to take into account the fact that the V&A *is* a museum of applied or decorative art, so that the Indian and East Asian artefacts within it are not in any simple sense subordi- nated to a higher 'Western' ideal of fine art, which the museum enshrines. To be sure, a conception of the transcendent worth of fine art is present in the museum, as we have indicated, but what characterizes the V&A is the circuit

of design, production and consumption which *subsumes* the very hierarchy to which Mitter and Clunas refer. For example, Raphael's 'Cartoons' were displayed alongside copies of his grotesques and lunettes in the Vatican Loggia. In other words, 'fine' art and decoration by the same artist/designer were placed together. Furthermore, the identity of the 'Cartoons' as authentic works by Raphael was undermined by the presence of the copies, which were given equal status in the display. Both the originals and the copies were *instances* of design, not objects of contemplation in and of themselves. This point also indicates the problem implicit in Barringer's statement. It is difficult to see how Oriental designs can be simultaneously portrayed as 'other' to the West *and* as models for 'contemporary British design'. What we would suggest is that there is a tension between the cultural hierarchies which the V&A inherits and its tendency to constitute a new form of museum, one which reorders such inherited rankings into a logic of display dictated by the values and requirements of commerce and education. In this respect, the very multiplicity of the V&A's displays, its embarrassment of riches, works against hierarchy, moving towards a different kind of spectacle, one which engenders a concern with the act of choice.

The choice to which we refer here is partly that of the consumer, presented with a mass of objects and styles in order that his or her taste be 'improved'. It is also, however, that of the designer, whose options are extended by the manifold examples displayed. This function of the collection was continually emphasized by Henry Cole, head of the Department of Practical Art and the museum's director. Cole attempted to justify expenditure on increasing varieties of designs and objects. This aspect of the collection was extended to the design of the building itself. Just as Raphael's originals were present in order to create the conditions for their being copied, so the many objects collected by the museum took their place in a building which was itself intended to exemplify the function and possibilities of design. Conway, again, exemplifies the claim to integrate cultural differences through the deployment of unifying principles. He describes the decorations designed by Owen Jones, author of the *Grammar of Ornament*, as a marvellous combination of cultural variety: 'Indian, Persian, moresque, and of the greatest beauty … each archway presenting a new design, and yet all in harmony.'[14]

We would argue, then, that Mitter and Clunas over-simplify the 'imperial' rationale of this collection. For them, the museum is to be understood in terms of *ideology*. It justifies the British Empire by reducing non-Western artefacts to curiosities, distinct from the higher principles embodied in fine art, a concept unique to the West and evidence of the superiority of its culture over those of other peoples. Other cultures are subordinated to a scientific/ethnographic gaze; Western culture is that gaze. In contrast, we would say that the imperial character of the museum is to be understood in

its internal dynamic, which generates an expanding and multiple body, not a closed system of meaning. This imperial dynamic may be characterized by its extension of the power to consume and generate consumption: of knowledge, objects and pleasures. True, the mechanisms of codification work to claim objective rational knowledge of objects and their identities, but this is also, here, in the service of rendering consumption more efficient, clarifying the conditions of choice. This is how the institutional logic of the V&A works against that of the British Museum, in which the concept of production plays no part, and that of consumption is played down. Of course, this is not to claim that the V&A is simply a department store of design ideas and commodities, though its institutional logic does engender comparable experiences, and, as Barringer has pointed out, we should not underestimate the historical connection between the rise of the department store and the establishment of museums of the industrial and decorative arts.[15]

However, as regards its representation of cultural difference, the V&A develops a distinctive character within the debates current during the mid-nineteenth century concerning the arrangement of collections. The idea that a museum should dramatize cultural differences and historical logics of artistic development was familiar by the mid-1850s. The influential German curator Gustav Waagen promoted such arrangements, describing in his writing the experience of a visit to the British Museum where he was confronted with a giant Egyptian fist, embodiment for him of the Egyptian power of Will: to dominate and form nature.[16] Waagen's view that historical relics incarnate stages of consciousness which the visitor relives in encounters within the museum, is echoed by some British commentators, though generally without his Hegelian slant. Ruskin argues that the peculiar moral and cultural character of nations is realized in their characteristic form of art, which fact the display of the National Gallery's collection should emphasize. As we have seen, the apparently chaotic character of the V&A is organized by an unresolved multiplicity of principles: cultural hierarchies, educative functions, ethnography, exemplary models, etc. These multiple functions and values overlay one another in ways which work to confuse clear ideological or practical logics to the display. This is what engenders Conway's belief that the experience of the V&A is analogous to travel and exploration, to the uncovering of a world of complex differences and connections. Conway, in fact, consistently describes his experience of objects from non-Western culture in such a way as to emphasize the connectedness generated by the museum. Thus, he writes of a large bronze depicting 'the beatified buddha', describing the 'majesty in the ideal represented'. He continues,

It is interesting to observe the strong impression made upon the casual visitor by this face so sweetly serene, so free from the lines which care and ambition trace upon the European face. I heard a little girl of thirteen years say, after her silent

gaze, 'how I would like to climb up and sit in his lap! Perhaps I would get some of his goodness.' How many little ones of the East have felt the same as they looked upon this face of perfect holiness.[17]

Here then, the Western and the Eastern children are linked by a common experience of innocence represented by the Buddha, while this image of 'perfect holiness' is set against the 'care and ambition' manifested in the 'European face'. Whether he is describing the European artistic tradition or actual faces remains ambiguous, but it is clear that Conway is drawing attention to an exchange between two traditions which the V&A makes possible, and which allows the values of the East to comment on those of the West. A similar connection is established when Conway discusses African artefacts. 'King Koffee's state chair' is of 'fine workmanship. It is rude in design, truly; but it is hardly ruder than the gold dove, the ampular which holds the oil used at English coronations.'[18]

Now, Conway is certainly an unusual witness here; an American anti-slavery campaigner, resident in London, biographer of Tom Paine and head of the rationalist South Place Ethical Society, he espoused a universal 'Religion of Humanity' expressed in his book *The Sacred Anthology*, a compendium of world spiritual wisdom. His objection to some aspects of British imperial policy is evidenced in his comments on exhibits at the V&A.[19] His ideas run counter to many of the V&A's own pronouncements about the racio-cultural character of peoples whose artefacts are present in the collection.[20] However, his fascination with the 'wonderful' accumulative and explanatory power of the museum is allied to an explicit faith in the transforming and modernizing potential of science, industry and Empire, the true principles of which the gallery makes manifest.[21]

Conway's belief that the V&A combines a spiritual message of global harmony with the specifically Western achievements of science draws attention to the fundamental problems with the collection that we have already indicated. Just as, for Conway, the cultural hierarchies of Empire are inverted by the spectacles it engenders, so those between fine and applied art are transformed by the internal logic of the collection and its development. As we have suggested, the high art represented by Leighton's imitations of Raphael is at once an ideal towards which all creativity aspires and a marginal decorative addition to the building.

Leighton's paintings also draw attention to the central difficulty with the logic of the V&A's collecting, its relation to manufacture. It is often argued that the original function of the institution, to illustrate principles and methods of design for industry, was compromised as it increasingly devoted its resources to collecting rather than the education of artisans. These paintings seem to symbolize this process. Set in Ancient Athens (*Industry Applied to Peace*) and Renaissance Florence (*Industry Applied to War*), they depict indi-

viduals examining, making or selling textiles, decorations and weaponry. Barringer argues that these images indicate a tension between Leighton's preoccupation with pictorial harmony and his fascination with the fetishistic glamour of commodities. In contrast, Colin Trodd, criticizing Barringer's use of Marx's theory of commodity fetishism, asserts that they depict 'magical kingdoms' in which commodities cannot be fetishized, but function to transcend social alienation through community.[22] This is analogous to Conway's vision of trans-cultural spiritual integration.

Barringer's deployment of the concept of commodity fetishism occurs in the context of his discussion of the ways in which Leighton's characters – described by him as 'self-absorbed' and 'narcissistic' – respond to the commodities depicted. These are all picturesque and archaic. The swords, breastplates and crossbows depicted as 'arts of industry applied to war' are, needless to say, of no obvious use to modern arms manufacturers. Of course, the V&A never claimed that its collection was allied to what we would now call industrial design, but this problem extends to the full range of the collection, in so far as it claims to function in alliance with manufacturing.

Here, then, we return to our main theme, the multiple character of the collection. We have suggested that the V&A was construed in various ways as a 'modern' institution. Its initial claim on a utilitarian and industrial rationale provided a model for its imperial invasion of the territory of less advanced art institutions, notably the National Gallery and British Museum: both still locked into 'disinterested' aristocratic forms of collecting. Indeed, Cole made a concerted attempt to seize part of the NG's holdings, using the V&A's possession of the Sheepshanks collection as a reason for bringing the National's own examples of recent British art to South Kensington. Sir Charles Eastlake, director of the NG, strongly resisted this raid on his territory.[23] Such a project allied the V&A's claim on modernity with national cultural production, not necessarily judged with reference to High Renaissance models, as at the NG. Those models themselves, including authentic works by Raphael and Michelangelo, were incorporated into the wider spectacle of design rather than isolated from it.

Yet Leighton's frescoes remind us of the role of this very Renaissance aesthetic in engendering 'magical kingdoms' which isolate design and its pleasures from production. This is the paradox of the V&A which we will now consider with reference to the use to which its collection was put.

Copying authenticity

We have suggested that the spectacle of the museum generates conditions for reversals of cultural hierarchy. We shall now return to the original

problems for which the institution was established: how to improve design and manufacture. As we have seen, the practice of *copying* was central to the V&A's institutional logic. Good models were to be reproduced. Design students learned by making detailed copy-drawings from objects. Likewise the Department of Practical Art had early on extended the collection by using modern technology to produce reproductions of 'masterpieces' for the collection. The provincial art schools were provided with prints and photographs of good examples from the gallery's growing holdings. Reproductions were displayed alongside originals. Casts were made of important objects – Trajan's column, samples of Indian architecture, Michelangelo's *Madonna and Child* from Notre Dame, Bruges.

This concern extended to the gallery's relationship with manufacturing. Some examples will illustrate this problem of the relation between production, design and display. The electrotyping process perfected and patented by Elkington's of Birmingham was frequently used to produce facsimilies of important objects for the museum's displays, such as the *Rosenborg Castle Lions* (1885). Elkington's quickly realized the value of producing designs which appealed to the then-prevailing tastes of Cole and his associates, developing pieces based on antique models, or in some cases directly copied by electrotyping. In addition to the museum purchasing their copies, they were rewarded for their faithful adherence to South Kensington when it paid £2000 for a silver and damascened iron parade-shield, depicting scenes from Milton's *Paradise Lost*, though quite how this imitation of the art of sixteenth-century Italian armourers would encourage modern manufacturing was not explained.

For Elkington's, this stamp of approval certainly boosted sales, enabling them to enlarge their factory from 400 workers in 1851 to 2000 by 1887. Thus the apparent irrelevance of a piece of High 'Leightonesque' design such as a parade-shield performed a clear commercial function. However, if the museum provided examples of 'high design' and then rewarded those manufacturers who based their products upon them, as with the purchases from the 1862 exhibition of work by approved Birmingham jewellers, surely it encouraged the divorce of design from innovation? Only decorative objects could successfully be based on obsolete artefacts such as armour. In wider terms this relationship between the museum and manufacturer can be seen as a self-perpetuating cycle of questionable value to the wider manufacturing economy.

Other examples illustrate the dangers inherent in advocating the value of the collection as a design source. Another favoured firm, with close connection to the V&A was Minton's ceramics. The museum had purchased 'exhibition' items such as Hamlet Bourne's copy of the Palissy ewer from the Soulanges purchases. After its very early days, the V&A scarcely bought examples of modern manufactures, only one-off pieces, made for museum

display, purchased as examples of skill, size and as rewards for the loyalty of the firms involved. Here the imperial logic of the V&A revealed its weaknesses. This process operates as a form of gift-exchange between the imperial centre and its client states, one which helps to sustain the system, but which encourages a form of institutional narcissism. This works to aestheticise production, to sustain the magical kingdom of taste constituted within the circuit of museum and manufacturer.

This process was not necessarily restricted to such examples of high design. Purchasing advisors were continuing to use the argument that intended acquisitions were being bought for 'the benefit of manufacturers' when other criteria can be suspected of having a higher priority. Thus, Cole and other officials made considerable efforts to purchase the collection of peasant jewellery put together by the Italian jeweller Castellani for the Paris Exhibition. Cole thinks 'the collection is beautiful and most instructive to manufacturers', and Owen Jones sees it 'as complete a collection of democratic jewellery [ever put together]'.[24] Such a collection will improve the design of 'jewellery for the people; popular jewellery'. Indeed, if the Government will not buy it, Cole will 'go down on my knees and beg Birmingham [the centre of cheap jewellery manufacture] to buy it. ... I cannot conceive of any collection whatever more useful to the trade of Birmingham.'[25]

Research into the Birmingham jewellery trade confirms the aesthetic gulf that separated the trade's own attempts at design reform, on what they sincerely believed was the approved model, from what, by Birmingham's standards of manufacture, was a collection of mostly oversized and badly made Italian peasant jewellery.[26] It is easier to believe that stung by criticisms of Britain's lack of popular traditions of jewellery-making and over impressed by Castellani, perhaps Europe's foremost jeweller, the curators felt highly pressurized to buy the collection.

If the Castellani collection was intended to improve 'jewellery for the people' it indicated that a model of popular culture (and of 'good' popular taste) existed which could not be reconciled with industrial manufacturing and marketing, but was bound up with the aesthetic category of the picturesque. However, the institutional circuit of gift-exchange was equally inapplicable, as these peasant bangles could not be transformed into exhibition pieces without being divorced from the claim that they provided a model for the design of low-priced adornments.

High- and low-class cultural institutions

This point brings us back to the cultural hierarchies with which we started and the problem of the *activity* of the museum in the community, the image

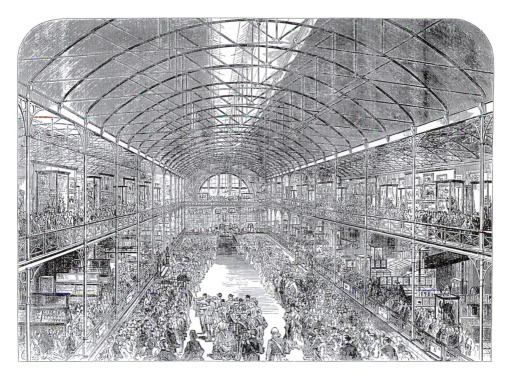

10.1 'The Opening of the Bethnal Green Museum', *Illustrated London News*, 10
December 1872

idealized in Leighton's frescoes. The V&A's offshoot, the Bethnal Green
Museum, which opened in 1872 (Figure 10.1), was intended to perform just
such an active role in the East End of London. As such it provides a model
for the examination of what we have called the 'narcissism' of the V&A's
relation to manufacturing.

Bethnal Green has sometimes been seen as an opportunity for the V&A to
'dump' its unwanted collections and concentrate on building the survey
museum of decorative arts at South Kensington. However, though opened
in the year of Cole's retirement, it recalls his earliest model for the institu-
tion, the exhibitions organized by the Mechanics Institutes during the 1830s
and 1840s. Toshio Kusamitsu has convincingly argued that these displays
led directly to the Great Exhibition, and hence to the V&A.[27] Like the V&A,
they offered a spectacular diversity of attractions. Thus an exhibition at
Newcastle included a 'splendid collection of paintings', 'a powerful oxy-
hydrogen microscope', a 'magnificent shield', 'specimens of natural history',
'a model of St Peter's at Rome', a 'Jacquard Loom at work', 'a beautiful
steam engine' and 'a circular canal on which steam boats occasionally ply'.[28]

This combination of marvels, natural and mechanical, allied popular enter-
tainment to local manufacture. While fine art and high design (a shield
again) are clearly present, they are not organised in any discernible hierar-
chy, indeed the emphasis is on technological spectacle. This complements
the aims of the Mechanics Institutes – 'the instruction of working men in the
arts they practise'.[29] In so far as the V&A sought to develop this model, it
was by connecting its schools of design with the collection. In the museum's
early years Cole had established 'circulation collections' to make available
exhibits to provincial towns, aiming to spread good examples of design
more widely. He dreamed of a system of branch museums, possibly self-
governing, which would receive regular loans from South Kensington,
particularly of items relevant to the local industries. Thus the Bethnal Green
Museum would mount exhibitions of leather goods and especially furniture,
being located close to East London's furniture trade in the Hackney Road.
This idea itself derived from the Mechanics Institutes. Their exhibitions had
sometimes concentrated on regional industry. At the 1840 Leeds show, 'the
staple manufacturing industries of Leeds ... exhibited their materials and
products [including] specimens of woollen manufacture at every stage, from
wool to the finished cloth'.[30]

This model is evident in the Animal Products and Food collection. This
had originated as 'class XVIII, animal manufactures', at the Great Exhibition.
It was then displayed at the Royal Society of Arts in 1855 whence it trans-
ferred to South Kensington (Figure 10.2). It possessed a mixture of oddity,
interest and, importantly, didactic labels and a catalogue. The collection was
close to the Leeds exhibition mentioned above, having displays of, for exam-
ple, stages of silk-making from the worms through to the finished article.
Later, examples of animal jewellery, such as earrings made from humming
birds, were included. Uniting science, art and manufacturing, this was very
close to the original mission of the V&A, but was by the 1870s an embarrass-
ment to many staff. Both Art historians and Naturalists declined the post of
curator, and it appears that Cole wrote the catalogue himself, suggesting his
own continued support for the project.

Such displays, despite their didactic function, were clearly related to tra-
ditions within popular culture: the exhibition of curiosities, an element that
was sometimes present in the Mechanics Institutes shows.[31] However, while
the earlier exhibitions offered a montage of attractions – science, technology,
art and nature – allied to manufacturing, Bethnal Green never effectively
conjoined its distinctive elements, which continued to function as distinct
pre-existing collections. Fragments of high art – the Wallace Collection, the
NPG – appeared and disappeared, as did the Pitt-Rivers collection of Afri-
can artefacts. The feeling that the Museum was indeed being used as a
depository, and its failure to fulfil its educational role, led to increasing

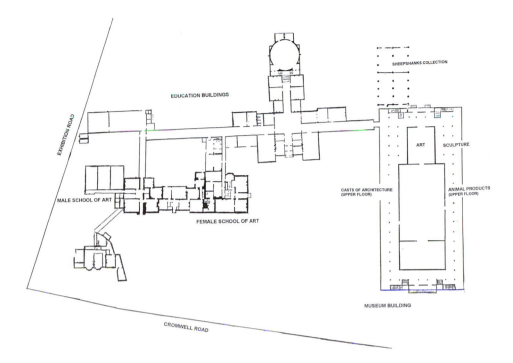

10.2 Plan of the South Kensington Museum in 1857

criticism, especially by members of the philanthropic art movement whose activities were centred on East London.[32] Interestingly, even when the Natural History and Science museums were established, the increasing specialization of science meant they did not want the Animal Products and Food collections, which remained at Bethnal Green.

Thus a traditional hierarchy of high and low culture was reproduced, Bethnal Green functioning as a storehouse of museological waste products – raw materials, grotesques, curiosities – while South Kensington displayed expensive and decorative objects. For reformers working in the East End, like Walter Besant and Samuel Barnett, a different form of institution would be required. The Empire of taste had failed as a model of the modern museum.

The V&A's claim on modernity was closely related to its imperial logic, as we have suggested. But like the Empire, it reproduced and intensified many of the hierarchies it sought to consume within itself. The utopian visions of Cole, Conway and Leighton all attest the museum's talismanic role as a project in which the circulation and dynamic of cultural activity could be figured and directed, but the magical kingdoms they each sought – of efficiency, globalism, beauty – condensed into a complex of competing projects in which an aggrandized aristocratic spectacle of consumption and expendi-

ture was supplemented by mysterious and alien fragments of other narratives, where bodily and productive process were exiled. In this, the V&A resembles closely the spectacle of profusion manifest in the Bowes Museum, and was as alien to industry as that other monument to pseudo-aristocratic narcissism where animal products and mechanical silver swans appeared in close proximity.

Notes

1. Following the museum's own practice, we will use the term 'V&A' to refer to the South Kensington Museum, though it was not named the Victoria and Albert Museum until 1899.
2. Kane 1996, pp. 89–92.
3. Kane 1996, p. 19.
4. Barringer 1997, p. 11.
5. Conway 1882, p. 83.
6. Hamlyn 1993, p. 10.
7. Letter in NPG archives: Portraits of Queen Elizabeth.
8. Mallett 1979, pp. 140–49.
9. Mitter 1997, p. 222.
10. Barringer 1997, p. 15.
11. Miller 1973, p. 192.
12. Mitter and Clunas 1997, p. 221.
13. Of course, their ethnographic identity is not *defined* by their non-Western origins, as collections of Curiosities are often European. The conflations here (decorative=ethnic='low'='other') are evasive when mapped on to a simple West/non-West opposition.
14. Conway 1882, p. 43.
15. Barringer 1999, pp. 138–9.
16. Waagen 1838, p. 123.
17. Conway 1882, p. 64.
18. Ibid., p. 72.
19. Conway says that artefacts appropriated after the Ashanti war of 1873–74 are 'unpleasantly suggestive of the worst phase of British policy, or impolicy' (ibid. p .72). See also Barringer 1997, pp. 21–2.
20. See Mitter and Clunas 1997, p. 231.
21. For Barringer, Conway epitomizes the 'imperial' gaze (Barringer 1997, p. 19).
22. Paper delivered at the Annual Conference of the Association of Art Historians, 1999. Parts of this argument are repeated in the introduction to the present volume.
23. Cooper, Ann (1993), 'For the Public Good: Henry Cole, his circle and the development of the South Kensington Estate' (unpublished PhD, Open University).
24. Parliamentary Papers, 1867 *Report*, no. 822.
25. Ibid., no. 820.
26. Wilson 1995.
27. Kusamitsu 1980, pp. 70–89.
28. Ibid., p. 78.
29. Ibid., p. 72.

30. Ibid., p. 79.
31. Ibid., p. 81.
32. See also Shelagh Wilson's essay on the Whitechapel Gallery (Chapter 11 in the present volume).

'The highest art for the lowest people': the Whitechapel and other philanthropic art galleries, 1877–1901

Shelagh Wilson

In this chapter the Whitechapel Art Gallery is the central focus of a wider study – that of the philanthropic galleries which emerged in the later nineteenth century. These institutions were created by individuals who felt that the major national galleries and their municipal counterparts had not succeeded in what they believed should be their prime objective: that of bringing art to all the people, including the very poor, women and children. The organizers were united by the project of social reform, though the object of such reform varied significantly. The exhibitions were only part of wider projects concerning education, housing, health and outdoor recreation. They capitalized on a number of factors coming together: the rising popularity of contemporary art, the development of socialist and welfarist ideas, and concerns about independent urban-popular cultures.

This essay will argue that the origins of the Whitechapel Gallery lay in anxieties concerning the increasingly important concept of 'culture', a term which was just beginning to develop its modern usage: the shared attitudes, interests and values of a social group. Stedman Jones has claimed that 'it was only at the beginning of the twentieth century – in London at least – that middle-class observers began to realize that the working class was not simply *without* culture or morality, but in fact possessed a culture of its own.'[1] Jones implies a sudden 'realization' on the part of these observers that such a thing as independent popular culture and ethics existed. In fact, this culture was itself a product of the late nineteenth century: the development of the music-hall, and later of cinema, the increasing importance of unions, and of the labour movement in general: all these worked to create the idea that a *distinctive* working-class socio-cultural consciousness existed.

However, for the leading figures in the philanthropic art movement the working man had no voice, he was seen as a void, living in the 'abyss': an empty vessel to be filled with either art and enlightenment or drink and

depravity. The founding figure of the movement, the Mancunian manufac-
turer T. C. Horsfall, openly appealed to fellow employers to donate money
to his gallery rather than pay higher wages: 'For we [the middle-class] alone
have learnt that money may have other powers than that of buying beer and
bread. Higher wages can only lead to greater debasement.'[2] William Rossiter,
another manufacturer, who founded the South London Gallery, and Rever-
end Samuel Barnett of Whitechapel (himself the son of a manufacturer) held
similar views. Rather than provide 'dole-outs' to his parishioners, Barnett
saw art exhibitions as an alternative to charity which he believed encour-
aged what would now be called a 'dependency culture'.

The characteristics of these philanthropic museums varied, but almost all
were financed from donations, rather than from national or local govern-
ment. Admission was free. They had extensive opening hours, typically
until 10 pm at night, and crucially were open on Sunday afternoons; they
offered cheap descriptive catalogues, and the collections had discursive la-
bels. Their founders all believed in 'education', but there their motives began
to diverge.

With their free art exhibitions in the late 1870s the Reverend Rogers and
Mark Judge were primarily concerned to promote Sunday opening. William
Rossiter held an exhibition of paintings in 1897 in his working men's library,
the success of which led to the creation of the South London Gallery.[3] Like-
wise, in 1877, Horsfall had formally proposed the creation of a gallery for
Manchester.[4] Both used Ruskin's gallery in Sheffield as their model, envisag-
ing educational collections of art, prints, specimens of natural history and
casts of sculpture. Samuel Barnett and his wife Harriet decided, after an
initial experiment when they too exhibited both objects and paintings, to
concentrate on showing contemporary art in the schoolrooms attached to St
Jude's Church, in Commercial Street, Whitechapel.[5] This seemed to be a
poor man's version of the fashionable Grosvenor Gallery that had opened in
1877. Although the Grosvenor's entrance fee excluded the masses, its tempo-
rary exhibitions provided a model, and many of the artists involved were to
become active in supporting philanthropic art exhibitions. Sir Coutts Lindsay,
its Director, was also to carry out one of the first experiments in Sunday
opening in the capital, doubtless influenced by the debates he experienced
as President of the Art Section of the 1877 Social Science Congress.

As the 'Art for the People' movement exhibitions were temporary, they can
only be recreated from contemporary recollections and archives. Undoubtedly
the most accessible and seductive account is Harriet Barnett's biography of
her husband, in which the Whitechapel project appears as the premier, inno-
vative gallery led as a form of godly mission by the saintly Samuel.[6] This
account overshadows and fails to acknowledge the writings of the other,
earlier pioneers of philanthropic art exhibitions, most notably Horsfall.

The idea of the beneficial effects of good art, design and architecture, was the moving force behind the earlier nineteenth-century movement for national museums. It was Henry Cole's main argument used to justify the Great Exhibition and the South Kensington Museum. While Cole linked those 'benefits' directly to the national economy and manufacturing industry, writers such as John Ruskin and Charles Kingsley added a moral dimension which extended the argument to wider concerns about cultural improvement. The need to *attract* workers to galleries to experience these benefits led to the emergence of thinking which stressed that such spaces should offer an enjoyable experience to visitors.

This shift in attitude is demonstrated in a speech Cole made on 'Art Culture' in support of a new gallery for Manchester in 1877:

A Museum of Art is absolutely necessary to the student, if he is to be well trained and educated; but it is most important to the public. The grown public are not children to go to a School of Art, but will flock to Museums, especially after church on Sundays, if they are made comfortable, well ventilated, and warmed, well located, and with a little music in the evening occasionally; and thus they will be taught in a way that no other process of education will do. And then there is the great advantage of such training of taste in a commercial point of view; you create consumers for your art products, and the work, whilst proving beneficial not only to students of art, will wean millions from the devil's temptations in the beershops.[7]

Although the educational role of museums is stressed there is an acknowledgement of their new role as sites for leisure and recreation. The concept of 'culture' – as evidenced in the title of the talk – is used to suggest the totality of the visitor's experience based on their own interests and preoccupations. This is a significant shift from earlier talk of improving 'taste'.

The interest in art as a means to transform working-class culture had been growing since the 1860s. The 1867 Reform Bill and 1870 Education Act had brought home to an increasing number of people that a 'culture' needed to be shared between the middle and lower classes if the fragmentation of society was not to result. For reformers the enabling legislation for museums was far too slow. Few municipal art galleries were even in the planning stages by 1880, and in London the organization of local government made the adoption of the Museums Act almost impossible in most parishes.

In 1877 Horsfall launched the movement with a letter to the *Manchester Guardian*: 'I may be asked why are we to do this work which it might seem is chiefly work that should be done for the city by itself – by its governing body. The answer is – we must do it, because we are willing to do it and can do it.'[8] Horsfall's words were a battle-cry for the many philanthropists who participated, gave money or lent pictures. By the mid-1880s there was a positive rage amongst middle-class do-gooders for 'slumming' in the poorest parts of the city. The East End became a particular focus of attention after

the publication of a series of salacious and gripping accounts of its degrada-
tion, such as Mearns's *The Bitter Cry of Outcast London*, as well as the real-life
Whitechapel murders of 'Jack the Ripper'.[9] Middle-class commentators, like
explorers discovering primitive tribes, observed the levels of depravation
existing in large areas of their cities. The ambiguous Victorian attitudes to
charity and the ever-present fears of assisting the 'undeserving poor' made
the idea of the gift of 'cultural' improvement particularly attractive.

After years spent in one of the poorest slums, Barnett explained to his
bishop that preaching alone would not

hasten that knowledge of God to which we clergy have devoted our lives … I am
equally certain that the sight of pictures, helped by the descriptions of those who try
to interpret the artist, does touch the memories and awaken the hopes of the people
… give me time, by means of pictures and of worship, to bring the people to God.[10]

The Barnetts developed a range of activities to involve the poor of their
parish and to bring them into contact with a wider 'improving' culture.
Whitechapel people were taken to middle-class homes, the countryside, gal-
leries and to artists' houses. Regular lectures and concerts were held. As well
as the annual fine art exhibition this project would eventually result in the
formation of the first 'settlement movement' at Toynbee Hall, whose influ-
ence would reverberate worldwide.

Horsfall, speaking at the Art Section of the National Association for the
Promotion of the Social Sciences, outlined the ideology behind his proposed
museum in Manchester consistently from 1877:

A considerable measure of success in spreading knowledge and love of beauty may,
I believe, be attained by means of a sensibly managed art gallery; and it is certain
that if art Galleries can be made to spread amongst workpeople love of beauty,
which includes hatred of ugliness, art galleries will be effective … I think all such
galleries should be, in a district filled with workpeople's houses. As we intend that
the museum shall contain only things which must make those who study them
'think nobly' both of the world and its Maker, and of that wonderful human nature
whose powers are revealed by art, we feel that no sensible person can object to its
being open on Sunday afternoons and evenings, as well as on the evenings of all
work days.[11]

Arguments as to just what would spread this 'knowledge and love of beauty',
varied quite considerably. Those who believed, like Leighton that beauty
should be the prime value disagreed strongly with Horsfall's decision at
Manchester to exclude the nude. The congress Art section included music in
its discussions and, although not discussed here, free concerts played an
important part in the mission of all of these reformers.

Walter Besant gave a paper in 1884, the year his major project, the People's
Palace, was founded. In *How can a Love and Appreciation of Art be best devel-
oped among the Masses of the People?* he indicated what the reformers found

unsatisfactory about existing museum provision. The Bethnal Green Museum, an East End offshoot of the V&A, was criticized as 'a complete and ignominious failure … It is, in fact, a dumb and silent gallery.'[12] Despite huge numbers of visitors, Bethnal Green failed for Besant because it refused to provide captions to interpret exhibits for its audience. In the Art section papers and addresses by the leading artists of the day, especially those involved in the philanthropic galleries, were a regular feature. Key influences and contributors included Leighton, Watts, Herkomer and, as one might expect, the group of artists connected to the Arts and Crafts movement who shared the ideas of Ruskin: William Morris, Burne-Jones, and many from the second generation such as Walter Crane. These artists also provided practical and moral assistance: they donated money; lent and gave pictures; wrote supporting letters; were available for openings; provided materials for the exhibitions and organized displays. The St Jude's Schoolrooms were furnished with Morris and Co. fabrics; the same firm furnished an entire room at the Ancoats Museum for Horsfall.

Without this shared belief in the value of provision of 'Art for the People' philanthropic art galleries could not have succeeded. The roots of that success lay partly in the readiness of artists such as Leighton and Watts to open up their houses in Kensington to groups of visitors. Both Harriet Barnett and Mrs Rossiter had, in the 1870s, started to organize day visits for groups of East and South Londoners respectively. The countryside and galleries were favourite destinations. In her description of the origins of the Whitechapel shows, Harriet Barnett records the words of her East End charges about gallery visits:

'Well, I should not have believed I could have enjoyed myself so much, and yet been so quiet,' describes a lesson learnt from an hour spent in Mr. Watts's Gallery … I was asked, 'Where now can we see such things often?' while further talk on the picture elicited from another of the same group, 'But that's more the philosophy of pictures; one wants to see a great many to learn how to see them so.'[13]

Frederic Leighton, a respected artist and President of the Royal Academy, used his influence and diplomatic skills to good effect on the Committee of the South London Art Gallery which he 'helped to pilot … from the somewhat exacting proprietorship of its founder towards its ultimate position as a public institution'.[14] His relationship with Whitechapel seems to have been less involved, but he gave regular admission to his house, though not his studio, taking great care always to be absent, and lent pictures here as elsewhere on such a regular basis he could not keep track. As he wrote in 1889, 'You can have what you like for the Whitechapel people, only I must ask you to fix what they have *not* had there. I lend so often, and everywhere that I don't know where things have been.' This indicates the extent to which loan exhibitions were becoming widespread.[15]

G. F. Watts was a particular friend of the Barnetts, who sent pictures almost every year. Samuel Barnett acknowledged Watts's support: 'It was Mr. G. F. Watts who more than any other artist encouraged us. He lent many of his pictures and by his own faith made faith.'[16] Watts was the artist associated more than any other with the Whitechapel art shows, not only because of the quantity of his lending but also because of the spiritual qualities of his work, celebrated by *Punch* in 1897,

> Pictures as good as sermons? Aye, much
> Better than some poor ones.
> Where Whitechapel's darkness the weary
> Eyes of the dreary workers dims,
> It may be found that Watts's pictures do
> Better than Watts's hymns.[17]

The reasons that the Whitechapel Art Exhibitions gained such prominence, eventually eclipsing much larger events such as the Picture Exhibitions at the People's Palace, must be largely credited to the extraordinary organizational and promotional ability of the Barnetts. Harriet and Samuel were a formidable team, able to attract support from all classes, politicians, the Church, educational institutions and the artistic community, for all their projects.

From its beginning in 1881 the Annual Art Loan Exhibition, became the highlight of the Whitechapel year. In addition to the philanthropic motivation it is obvious that the Barnetts and their 'gang' of helpers enormously enjoyed the exhibition, the art and the attention. Furthermore, considerable publicity for all their other projects was generated. The events of the 1880s made Whitechapel a particular focus of attention, and by 1892 the Fine Art Exhibition was part of the tourist experience described in Baedeker as:

a loan exhibition of pictures, est. by Mr and Mrs Barnett, is held for a fortnight or three weeks every Easter (10–10) free in the schoolrooms adjoining St. Jude's. It generally contains some of the best works of modern English artists, and now ranks among the artistic 'events' of the year.[18]

Harriet's lively article 'Pictures for the People' of 1883, though very informative, must be regarded primarily as a promotional exercise aimed at the middle- and upper-class audience whose assistance in lending pictures and providing financial and moral support was vital. The repeated use of quotations can be seen as a deliberate attempt to engage in one of the Barnetts' principal concerns – bringing the classes into contact with each other. The responses of the ignorant poor are recounted as amusing anecdotes. Harriet stresses their wide-eyed enthusiasm at being allowed to share such treasures. This not only attracted loans and donations but also groups of middle-class volunteers for the hanging, decoration, advertising and finance committees. Once Toynbee

Hall was in existence, from the 1885 exhibition onwards, the residents as part of their service to the community undertook some of this work.[19]

This efficient though informal organization was reorganized and formalized in the late 1890s as the permanent Art Gallery was developed. In 1898 a formal committee of trustees was appointed when the Whitechapel Art Gallery was set up as an independent unendowed charity, though in practice many old activists remained. The original Charity Commission document listed nine organizations responsible for appointing thirteen trustees who then co-opted a further four members.[20] The administration reflected its origins as an independent Gallery with strong links to Toynbee Hall but it is noticeable that the balance is largely in favour of educational interests. The minor role allotted to the local authority is most marked and even though the two Library seats went to representatives from Stepney Borough Council from 1904 this can hardly justify Brandon Taylor's claim that the Gallery was finally 'subsumed by the London Borough of Stepney'.[21] The main change in 1901 was the appointment of the first Curator, Charles Aitken, who was gradually to change the nature of the exhibitions. The most noticeable difference was the switch from contemporary art to mainly retrospectives, commemorating historical periods or rural traditions. This can be seen as a retreat from the modern to the celebration of 'Englishness' and 'heritage' which makes the Whitechapel, prior to its post-war reinvention, the very opposite of the bastion of modernism Taylor claims it to be.

Another change was the professionalization of the gallery, which can be clearly seen in the catalogues, where Aitken's scholarship replaced the amateurish charm of their earlier style. The large committees no longer had an active role in the organization but were reduced to fund-raising and donations. In this sense at least the 'experiment' of involving the middle class directly in the improvement of the poor was over. Also, formal education was increasingly replacing the myriad of classes that independently – through the Workers Education Association, Toynbee Hall and others – had brought many of the 'helpers' in the Exhibition to the East End in the first place. The artist William Rothenstein, as a young man, taught drawing and modelling one evening a week in a boys' club. He recalled his experience as a volunteer warden for the art exhibitions:

To become a worker in Whitechapel seemed an adventure; the East End was a part of London remote and of ill repute, which needed 'missionaries' it appeared, and it flattered my self-esteem to be one of these These activities were rather worrying to my parents; it was the time of the murders by Jack the Ripper, and Whitechapel had a sinister sound to provincial ears. As a matter of fact, I came into touch this way with many fine and enlightened people.[22]

It was the educational and other philanthropic activities that the Barnetts set up in the 1870s that produced this pool of middle-class instructors. Kenneth

Grahame was a clerk at the nearby Bank of England when he volunteered as the Financial Secretary for the Exhibitions in 1881. In the 1870s Mary Fraser Tytler was a rich philanthropist teaching art in Whitechapel. She later advised Watts on supporting the gallery, and in 1886 married him – art and social reform being directly united.

It was through volunteering to assist in Octavia Hill's philanthropic housing schemes, themselves inspired by Ruskin, that Harriet had first met Samuel Barnett. Harriet Barnett, threw herself enthusiastically into the expected philanthropic role of Vicar's wife, setting up the Children's Country Holiday Scheme (1877) and the Pupil Teachers Organisation. Her skill in establishing organizations for philanthropy was formalized in the creation of the National Association of Women Workers in 1895. This was in addition to the large amount of direct work in poor relief that the Barnetts both wrote about in *Practicable Socialism*. All of their work was part of 'passionless preaching'. By the 1880s they had gained confidence, and great organizational expertise in developing systems of networks of self-improvement groups led by middle-class facilitators. In Samuel Barnett's mission of 'nationalising luxury' the rich should be directly involved in the lives of the poor, not just passive donors of money; 'things should be done with the people rather than for them'.[23]

However, there is little sense that the poor were involved, except as the passive audience who were to be 'spoken to' by previously 'dumb' paintings, with assistance in interpretation from well-educated middle-class helpers. Many of the helpers were there in roles of policing and fire protection.

[People] crowded and lingered round the pictures with a story ... the floors were weak – and therefore only one popular canvas could be placed on each wall – the means of egress and exit were small, visitors sometimes drunken, and panic easily aroused in crowds. [There were] eighteen or twenty gentlemen who came down daily to watch for four hours in the rooms; where their presence not only served to prevent unseemly conduct, but their descriptions of pictures and homely chats with the people made often all the difference between an intelligent visit and a listless ten minutes stare.[24]

In addition to the precautions taken once the people were in the small schoolrooms some of the committee acted as 'chuckers-in',[25] as the entrance was not on the main street but down a narrow, dingy passageway and 'people came in such numbers that, at intervals, the iron gate at the end of the street passage had to be closed, to enable some of the crowd to leave the building before others were admitted'.[26] Such was the attraction of modern British art in the 1880s!

Evidently the paintings shown at Whitechapel were popular, but what were they? The pictures were mostly modern, painted by living British

artists. They included narrative, allegorical (which after Watts, the Barnetts called 'symbolical'), landscape, and genre painting. The most favoured artists were Watts, Herkomer, Rossetti, Hunt, Millais, Leighton and Israel. Some French art was included: Millet's *Angelus*, almost certainly a copy or print, for its talismanic status as a popular religious image. Occasionally a single major lender could alter the balance, such as Alexander Young's large loan of Corots and Hague School works in 1893, which gave the exhibition a distinct continental bias. There were occasional loans of older pictures, more so as time went on. The pictures would be arranged mostly at eye-level, fixed on to a structure of wooden battens that had been nailed over the hessian wallcovering. A low wooden barrier prevented too close inspection, as is seen separating the over-enthusiastic couple from interfering too closely with the painted wedding in the *Pall Mall Gazette*'s 1886 illustration of 'The Symbol' (see Figure 0.1).

Whilst the people were physically kept at a distance, the distinctive feature of the philanthropic gallery, as referred to in the debates at the Congresses was the interpretation provided. In addition to the explanations from the 'watchers', regular guided tours would move from room to room drawing the lessons from paintings. Each painting was captioned and, most importantly, after 1882 there was a catalogue. Catalogues and interpretation of paintings for the working man were not a new feature, examples can be found for the 1857 Manchester Art Treasures Exhibition and many others, but were often little more than lists. The awareness of increased literacy following the 1870 Education Act made catalogues more important and the Barnetts were always keen to stress the high sales of their catalogues. The *Pall Mall Gazette* praised the benefits of the 'intelligible accounts of what each picture means', citing the 'sharp lad – who has stolen half an hour in the morning to go round with his catalogue – bringing his father and mother with him in the evening and showing them the points in his favourite pictures'.[27] Examination of the actual catalogues reveals these accounts to be somewhat exaggerated. Only the minority of pictures had captions and many of those were a fanciful quotation or a straightforward explanation of a classical or literary subject.[28] The example of the Young loan is atypical in that the captions emphasize 'aesthetic' values, of light and colour. The instructive homilies which were supposed to assist understanding were few, and far more limited in content than other contemporary 'popular' catalogues.[29]

East-Enders obviously preferred the narrative painting, particularly those with a bit of action. Barnett wanted to bring them by degrees to works such as the 'symbolical' paintings by Watts. The Barnetts also found the lack of interest in landscape worrying. Their middle-class vision of the rural idyll was perhaps at odds with those who came from the country to escape the

appallingly low wages or the dangers and precarious living to be made on the river.

Watts's support and friendship were valued, as were his many loans of portraits and pictures to St Jude's. His symbolical paintings, particularly those from the 'Cycle of Death' series, were felt to be the ideal pictures for 'raising the people to higher thoughts' and provided the best 'silent sermons'. It was to these that Canon Barnett applied his time and energy during the exhibitions as he considered them to be the most rewarding in spiritual terms. Watts's *Time, Death and Judgement* was the picture most exhibited, discussed and admired by the Barnetts and their friends, who chose it to be reproduced as a huge mosaic on the outside of St Jude's, presented by supporters to the Barnetts in 1885 (Figure 11.1). The significance of this mosaic was threefold: as a representation of the religious purpose behind the picture gallery project; as an expression of beauty, the contemplation of which would elevate the spirits; and as an instance of a novel development in public use of art. In this last respect the painting was an early example of the provision of art as an attempt to improve an economically depressed area, a development characteristic of the twentieth century. Its position above the fountain neatly ties this in with public health concerns of the time.

Barnett thought that the sight of this picture, in conjunction with his interpretation, 'does touch the memories and awaken the hopes of the people. Never in my intercourse with my neighbours have I been so conscious of their souls and their souls' needs as when they hung around me listening to what I had to say of Watts's picture, *Time, Death and Judgement*.'[30] The label provided for the painting seems rather prescriptive:

Time is represented as a strong man ever looking on to the future; Death as a sad mother. Time and Death walk hand in hand. Both are overtaken by Judgement, whose scale weighs deserts and whose whip of fire burns out wrong. The Lord is a God of Judgement. Blessed are all they that wait for him.[31]

Perplexed parishioners led Harriet to believe that 'it was not successfully described'. It and Richmond's equally symbolic *Sleep and Death* were singled out as the type of picture most in need of 'all the help that was possible from explanation'.[32]

However, Samuel Barnett's faith in *Time, Death and Judgement* was clear: 'In days to come, the picture will teach to many wayfarers; a lesson the world sadly wants.' By this picture it may be seen that 'the past and the future will predominate over the present'. The recognition of such predominance, we are told, will of itself 'advance men in the dignity of thinking beings; but here the past will be one of the thoughtful kindness which saw the equality of rich and poor, and here the future will be one when judgement will be done on the prince of this world.'[33]

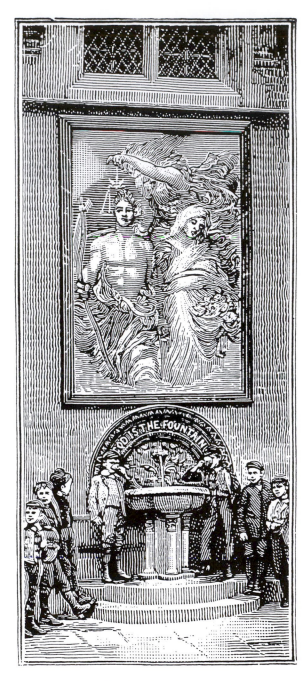

11.1 The exterior of St Jude's Church, Whitechapel, showing the mosaic of *Time, Death and Judgement* and the public fountain

Unfortunately the people continued to prefer narrative pictures which they consistently voted as their favourite of the year. In 1897, a year of a huge Watts's loan, Barnett had to admit 'Watts is above the people – ... [he] makes a demand on thought which people are too tired or too busy to give.'[34] However he, Harriet and their special friends remained convinced of his genius. *Time, Death and Judgement* and other symbolical paintings which Watts presented to the nation are now unavailable, languishing in a Tate Gallery store in Southwark, a sign of just how these values are no longer admired in art. The important mural by Walter Crane was to have extended this mission on the front of the new Whitechapel Art Gallery, but perhaps an indication of impending change in taste was that no money could be found for its execution.

The growing success of the annual shows convinced Samuel Barnett that a more permanent and suitable home was needed and for years he attempted, ultimately unsuccessfully to gain municipal support for an art gallery. The organization of local government in London, with its system of small parishes arranged into vestries, hindered the development of municipal galleries. Whitechapel was one of the smallest and poorest parishes, so Barnett appealed for public donations. Eventually Passmore Edwards was persuaded to become the major benefactor of the Whitechapel Art Gallery.

The architect C. H. Townsend exhibited his remarkable drawing for the proposed building at the Royal Academy in 1896. Townsend's first plan could at a glance be taken for a variation on a Romanesque church, which given Barnett's belief in art as sermons seems entirely appropriate, but by 1899 the resubmitted plans for the new site with a much smaller frontage were almost completely revised. Nevertheless, within his massively reduced brief Townsend still managed to produce the striking hooded entrance which, with its determinedly asymmetrical placing within an otherwise symmetrical frontage, creates a sense of identity for the gallery and, most importantly, a sense of embrace, physically enticing people in from the streets in much the same way that the 'chuckers-in' did in the St Jude's days. The doorway opening straight on to the street, is in marked contrast to the set-back classical entrance with flights of steps that was the model from national and municipal galleries. Inside, the main exhibition room looks forward to the twentieth century; the plain top-lit space, although originally panelled with hessian to picture-rail height, has none of the deep red, or green splendour which typified Victorian galleries. The flexible layout was well suited to accommodate changes in exhibition practice, a necessity if the gallery was to survive the changing cultural climate of the new century.

By 1900 many more towns and some London boroughs had or were establishing museums and art galleries. The lessons taught by the philanthropic museums – accessibility, education and interpretation – were widely adopted

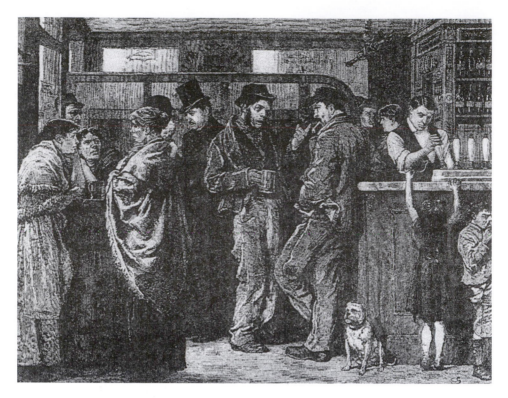

11.2 'Sunday Afternoon in a Gin Palace, Drawn from Life', *The Graphic*, 8 February 1879

(Figures 11.2 and 11.3). The wider network of social action of which the gallery formed a part was also influential, as it involved a systematic attempt to overcome the fragmentation of cultural experience in the city, but – because of the alien mental worlds it forced into conjunction – emphasized the need for an analysis of 'culture' as a form of social identity, rather than 'taste' as an accomplishment to be acquired. The Barnetts sought to use popular narrative painting to elevate the minds of working-class parishioners in a manner that would inculcate moral self-examination and thus self-reliance. However, the attraction of narrative pictures never led towards widespread appreciation of the 'elevated' Watts or the 'pure' Corot. Instead it was the new cinema industry that capitalized on the conventions of Victorian narrative painting to help develop an independent commercial-popular culture which triumphed over the paternalistic rhetoric of improvement by middle-class example to which Horsfall and the Barnetts devoted themselves. When the first cinema opened near Horsfall's gallery, attendance at the exhibitions dropped away. Hollywood, rather than the ale-house was to be its real rival.

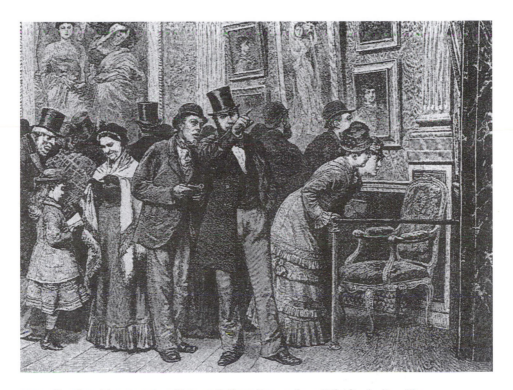

11.3 'Sunday Afternoon in a Picture Gallery, Drawn from Life' [including *Time, Death and Judgement*], *The Graphic*, 8 February 1879

Notes

The title of this chapter derives from Harriet Barnett's reference to 'Mr. Barnett's unquenchable certainty that even the lowest people could appreciate the highest art' (Barnett 1918, p. 161).

1. Jones 1974, p. 463.

2. Horsfall 1877, p. 8.

3. See Rossiter 1899; and Waterfield 1994. Rossiter's lectures are recorded in *Weekly Notes* 1891–92.

4. See Harrison 1985.

5. See Borzello 1987 and Koven 1994.

6. Barnett 1883 and 1918.

7. Cole 1878, p. 48.

8. Horsfall 1877, p. 7.

9. Mearns 1883. This and other fictional and factual texts are discussed in Keating 1973.

10. Letter from S. Barnett, to Bishop of London in defence of Sunday opening, April 1882 (quoted in Barnett 1918, pp. 152–3).

11. Horsfall 1882, p. 585.

12. Besant 1884, p. 726.

13. Barnett 1883, p. 344; reprinted in Barnett and Barnett 1888.

14. Walter Crane, quoted in Barrington 1906, vol.2, p. 8; cited in Ormond, Leonée, *A Leighton Memorial*, pp. 19–29 in Waterfield 1994.

15. Letter dated 19 March 1889; this and other comments in Barrington 1903, p. 17.

16. Barnett 1918.

17. *Punch*, 24 April 1897.

18. Baedeker 1892, p. 109.

19. Toynbee Hall reports, n.d., London Metropolitan Archives.

20. Information provided by Janeen Haythornwaite, Whitechapel Art Gallery Archivist.

21. Taylor 1999.

22. Borzello 1987, p. 56.

23. Barnett, S., 'Sensationalism in Social Reform', in Barnett and Barnett 1888, p. 181.

24. Barnett, 1883, p. 110.

25. The *Municipal Journal*, 8 March 1901; quoted in Borzello 1987, p. 51.

26. Barnett 1918, p. 156.

27. *Pall Mall Gazette*, 28 April 1886, p. 2.

28. Whitechapel Fine Art Loan Exhibition catalogues, 1882–96.

29. Such as *What to See* 1878, and Halkett 1878.

30. Letter from S. Barnett, quoted in Barnett 1918, p. 152.

31. Whitechapel Fine Art Loan Exhibition catalogue, 1882.

32. Barnett 1883, p. 347.

33. Spoken at the official presentation of the mosaic (Barnett 1918, pp. 170–71).

34. Samuel Barnett to his brother, 23 April 1897 (London Metropolitan Archives Barnett Letters n.170).

A 'state' gallery? The management of British art during the early years of the Tate

Alison Smith

In March 1891 a letter signed 'A Constant Reader' was published in the periodical *Land and Water* suggesting that the prefix 'S' be added to the name of the donor of funds for a new gallery of national art, so the British Luxembourg would become 'The State Gallery'.[1] Although this statement marries two seemingly incompatible concepts, philanthropic individualism with central cultural authority, the idea of the museum as a semi-autonomous organization had been promoted at various times throughout the century. The early history of the Tate is often presented as a compromise between the interests of the state and entrepreneurial capitalism in the matter of promoting British art amongst a democratic audience, a compromise which paradoxically assisted in both the popularization and marginalization of the British school.[2] Recent centenary celebrations and the anticipated restoration of the Tate to its original role as the custodian of native art have led scholars to reflect on how the early policies of the governing board might influence future decisions.[3] Will the Millbank Tate have a similar subordinate relation to the new Gallery of Modern Art at Bankside as it had to the National Gallery (NG)? And will it ever resolve its relationship with Trafalgar Square over the representation of British art within an 'Old Master' context? With the dividing line between the two collections now fixed at 1900, Victorian art remains nevertheless excluded from the NG, re-affirming previously projected ideologies concerning the singularity of the English school and the difficulty of accommodating it within the European mainstream.[4] By reversing the perspective back on to the nineteenth century, this essay examines the early history of the Tate (officially established as the National Gallery of British Art) under the control of the NG board, and considers how the compromise reached over management resulted in a succession of expedient but inconsistent policies which provoked a public debate about the very concept of a 'national' gallery.

The first practical suggestion of a National Gallery of British Art for which the state would be partly responsible can be traced back to a Select Committee report of the House of Commons for 1836 which recommended that part of the new Trafalgar Square building should be dedicated to the perpetuation of British art. Despite various later campaigns both to tempt and to cajole successive governments into providing a building, spurred on by a number of bequests to the nation, it was not until 1897 that a British gallery finally materialized in the form of the sugar-refiner Henry Tate's gift to the nation.[5] In the fifty years between Henry Cole's speech to the Society of Arts advocating a National Gallery of British Art by public voluntary contributions and the opening of the Millbank gallery, the campaign had spread beyond specialists in the art world to become a broader public concern.[6] In general terms the demand can be related to the rise in the middle-class patronage of British art fostered by a powerful dealer-critic system. The expansion in art education, and exhibition venues in London and the provinces, were significant in attracting a wider audience for art, an interest further stimulated by the International Exhibitions and shows organized in celebration of major anniversaries in the Queen's reign such as the Manchester Royal Jubilee Exhibition of 1887. Such developments were fuelled by a belief that art could act as a panacea for the social and moral ills induced by secularism and modern materialism. The conflation of art and ethics in contemporary criticism encouraged both the state and private citizens to provide for the country's cultural welfare. The call for a National Gallery of British Art was further sustained by a discourse on the nation's art that asserted its independence from continental traditions. Ernest Chesneau's claim that there was no English school, only 'separate manifestations', served to reinforce stereotypes about the 'individuality' of English art, paradoxically at a time when it was also acknowledged that the national school was becoming denationalized.[7]

The concept of 'separate manifestations' can also be applied to the collecting policy of the NG with regard to British art. In sharp contrast to the present day, the institution could list some 500 British works in 1897 (amounting to about a third of its entire collection), most of which had been given as gifts or bequests rather than purchased with the intention of establishing a comprehensive collection of distinction as was the case with other schools. The NG benefited from the tradition of bequests which encouraged both trustees and rich private collectors to view each other as collaborators working towards a similar goal. However, there existed a strong body of public opinion which suspected that the aristocratic trustees of the NG were more willing to invest public money in continental Old Masters than British works for which the ordinary tax-payer had greater empathy.[8] Although congestion was the main reason given for the poor display of British paintings at Trafal-

gar Square, works such as Frith's *Derby Day* (Jacob Bell bequest 1859) commanded a popular appeal. Annual Reports for the years leading up to the establishment of the Tate record attendance figures for copyists of both the categories into which the NG divided its collection – the Foreign (Old Masters), and the British and Modern – with attendance in the latter outnumbering the former by as much as 711 to 381 in 1888. The most popular artist for copyists was Landseer, his *Dignity and Impudence* and *Spaniels of King Charles' Breed* being the most frequently copied works of the British and Modern schools during the years 1887–93.[9]

Delay over the establishment of a gallery of British art can also be ascribed to the equivocation of successive governments. Increased state intervention in matters of social welfare and education during the course of the century has to be set against a more cautious view which maintained that art, for all its civilizing influence, was a luxury and that public funds were better directed towards serving more immediate needs. Such pragmatism resulted in a policy of non-interference, leaving the initiative in the hands of private benefactors. State ambivalence helps explain why so many museums had been set up as 'quangos' or Trustee museums, separate from Government departments.[10] One important demand to emerge from the paper the landscape painter James Orrock read to the Society of Arts in 1890 on the need for a fuller representation of British art at the NG, was that the State should take a more proactive role in the organization of the main collecting galleries (the British Museum, NG and South Kensington Museum). With no Ministry of Fine Arts or Act of Parliament to define the scope of these bodies, it was inevitable that they functioned at cross-purposes, each accepting works which ought to be the exclusive concern of one of the others.[11]

From the time Tate's gift was first announced in the press in the Spring of 1890, to the official opening of the gallery on 21 July 1897, the project was referred to as the 'British Luxembourg'. Established in 1818, the Museé du Luxembourg became the first European gallery to serve as a repository for officially sanctioned contemporary national art. Funds for purchases were voted each year by government and selection took place via the agency of the Directeur des Beaux Arts and a committee of consultation, both appointed by the Ministry of Public Instruction. By 1875 the Luxembourg had accumulated some 240 works but managed to maintain space for new acquisitions via a filtering system through which pictures were transferred either to the Louvre or the provinces. A rule stipulated that ten years had to expire following the death of an artist before any work judged as a masterpiece could be promoted to the Louvre. In a letter to Tate, an unidentified writer described the role of the Luxembourg in Darwinian terms: 'a museum of selection in which the fittest survives ultimately in the Louvre'. Works deemed unworthy of promotion were dispatched 'into purgatory (the provinces) or state buildings'.[12]

The Luxembourg model was favoured by commentators such as Orrock who thought neither the quango nor benefactor systems served the best interests of British art. Orrock proposed an alternative: a federation of galleries under a Ministry of Fine Arts, which would adjudicate and select works from bequests in order to establish quality control. John Charles Robinson, erstwhile Curator of the South Kensington Museum, was also forthright in warning against the dangers presented by private donations, some of which, like the Sheepshanks and Tate gifts, he dismissed as 'worthless trash'![13]

The new gallery thus presented the challenge of activating a state reluctant to fund the arts, and regulating, without deterring, the conscientious capitalists who had been largely responsible for the formation of many galleries in London and the provinces, either funding a whole enterprise or intervening when local rates proved insufficient.[14] However, a number of critics opposed the principle of government intervention, contending that greater state involvement in the market for pictures would pave the way for the 'immense machines' seen in the French Salons, undermining the individuality of the English school.[15] There was also the question of funding. Should the government oversee the whole process of selection and purchase, and how would this affect ordinary taxpayers? While one commentator believed a slight increase in income tax would be widely accepted so long as the grant was directed towards serving a national gallery, the academic W. M. Conway argued that if the collection was to be called 'national' and paid for out of a consolidated fund, it would have to be constantly itinerant. Were it to be permanently resident in London it would have to be subsidized by private munificence rather than London rates as the LCC did not have the same incentive as provincial municipalities for such expenditure, there already existing a ready market in the form of exhibitions.[16] Conway's concept of a circulating collection may well have been intended as a corrective to the French model of 'promotion', not to mention the National Gallery Loan Act of 1883, which allowed the museum's trustees to 'weed out' 'superfluous' works for the regions, reinforcing metropolitan superiority.[17]

Another subject of contestation was the intended function of the proposed gallery. Should it form a representative history of national art, or was it to be a museé de passage through which British masterpieces entered the NG? Though the principle of 'promotion' was accepted implicitly, the exact relation of the new gallery to Trafalgar Square remained unclear. Should the NG still accept works by living artists? How many years would it take for a work to qualify for transference? And would the loss of British works impair the existing display at Trafalgar Square? The Spectator recommended that the NG should abandon its present pedagogic hang, in which paintings were arranged chronologically according to school, and instead revert to a system where important British works could be displayed alongside the Old Masters.[18]

Although critics were unanimous in wanting to elevate the reputation of modern 'classics' such as Constable and Turner, they were less united in pronouncing which contemporary painters were worthy of promotion. Millais, for instance, was England's most commercially successful artist yet, while many critics believed he deserved a position in the NG on grounds of technical dexterity, dissenters such as Mrs Barrington found his works 'popular', lacking the necessary 'distinction' which alone qualified an artist for a place among the Old Masters.[19]

Established through the combined agencies of the art market, private munificence and institutional authority, the Tate in the event did not fit the Luxembourg model. Writing in 1962, John Rothenstein described the early collections as 'a heterogeneous group' that 'lacked coherence'.[20] In 1897 the new Millbank gallery displayed some 266 works assembled from four disparate collections: 65 paintings and two bronzes from the Tate gift; 85 works purchased under the terms of the Chantrey Bequest and transferred from the South Kensington Museum; 18 paintings presented by G. F. Watts; and 96 paintings conveyed from the NG, including 38 works from the Vernon collection.[21] Rather than forming a comprehensive survey, the collections were hung separately in the seven picture galleries provided by Sidney Smith's grand design, each representing a 'separate manifestation' of the British school (Figure 12.1).[22]

The Chancellor of the Exchequer, Sir William Harcourt, established the gallery as an annexe to the NG, partly to assuage rivalry and to secure an outlet for works which could not be shown at Trafalgar Square due to overcrowding. There was only one Board for the two galleries. Although the Tate had its own Keeper, Charles Holroyd, he was responsible to the Board of the NG and it was to this body that he had to appeal for further transfers. Otherwise all purchases and the allocation of pictures between the two galleries rested with the trustees, whose power had become more real after 1894 when the Director, while remaining Chief Executive, was made a member of the Board, responsible with the trustees for policy.[23] The Board was answerable to the Treasury whose solicitors had sanctioned the Tate gift plus the costs of staffing and maintenance, as well as approving the hours and conditions of opening.[24] The trustees were Liberal aristocrats and wealthy businessmen, a number of whom were collectors of British art, notably Sir Charles Tennant and the Earl of Carlisle. The latter was a prime mover behind the establishment of the National Gallery of British Art, having defined the scope of its collections and liaised closely with Tate over the problem of the site.[25] The traditional bias of the Board towards collecting continental Old Masters was therefore modified by the presence of members who were keen advocates of the British school. The NG Director, E. J. Poynter, like his precursor Sir Charles Eastlake, was an artist, educationalist and official,

GROUND FLOOR PLAN.

The Sculpture Hall, Vestibule and 7 Galleries comprise the portion
of the building at present erected.

———

1.—CHANTREY BEQUEST.

2.—WATTS COLLECTION.

3.—TATE COLLECTION.

4.—BRITISH SCHOOL from NATIONAL GALLERY
 and VERNON COLLECTION.

5.—BRITISH SCHOOL from NATIONAL GALLERY.

6.—WATTS COLLECTION, &c.

7.—CHANTREY BEQUEST.

8. FIRST FLOOR.—WATER-COLOURS, &c.

1046—3—11/98 Wt 17690 D & S 26 A 2

12.1 Ground floor plan of the Tate Gallery, 1898

having served as Slade Professor of Art and Principal of the National Art Training School. In 1896 he was elected President of the Royal Academy and thus became a vital intermediary between the RA and NG in managing the Tate collections in which the RA was involved through its control of the Chantrey Bequest funds. In November 1898 the Treasury requested that the NG Board concur in a proposed intimation from the government to the RA 'that no power of selection or elimination [be] claimed on behalf of the Trustees and Director of the National Gallery in respect to works purchased under the terms of the Chantrey Bequest.'[26]

The Tate was thus subordinate to the authority of two institutions, each of which was concerned to protect its own distinct interests. In July 1898, on the recommendation of the Treasury, the number of trustees was increased from six to eight, new members including Tate himself, John Murray Scott and Earl Brownlow.[27] The reconstitution of the Board assisted in widening the gulf between the power of the trustees and the impotence of Tate officials over policy. Yet, while the presence of commercial representatives on the Board was indicative of how the amateur aristocratic system of management was converging with bourgeois power over cultural control, in the public realm the demand was voiced for a greater professionalism within art institutions. The establishment of the Museums Association in 1889 was just one indication of this, as were the requests voiced in several papers for the introduction of 'new blood' into the administrative framework of both the NG and RA.[28]

In March 1897 the Board debated the question of which pictures from the national collection should be transferred to Millbank. Recognising the difficulties of assembling a selection that was comprehensive and logical, the trustees postulated three guiding principles for transference: that Trafalgar Square should not be denuded of masterpieces; that only pictures which belonged clearly to the modern British school should be removed; that the Board should endeavour to avoid a selection that appeared to have been dictated by the desire to send only inferior works to the new gallery.[29] While the first tenet was upheld, the second and third were interpreted more opportunely, reinforcing the fledgling status of the new gallery and, by implication, the British school.

Because the NG had accepted British works on a variety of bases, the legality of the proposed transfer was bound to be a matter of contention as much from within as outside the institution. To begin with, there was considerable disagreement amongst the trustees over how to define the 'modern' period. While Poynter, Carlisle and J. P. Heseltine argued for the new gallery's remit to begin with artists born in 1790 or later on the basis that this would allow for a representative selection of British art at Millbank, Lansdowne and Rothschild preferred 1800 as a more straightforward benchmark. The latter group feared the removal of notable works from a building

with which they had been long associated would result in the new gallery gaining prestige at the expense of the older institution, despite Carlisle's assurances that because the Tate was intended to serve as the 'Luxembourg' for the reception of modern pictures, and due to its being under the control of the Board, any picture temporarily removed could ultimately be returned upon the trustees' request.[30] An understanding was reached whereby modern works by 'popular' artists such as Landseer and Millais remained, while a number of works by artists born before 1790 were transferred, notably six Constables and six Wilkies.[31]

The legal status of bequests was also disputed. Of the 139 works (excluding the Vernon bequest) drawn up for transfer, gifts and bequests outnumbered purchases by 103 to 35.[32] The majority of gifts had been donated on the understanding that they would remain perpetually in the NG although no contractual agreement to guarantee this was entered into, there having been no alternative destination until 1897. Rothschild and Lansdowne had opposed the removal of any notable work acquired by bequest, and even after a compromise was reached, the Board was occasionally called upon to justify its decision.[33] In August 1897 Mrs Constance Lawson, widow of Cecil Lawson, complained in two letters to the Keeper, Charles Locke Eastlake, that her husband's *August Moon*, presented in 1883, had been transferred in breach of the original agreement. However, upon referring to the letter that accompanied the gift, the Board confirmed that, as with other donations, no such conditions had been specified which could veto the transfer.[34] It is likely that Charles Tennant had this case in mind when he proposed to donate Millais's *Portrait of Gladstone* to the nation. A letter from him read at a Board meeting of 24 May 1898 stipulated that the offer was 'subject to the condition that the picture remain permanently at the National Gallery, Trafalgar Square'.[35] Tennant's terms were accepted by the Board even though they contravened both the 1790 principle and a National Portrait Gallery resolution read and adopted the same meeting which stated that any work given or acquired by the nation 'if it be *prima-facie* a portrait of great historical importance, should be deposited in the National Portrait Gallery'.[36] However, this rule-bending to accommodate a distinguished trustee did not become a regular habit. In May 1900, Carlisle, acting as Chairman of the Burne-Jones Memorial Committee, proposed that the NG should accept the artist's *King Cophetua and the Beggar Maid* on the understanding that the balance of the purchase money of £6,500, of which over £5,000 had been subscribed by the public, should be provided from NG funds. The Board turned down the proposal arguing that the money at its disposal could not be used for the purpose on the 1790 rule. The remaining sum was thereafter raised by general subscription and the Board eventually agreed that the painting could hang among the Old Masters for six months prior to its being removed to Millbank.[37]

Such instances would imply that the trustees neither envisaged nor developed a clear policy with regard to the division of pictures. The Board's policy of no policy was essentially a pragmatic response to the problem of fulfilling the role assigned to it by government: of establishing a coherent system of regulation while maintaining the bequest system on which the collections depended. Partly as a result, from the very beginning, the management of the Tate became the focus of considerable press criticism. Some critics felt the trustees were failing to serve the cause of British art through the implementation of arbitrary policies. In 1898 the *Daily News* questioned the extent to which the Board was empowered to loan paintings donated to the nation to fee-charging exhibitions. The Tate had the most representative selection of Millais's paintings, affirming the artist's reputation as England's most popular painter. That January, six works entrusted to the nation were loaned to the Millais retrospective at Burlington House, and the paper asked: 'Why should the non-paying public be deprived of the privilege of seeing them, in order that the paying public at Burlington House may be saved a journey to Trafalgar Square and Millbank?'[38] The complaint was not against Tate who had made such loans a condition of his original gift, but the NG Board, who were infringing the National Gallery Loan Act by authorizing the dispatch of the celebrated *A Yeoman of the Guard*.[39]

Suspicions that the Tate was subject to the indiscriminate judgements of a coterie of Academicians and public figures surfaced in the form of complaints regarding omissions from the British collection, despite Holroyd's intervention in attempting to persuade the Board to help the gallery build a more comprehensive collection.[40] Both the Tate gift and the Chantrey Bequest were dominated by works by Royal Academicians to the exclusion of 'outsiders' and alternative networks such as the NEAC and Glasgow Impressionists. The critic D. S. MacColl compared the Chantrey trustees' purchase of a watercolour by a nonentity for £150 with the French government's acquisition in November 1891 of Whistler's *Portrait of his Mother* for £160.[41] Even though omissions were gradually filled by gifts, the fact that these were individual donations reinforced the idea that the survival of the British school depended upon private munificence. Criticisms of the way in which the RA trustees managed the Chantrey Bequest were aggravated by the institution's quasi-autonomous status which protected it from outside interference. The barrister W. J. Laidlay and the critics George Moore and MacColl were at the forefront in attacking the RA as a commercial enterprise subventioned by government, contending that, rather than functioning to represent the full range of the nation's art, the institution turned its handling of the Bequest to its own advantage by buying works by Academicians which did not sell on the open market for inflated prices and then imposing these on the public.[42]

By 1900 it was widely acknowledged that the RA was colluding with the NG in using the Tate as a dumping ground for inferior works, and that demotion rather than promotion had become the presiding principle of transfer. That year the Board decided to remove temporarily to Millbank nine modern foreign pictures which hitherto had been displayed alongside British paintings at Trafalgar Square, plus 17 drawings and 22 British pictures, a number of which were by artists born before 1790.[43] The transfer of the foreign paintings incited outrage amongst proponents of British art. In one of a series of articles on the Tate, M. H. Spielmann spoke out against the Board, accusing its members of betraying Tate's patriotic scheme by employing the new site as a convenience for the disposal of unwanted modern works.[44] As the demand rose for a public inquiry into the administration of the Tate, a number of critics went so far as to demand an absolute separation of the National Gallery of British Art from the NG on the grounds that the present system was detrimental to the reputation of the national school. Because the Tate had been established as a 'national' gallery, the issue of the legality of the division and transfer of works was inevitably made transparent via the democratic agency of the press, and the benefits of the Luxembourg model for serving the cause of British art were consequently questioned. Although the Board was exonerated through its role as the arbiter of an inveterate problem, the early management of the Tate brought to public attention the institution's lack of any real cultural autonomy. The Tate's struggle for a separate identity thus continued in the following century. On the recommendation of the 1915 Curzon Report the Tate was converted from a Gallery of Modern British Art to a Gallery of British and Modern Foreign Art, and was allowed its own Board of trustees in 1917. The Gallery was given a separate Purchase grant in 1946, but it was not until 1955 that it became legally separated from the NG. In 2000 the Tate will revert to its original role as the National Gallery of British Art.

Notes

1. *Land and Water*, 28 March 1891 (TGA Press Cuttings, p. 51).

2. Taylor 1994, p. 27; Fyfe 1995, pp. 5–41; Spalding 1998, pp. 13–21.

3. See, for example, editorial in the *Burlington Magazine*, vol. 140, no. 1142, May 1998, p. 229.

4. The terms 'British' and 'English' were used interchangeably by critics during the late nineteenth century. Ideas concerning the insularity and individuality of English art were widely propagated with the publication in English of Sizeranne 1898, and in the numerous official and non-official catalogues of the Tate Gallery.

5. The most important precedents for the Tate gift were the donations of British works given by Robert Vernon (1847), J. M. W. Turner (1856), and John Sheepshanks (1857). The Chantrey Bequest, which became effective from 1876, was administered by the trustees of the RA and was directed towards the purchase of British works in the hope that the government would provide a suitable building. Tate was the *éminence grise* behind the establishment of a British gallery,

offering first his collection of modern British art, and later £80,000 for the erection of a building. The full history of the negotiations surrounding the establishment of the Tate falls beyond the scope of this study and is well documented in Farr 1984; Taylor 1994; Tate Gallery 1997; Spalding 1998.

6. Cole 1848, pp. 22–4.

7. Chesneau 1885, p. 2; Cook 1898, p. 11; Tate Gallery, 1897; Hartley 1905, pp. 197–8.

8. *The Graphic*, 1890; *Liverpool Daily Post*, 2 November 1892 (TGA Press Cuttings, pp. 10 and 95); Cook 1898, p. 6.

9. Report of the Director of the National Gallery for 1888, p. 28. It was partly due to Landseer's popularity with copyists that the governing Board later decided to retain the majority of his works at Trafalgar Square.

10. Pearson 1982, p. 26.

11. The same point was made by Harry Quilter in a letter to *The Times*, 16 July 1890 (TGA Press Cuttings, p. 31). Orrock's speech was linked to Tate's offer in a leading article in *The Times*, 13 March 1890, p. 9.

12. Extracts from a letter from Paris regarding the Museé de Luxembourg (TGA Letter Album, No. 7811.3.54).

13. 'Letter to the editor', *The Times*, 1 July 1890 (TGA Press Cuttings, p. 27). Criticisms of the benefactor system were also levelled by *The Graphic*, 1890; the *Daily Chronicle*, February 1892; *Society*, 20 February 1892 (all opposing the Tate gift; TGA Press Cuttings, pp. 10, 64 and 67). Attacks on other bequests were made by the *Whitehall Review,* 21 March 1891; the *Speaker*, 20 February 1892 (TGA Press Cuttings, pp. 51, 85); the *Academy*, 4 September 1897, p. 186.

14. For other examples of private munificence see Waterfield 1991, pp. 89, 92 and 112; Farr 1984, pp. 343–4.

15. *The Times* 1 July 1890 (TGA Press Cuttings, p. 26).

16. Unidentified letter to Henry Tate (7811.3.54); W. M. Conway, 'A letter to the editor', *The Times*, 11 April 1890 (TGA Press Cuttings, p. 13).

17. *The Times*, 1 July 1890 (TGA Press Cuttings, p. 26). Following Tate's withdrawal of his offer due to government prevarication over the site, the *Birmingham Daily Post* proposed that the British gallery be adjoined to the Birmingham art gallery and funded from regional capital (5 March 1892; TGA Press Cuttings, p. 76).

18. *The Spectator*, 24 July 1897, p. 113.

19. Barrington 1882, p. 63.

20. Rothenstein 1962, p. 19.

21. These statistics are taken from the *Descriptive … Catalogue of the National Gallery of British Art* 1898.

22. The display itself represented a compromise between market forces and institutional authority. Works from the Tate collection were selected by the trustees of the RA and hung by Sir William Agnew. E. J. Poynter was responsible for arranging the Chantrey Bequest and the paintings transferred from the NG.

23. 'The New Trustees of the National Gallery', *Art Journal*, December 1894, pp. 348–9; Holmes and Collins Baker 1924, pp. 65–6.

24. NG Board Minutes, vol.6, 7 August 1894, p. 289; vol.7, 1 June 1897, p. 1. The Tate was open to the public on the same terms as the NG. An admission of 6d was charged on 'student days' (Thursday–Friday); otherwise it was free on 'public' days (Monday–Wednesday, Saturday–Sunday).

25. In 1897 the trustees were the Marquess of Lansdowne, Mr John P. Heseltine, Lord Savile, Sir Charles Tennant, the Earl of Carlisle and Alfred C. de Rothschild (NG Board Minutes, vol.6, 13 April 1897, p. 389). Sir Charles Tennant was Director of the Assam Oil Company and of the Assam Railways and Trading Company. His picture collection included works by Gainsborough, Reynolds and Millais. He was made a trustee of the NG in 1894 (DNB entry signed 'A. H. M.' Supplement 1901–3, Vols. 1–3, p. 496). George Howard, 9th Earl of Carlisle, was an amateur artist and collector, particularly of the 'aesthetic' school (pp. 306–7). His correspondence with Tate over the site and role of the new gallery is in the Tate Gallery Archives.

26. NG Board Minutes, vol.7, 29 November 1898, p. 61. The Board was, however, permitted to loan works recently purchased by the Chantrey Bequest to the provinces prior to their being placed in the Tate Gallery (NG Annual Report 1897, p. 10; 1898, p. 4).

27. The increase in the number of trustees was originally put forward by Carlisle (NG Board Minutes, vol. 6, 9 February 1897, p. 377).

28. Waterfield 1991, p. 28; Fyfe 1995, p. 27.

29. NG Board Minutes, vol.6, 13 April 1897, p. 394.

30. Ibid., vol.6, 4 May 1897, p. 396; 13 April 1897, pp. 389–90.

31. Ibid., vol.6, 4 May 1897, pp. 394–6.

32. Ibid., pp. 382–8 (35 purchases, 67 bequests, 36 gifts). One painting was not accounted for in this list.

33. Ibid., vol.6, 8 March 1897, p. 380.

34. Letters to Eastlake from Mrs Constance Lawson, 16 August 1897 and 19 August 1897, NG Board Minutes, vol.7, 7 December 1897, p. 23. Although *August Moon* was widely hailed a masterpiece of the British school it was unfortunately placed in Room 7 above Frith's *Derby Day* where reflections made it virtually invisible. See *Sunday Times Short Guide* 1897, p. 16; *The Academy*, 21 August 1897, p. 153. The absence of a clear policy with regard to bequests resulted in the Board turning down J. Middlemore's offer to donate Holman Hunt's *Triumph of the Innocents* on the condition that it be placed in the NG (NG Board Minutes, vol.6, 20 January 1897, p. 370).

35. Letter to the Director from Charles Tennant, 23 May 1898 (NG7/224/1898); NG Board Minutes, vol.7, 24 May 1898 p. 50.

36. NPG Board Resolution of 19 May 1898 (NG7/224/1898), NG Board Minutes, vol.7, 24 May 1898, p. 51. Millais's *Portrait of Gladstone* (no. 1666) subsequently passed to the Tate and is now in the NPG.

37. NG Board Minutes, vol.7, 29 May 1900, p. 112; 2 August 1900, p. 120. The purchase of Sir Robert Peel's collection with a special Treasury grant of £75,000 in 1871, resulted in a substantial reduction in the annual grant, even after 1897 when this was supposed to be shared with the Tate (Farr 1984, p. 351).

38. *The Daily News*, 10 January 1898 (TGA Press Cuttings p. 174). The entrance fee was 1s. The Treasury agreed to the loan assuming that the RA would meet insurance costs. NG Board Minutes, vol.7, 11 January 1898, p. 30.

39. *A Yeoman of the Guard* was widely praised for its striking colour harmonies. According to Reid it was acclaimed by French critics when shown at the International Exhibition in 1878 (Reid 1909, p. 78).

40. See, for instance, Holroyd's 'Statement of Apology' with regards to the work of Alfred Stevens (Rothenstein 1962, p. 22).

41. Farr 1984, p. 345; MacColl 1903 (reprinted with additions 1904). See also MacColl's Desiderata List, 22 June 1909 (NG Archives), a request for a more controlled policy with regard to purchases to enable the Tate to establish a more comprehensive collection.

42. Laidlay 1898; Moore, G. (1892), *Fortnightly Review*, June (see *Chantrey* 1904); MacColl 1903.

43. NG Board Minutes, vVol.7, Special Meeting, 27 March 1900, pp. 103–5; Annual Report 1900, p. 6. The transfer was made in view of the enlargement of the Tate Gallery and the continued lack of space at Trafalgar Square. The foreign paintings were by H. Vernet, A. Scheffer, J. L. Dyckmans, F. Bonvin, C. Poussin, G. Costa, H. Fantin Latour and P. J. Clays. British artists born before 1790 included John Varley, David Cox and David Wilkie.

44. Spielmann, M. H.(1903), 'An Art Causerie', *The Graphic*, 5 September (TGA Press Cuttings, p. 191).

Select bibliography

Parliamentary papers

Report of the Select Committee on Arts and their Connexion with Manufactures (1836)
Report from the Select Committee on National Monuments and Works of Art (1841)
Report from the Select Committee on Art Unions (1845)
Seventh Report of the Fine Art Commissioners (1847)
Report of the Select Committee on the National Gallery (1850)
Report of the Select Committee on the National Gallery (1853)
Report of the National Gallery Site Commission (1857)
Report from the Commissioners on the Present Position of the Royal Academy in Relation to the Fine Arts (1863)
Report from the Select Committee on Art Union Laws (1866)
Report from the Select Committee on the Paris Exhibition (1867)

Published texts

Albert, Prince (1862), *The Principal Speeches and Addresses of His Royal Highness the Prince Consort*, London: John Murray
Alexander, C. and Sellars, J. (1995), *Art of the Brontes*, Cambridge: Cambridge University Press
Arnold, Mathew (1903), 'Culture and Anarchy', *The Works of Mathew Arnold* , vol. 6, London: Macmillan
Baedeker, K. (1892), *London And Its Environs*, 5th edition, Leipzig: Karl Baedeker
Barlow, Paul (1990), 'The Backside of Nature: Hogarthianism in Victorian Art', D.Phil, University of Sussex
—— (1994), 'The Imagined Hero as Incarnate Sign: Thomas Carlyle and the Mythology of the "National Portrait" in Victorian Britain', *Art History,* 17(4)
Barnett, Harriet (1883), 'Pictures for the People', *Cornhill Magazine*, vol. 47, March
—— (1918), *Canon Barnett, His Life, Work and Friends*, 2 vols, London: John Murray
Barnett, S and Barnett, H. (1888), *Practicable Socialism: Essays on Social Reform*, London: Longmans, Green and Co.

Barrell, John (1986), *The Political Theory of Painting from Reynolds to Hazlitt*, New Haven and London: Yale University Press

—— (1992), *Painting and the Politics of Culture 1700–1850* Cambridge: Cambridge University Press

Barringer, Tim (1997), 'The South Kensington Museum and the Colonial Project', in T. Barringer and T. Flynn (eds) (1997), *Colonialism and the Object*, London and New York: Routledge

—— (1999), 'Leighton in Albertopolis: Monumental Art and Objects of Desire', in T. Barringer and E. Prettejohn (1999), *Frederic Leighton: Antiquity, Renaissance, Modernity*, New Haven and London: Yale University Press

Barrington, E. I. (1882), 'Why is Mr. Millais our Popular Painter', *Fortnightly Review*, July

—— (1903), *Leighton and John Kyrle*, Edinburgh: David Douglas

—— (1906), *The Life, Letters and Work of Frederic Leighton,* 2 vols, George Allen: London

Battiscombe, G. (1978), *Reluctant Pioneer: A Life of Elizabeth Wordsworth*, London: Constable

Bennett, T. (1995), *The Birth of the Museum*, Routledge: London.

Bermingham, Ann (1994), 'System, Order, and Abstraction: The Politics of English Landscape Drawing Around 1795', in W. J. T. Mitchell (ed.) (1994), *Landscape and Power*, London and Chicago: University of Chicago Press

Besant, Walter (1884), 'How can a Love and Appreciation of Art be best developed among the Masses of the People?', *Transactions of the National Association for the Promotion of Social Science*, London: Green and Co.

Boase, T. S. R. (1954), 'The Decoration of the New Palace of Westminster, 1841–1863', *Journal of the Warburg and Courtauld Institutes*, 17

—— (1959), *English Art: 1800–1870*, Oxford: Oxford University Press

Bodichon, M. D. (1859), *Of Humanity*, London: Holyoake and Co.

Boime, Albert, (1980), *Thomas Couture and the eclectic vision*, New Haven and London: Yale University Press

Bond, M. (ed.) (1980), *Works of Art in the House of Lords*, London: HMSO

Borzello, F. (1987), *Civilizing Caliban: The Misuse of Art, 1875–1980*, London: Routledge and Kegan Paul

Bourdieu, P. (1993), *The Field of Cultural Production*, Cambridge: Polity Press

Bourne, J. H. (1986), *Patronage and Society in Nineteenth-Century England*, London: Matthew Arnold

Carlyle, T. (1989), *The French Revolution*, Oxford: Oxford University Press

Chantrey and his Bequest: A complete illustrated record (1904), London: Cassell and Co.

Cherry, Deborah (1995), 'Women Artists and the Politics of Feminism 1850–1900', in C. C. Orr (ed.) (1995), *Women in the Victorian Art World*, Manchester: Manchester University Press

Chesneau, E. (1885), *The English School of Painting*, trans. by L. N. Etherington, London: Cassell and Co.

Clarke, H. G. (1842), *The National Gallery: its Pictures and their Painters*, London: Clarke and Wilson

—— (1843), *A Hand-Book Guide to the Cartoons now Exhibiting in Westminster Hall*, London: H. G. Clarke and Co

—— (1844), *A Critical Examination of the Cartoons, Frescoes and Sculptures in Westminster Hall, to which is added the History of Fresco Painting*, London: H. G. Clarke and Co.

Cole, Henry (1848), 'On the formation of a National Gallery of British Art by Public Voluntary Contributions', in *A Catalogue of the pictures, drawings, sketches, etc. of William Mulready, R.A. (1848)*, Chiswick: Charles Whittingham

—— (1878), 'The Meaning of Art Culture', in *Annual Report of the Manchester School of Art*, Manchester: Falkner and Sons

Constable, John (1962–68), *Correspondence*, ed. R. B. Beckett, Ipswich: Suffolk Records Society

Conway, M. D. (1882), *Travels in South Kensington with Notes on Decorative Art and Architecture in England*, London: Trübner & Co., New York: Harper & Bros

Cook, E. C. (1897), *London and Environs*, London: Darlington & Co.

Cook, E. T. (1898), *A Popular Handbook to the Tate Gallery 'National Gallery of British Art'*, London: Macmillan and Co.

Coombes, A. E. (1994), *Reinventing Africa: Museums, Material Culture, and Popular Imagination in Late Victorian and Edwardian England*, New Haven and London: Yale University Press

Corrigan, P. and Sayer, D. (1985), *The Great Arch: English State Formation as Cultural Revolution*, Oxford: Blackwell

Cunningham, A. (1829–33), *The Lives of the Most Eminent British Painters, Sculptors, and Architects*, 6 vols, London: John Murray

Denis, R. and Trodd, C. (eds) (2000), *Academies of Art in the Nineteenth Century*, Manchester: Manchester University Press

Descriptive and Historical Catalogue of the Pictures and Sculptures in the National Gallery of British Art with Biographical notes of the Deceased Artists (1898), 3rd edition, London

Dick, W. R. (1853), *Inscriptions and Devices, in the Beauchamp Tower*, London: Peter Ramage

Dodd, Sara, M. (1995), 'Art Education for Women in the 1860s: a Decade of Debate', in C. C. Orr (ed.) (1995), *Women in the Victorian Art World*, Manchester: Manchester University Press

Duncan, Carol (1991), 'Art Museums and the Ritual of Citizenship', in I. Karp and S. D. Lavine (eds) (1991), *Exhibiting Cultures: the Poetics and Politics of Museum Display*, London and Washington: Smithsonian Institution Press

—— (1995), *Civilising Rituals: Inside Public Art Museums*, London: Routledge

Dyce, W. (1853), *The National Gallery. Its Formation and Management considered in a Letter Addressed by Permission to H.R.H. The Prince Albert, K.G.*, London: Chapman and Hall

Eagles, J. (1857), *Essays Contributed to Blackwood's Magazine*, Edinburgh and London: Bodkin and Co.

Edwards, E. (1840), *The Fine Arts in England, their State and Prospects Considered Relatively to National Education*, London: Saunders and Otley

Egerton, Judy (1998), *National Gallery Catalogues: The British School*, London: National Gallery Publications

Elmes, J. (1831), *Topographical Dictionary of London*, London: Whittaker, Treacher and Arnot

Farington, Joseph (1978–98), *Diary*, ed. K. Garlick, New Haven and London: Yale University Press

Farnborough, Lord (1826), *Short Remarks and Suggestions Upon Improvements now carrying on or under Consideration*, London: J. Hatchford and Sons

Farr, Denis (1984), *English Art 1870–1940*, Oxford and New York: Oxford University Press

Feaver, William (1975), *The Art of John Martin*, Oxford: Clarendon Press

Fenwick, S. and Smith, G. (1997), *The Business of Watercolour: A Guide to the Archives of the Royal Watercolour Society*, Aldershot: Ashgate

Foggo, G. (1835), *A Letter to Lord Brougham on the History and Character of the Royal Academy*, London: privately printed

—— (1837a), *Report of the proceedings at a public meeting held to promote the admission of the public, without charge, to Westminster Abbey, St. Paul's Cathedral, and depositories of works of art, of natural history, and objects of historical and literary interest in public edifices.* London: privately printed

—— (1837b), *Results of the Parliamentary Inquiry Relative to Arts and Manufactures*, London: T and W. Boone

Foucault, Michel (1977), *Discipline and Punish*, trans. A. Sheridan, London: Allen Lane

—— (1986), 'Of Other Spaces', *Diacritics*, 16 (1)

Fullerton, Peter (1982), 'Patronage and Pedagogy; the British Institution in the Early Nineteenth Century, *Art History*, 5 (1)

Funnell, Peter (1992), 'The London Art World and its Institutions', in C. Fox (ed.) (1992), *London – World City – 1800–1840*, New Haven and London: Yale University Press

—— (1995), 'William Hazlitt, Prince Hoare, and the Institutionalisation of the Briitsh Art World', in B. Allen (ed.) (1995), *Towards a Modern Art World*, New Haven and London: Yale University Press

Fyfe, Gordon (1995), 'The Chantrey Episode: Art Classification, Museums and the State, 1870–1920', in S. Pearce (ed.) (1995), *Art in Museums: New Research in Museum Studies* (5), London: Athlone

—— (2000), 'Auditing the RA: official discourse and the nineteenth-century Royal Academy', in R. Denis and C. Trodd (eds) (2000), *Academies of Art in the Nineteenth Century*, Manchester: Manchester University Press.

Gage, John. (1995), '*The British School* and the British School', in B. Allen (ed.) (1995), *Towards a Modern Art World*, New Haven and London: Yale University Press

Gillett, P. (1990), *The Victorian Painter's World*, Gloucester: Alan Sutton

Gladstone, W. E. (1841), *The State in its Relations with the Church*, 4th edition, 2 vols, London: John Murray

Godwin, G. (1854), *London Shadows; a Glance at the 'Homes' of the Thousands*, London: George Routledge and Co.

—— (1872), *Town Swamps and Social Bridges*: Leicester: Leicester University Press

Gosse, E. (1885), *The Masque of Painters*, privately printed

Grote, H. (1850), *The Case of the Poor against the Rich Fairly Considered by a Mutual Friend*, London: Savill and Edwards

—— (1862), *Collected Papers*, London: John Murray

Halkett, G. R. (1878), *Walker Art Gallery Notes*. Liverpool: Warburton Bros

Hall, Catherine (1992), *White, Male, Middle-Class: Explorations in Feminism and History*, Cambridge: Polity Press

—— (1994), 'Rethinking Imperial Histories: the Reform Act of 1867', *New Left Review*, 208, December

Hamerton, P. G. (1873), *Thoughts about Art:* London: Macmillan and Co

Hamilton, J. (1997), *Turner: A Life,* London: Hodder and Stoughton

Hamlyn, R. (1993), '*Robert Vernon's Gift: British Art for the Nation, 1847*, London: Tate Gallery

Handbook to the Water Colours, Drawings, and Engravings, in the Art Treasures Exhibition (1857), Manchester: Bradbury and Evans

Harrison, M. (1985), 'Art and Philanthropy: T. C. Horsfall and the Manchester Art Museum', in A. Kidd and K. Roberts (eds) (1985), *Class, City and Culture*, Manchester: Manchester University Press.

Hartley, C. G. (1905), *Pictures in the Tate Gallery*, London: Seely

Haskell, F. (1980), *Rediscoveries in Art: some aspects of taste, fashion and collecting in England in France*, 2nd edition, London: Phaidon

Haydon, B. J. (1844–46), *Lectures on Painting and Design*, London: Longman, Brown, Green and Longmans

—— (1853), *Life of Benjamin Robert Haydon, Historical Painter, from His Autobiography and Journals*, ed. T. Taylor, 3 vols, London: Longmans

Hazlitt, William (1930–34), *The Complete Works*, ed. P. Howe, 21 vols, London, Toronto, J. M. Dent

Hemingway, A. (1993),'Genius, gender and progress: Benthamism and the arts in the 1820s', *Art History*, 16 (4)

Herstein, S. R. (1985), *A Mid-Victorian Feminist: Barbara Leigh Smith Bodichon*, London and New Haven: Yale University Press

Hodgson, J. E. (1887), *Fifty Years of British Art as illustrated by the pictures and drawings in the Manchester Royal Jubilee Exhibition*, London: John Heywood

Holmes, Sir Charles and Collins Baker, C. H. (1924), *The Making of the National Gallery 1824 to 1924: An Historical Sketch*, London: National Gallery

Hooper-Greenhill, E. (1992), *Museums and the Shaping of Knowledge*, London: Routledge

Horsfall, T. C. (1877), *An Art Museum for Manchester*, Manchester: privately printed

—— (1882), 'In what way can the Influence of Art be best brought to bear on the masses of the Population in Large Towns?', in *Transactions of the National Association for the Promotion of Social Science*, London

Jones, G. S. (1974), 'Working Class Culture and Working Class Politics in London 1879–1900', *Journal of Social History* 7 (4)

Kane, Sarah (1996), 'Turning Bibelots into Museum Pieces: Josephine Coffin-Chavallier and the Creation of the Bowes Museum at Barnard Castle', *Journal of Design History*, 9 (1)

Keating, P. J. (1973), 'Fact and Fiction in the East End', H. J. Dyos and M. Wolff (eds) (1973), *The Victorian City: Images and Realities*, London: Routledge

King, Anthony, (1964), 'George Godwin and the Art Union of London 1837–1911', *Victorian Studies*, 8 (2)

King, L. S. (1985), *The Industrialization of Taste: Victorian England and the Art Union of London*, Ann Arbor, Michigan: UMI Research Press.

Knight, C. (1841), *London*, London: Knight and Co

Knowles, J. (ed.) (1830), *Lectures on Painting, Delivered at the Royal Academy*, 2nd series, London: John Murray

Koven, Seth (1994), 'The Whitechapel Picture Exhibitions and the Politics of Seeing', in D. J. Sherman and I. Rogoff (eds) (1994), *Museum Culture: Histories, Discourses, Spectacles*, London: Routledge

Kusamitsu, Toshio (1980), 'Great Exhibitions before 1851', *History Workshop*, 9

Laidlay, W. J. (1898), *The Royal Academy, its Uses and Abuses*, London: Simpkin, Marshall, Hamilton Kent and Co. Ltd

Laing, Alistair (1998), 'William Sequier and Advice to Picture Collectors', in C.

Sitwell and S. Staniforth (eds) (1998), *Studies in the History of Painting Restoration*, London: Archetype Publications in association with the National Trust

Lee, A. (1955), *Laurels and Rosemary: the Life of William and Mary Howitt*, London: Oxford University Press

Leslie, C. R. (1855), *A Hand-book for Young Painters*: London: John Murray

—— (1860), *Autobiographical Recollections*, ed. T. Taylor, 2 vols, London: John Murray

Lloyd, Duncan and Thomas Paul (1998), *Culture and the State*, New York and London: Routledge

MacColl, D. S. (1903), 'The Maladministration of the Chantrey Bequest'; 'Parliament and the Chantrey Bequest', *Saturday Review*, 25 April; 6 June (reprinted with further details as a pamphlet 1904)

MacDonagh, O. (1977), *Early Victorian Government*, London: Weidenfeld

Macdonald, S. (1970), *The History and Philosophy of Art Education*, London: University of London Press

Mace, R. (1976), *Trafalgar Square: Emblem of Empire*, London: Lawrence and Wishart

Mallet, D. (1979), *The Greatest Collector, Lord Hertford and the Founding of the Wallace Collection*, Frome and London: Butler and Tanner

Marrinan, M. (1988), *Painting Politics for Louis-Philippe: Art and Ideology in Orleanist France*, New Haven and London: Yale University Press

—— (1994), 'Historical Vision and the Writing of History at Louis Philippe's Versailles', in P.-D. Chu and G. P. Weisberg (1994), *The Popularization of Images: Visual Culture under the July Monarchy*, Chichester N.J.: Princeton University Press

Martin, Gregory (1974), 'The Founding of the National Gallery in London' (in 9 parts), *Connoisseur*, April–December

McCelland, Keith (1996), 'Rational and Respectable Man', in L. Frader and S. O. Rose (eds) (1996), *Gender and Class in Modern Europe*, London and Ithaca: Cornell University Press

Mearns, Andrew (1883), *The Bitter Cry of Outcast London*, reprinted with intro. by A. S. Wohl (1970), Leicester University Press

Miller, E. (1973), *That Noble Cabinet; A History of the British Museum*, London: Andre Deutsch

Millet, K. (1971), *Sexual Politics*, New York: Avon

Millingen, J. (1831), *Some Remarks on the State of Learning and the Fine Arts*, London: J. Rodwell

Mitter, P. (1997), 'The Imperial Collections: Indian Art', in M. Baker and B. Richardson (eds) (1997), *A Grand Design, The Art of the Victoria and Albert Museum*, London: V & A Publications

Mitter, P. and Clunas, C. (1997), 'The Empire of Things: The Engagement with the Orient', in M. Baker and B. Richardson (eds) (1997), *A Grand Design, The Art of the Victoria and Albert Museum*, London: V & A Publications

Moore, G. (1893), *Modern Painting*, London: Walter Scott Ltd

Mulock, D. (1858), *A Woman's Thoughts about Women*, London: Hurst and Blackett

Munford, W. A. (1960), *William Ewart, M.P., 1798–1869, Portrait of a Radical*, London: Grafton and Co.

Newall, C. (1987), *Victorian Watercolours*, Oxford: Phaidon

Nunn, P. G. (1987), *Victorian Women Artists*, London: Women's Press

—— (1995), *Problem Pictures: Women and Men in Victorian Painting*, London: Scolar Press

Orr C. C. (ed.) (1995), *Women in the Victorian Art World*, Manchester: Manchester University Press

Ottley, W. Y. (1832), *A Descriptive Catalogue of the Pictures in the National Gallery, with Critical Remarks on their Merits*, London: John Jackson and Co.

Palgrave, F. T. (1862), *Descriptive Handbook to the Fine Arts Collections in the International Exhibition of 1862*, London and Cambridge: Macmillan

—— (1866), *Essays on Art*, London: Macmillan and Co.

Pearson, N. (1982), *The State and the Visual Arts*, Milton Keynes: Open University Press

Pointon, M. (1993), *Hanging the Head: Portraiture and Social Formation in Eighteenth-Century England*, New Haven and London: Yale University Press

—— (ed.) (1994), *Art Apart: Art Institutions and Ideology across England and North America*, Manchester: Manchester University Press

Pomeroy, Jordana (1998), 'Creating a National Collection. The National Gallery's Origins in the British Institution', *Apollo*, August

Port, M. H. (1976), *The Houses of Parliament*, London and New Haven: Yale University Press

—— (1995), *Imperial London: Civil Government Building in London 1850–1915*, New Haven and London: Yale University Press for Paul Mellon Centre for Studies of British Art

Postle, Martin (1995a), 'The Foundation of the Slade School of Fine Art' Walpole Society

—— (1995b), 'In Search of the "True Briton": Reynolds, Hogarth, and the British School', in B. Allen (ed.) (1995), *Towards a Modern Art World*, New Haven and London: Yale University Press

Poynter, E. (1880), *Ten Lectures on Art*, 2nd edition, London: Chapman and Hall

Prettejohn, Elizabeth (1997), 'Aesthetic Value and the Professionalization of Victorian Art Criticism 1837–1878', *Journal of Victorian Culture*, 2 (1)

Pullan, Ann (1998), 'Public Goods or Private Interests? The British Institution in the early Nineteenth Century', in A. Hemingway and W. Vaughan (eds) (1998), *Art in Bourgeois Society 1790–1850*, Cambridge: Cambridge University Press

Reid, J. E. (1909), *Sir John Everett Millais PRA*, London: The Walter Scot Publishing Co. Ltd

Reynolds, J. (1959), *Discourses on Art*, ed. R. Wark, Yale University Press: New Haven and London

Robinson, A. J. and Chessyre, D. H. B. (1986), *The Green*, London: Tower Hamlets Central Library

Roget, J. L. (1891), *A History of the 'Old' Water-Colour Society*, London: Longmans

Rothenstein, J. (1962), *The Tate Gallery*, London: Thames and Hudson

Rothenstein, W. (1931), *Men and Memories: Recollections of William Rothenstein 1872–1900*, London: Faber and Faber

Rule, J. (ed.) (1988), *British Trade Unionism 1750–1850: the Formative Years*, London: Longman

Ruskin, John (1903–12), *The Works of John Ruskin*, ed. E. T. Cook and A. Wedderburn London: George Allen

Sandby, W. (1862), *The History of the Royal Academy*, 2 vols, London: Longman Green

Saville, John (1994), *The Consolidation of the Capitalist State, 1800–1850*, London: Pluto Press

Scharf, George (1858), *Artistic and descriptive notes of the most remarkable pictures in the British Institution of the Ancient Masters*, London: Longman Green

Shee, M. A. (1805), *Rhymes on Art*, London: John Murray

Shee, M. A. (1860), *The Life of Sir Martin Archer Shee by his Son*, 2 vols, London: John Murray

Sizeranne, Robert de la (1898), *English Contemporary Art,* trans. H. M. Poynter, London: Archibald Constable and Co.

Sherman, Daniel J. and Rogoff, I. (eds) (1994), *Museum Culture*, London: Routledge

Skaife, T. (1854), *Exposé of the Royal Academy*, London: Piper, Stephenson and Spence

Smith, F. B. (1996), *The Making of the Second Reform Bill*, Cambridge: Cambridge University Press

Spalding, F. (1998), *The Tate: A History*, London: Tate Gallery

Sunday Times Short Guide to the Tate Gallery of Contemporary Art (1897), London: Sunday Times Office

Survey of London, (1940), Vol.20, Trafalgar Square and Neighbourhood, by G. Gater and F. R. Hiorns, London: London County Council

Survey of London (1975), general editor F. H. W. Sheppard, Vol.38, The Museums Area of South Kensington and Westminster, London: Greater London Council

Tate Gallery (1897), *The National Gallery of British Art Illustrated Catalogue*, with intro. by D. C. Thompson, London: The Art Journal Office

Tate Gallery (1997), *Henry Tate's Gift: A Centenary Celebration*, London: Tate Gallery

Taylor, Brandon (1994), 'From Penitentiary to "Temple of Art": early modern metaphors of improvement at the Millbank Tate', in M. Pointon (ed.) (1994), *Art Apart: Art Institutions and Ideology across England and North America*, Manchester: Manchester University Press

—— (1999), *Art for the Nation: Exhibitions of the London Public 1747–2001*, Manchester: Manchester University Press

Taylor, T. (1857), *A Peep at the Pictures*, Manchester: Gore

Taylor, W. B. S. (1841), *The Origin, Progress and Present Condition of the Fine Arts in Great Britain and Ireland*, 2 vols, London: Whittaker and Co.

Thackeray, W. M. (1904), *Critical Papers in Art*, London: Macmillan and Co. Ltd

Thomas, C. (1967), *Love and Work Enough: the Life of Anna Jameson*, Toronto: University of Toronto Press

Thomas, W. E. S. (1979), *The Philosophic Radicals,* Oxford: Oxford University Press

Trodd, Colin (1994), 'Culture, Class, City: the National Gallery, London, and the Spaces of Education, 1822–1857', in M. Pointon (ed.) (1994), *Art Apart: Art Institutions and Ideology across England and North America*, Manchester: Manchester University Press

—— (1997), 'The Authority of Art: cultural criticism and the idea of the Royal Academy in mid-Victorian Britain', *Art History*, 20 (1)

—— (2000), 'Academic Cultures: The Royal Academy and the Commerce of Discourse in Victorian London', in R. Denis and C. Trodd (eds) (2000), *Academies of Art in the Nineteenth Century*, Manchester: Manchester University Press

Trodd, Colin, Barlow, P. and Amigoni, D. (eds) (1999), *Victorian Culture and the Idea of the Grotesque*, Aldershot: Ashgate Publishing.

Verney, F. P., Lady (1870), 'Fernyhurst Court', chapter 27, 'Waiting at the Exhibition', *Good Words*, 1 December

Waagen, Gustav (1838), *Works of Art and Artists in England*, trans. H. E. Lloyd, 3 vols, London: John Murray

—— (1853), 'Thoughts on the new building to be erected for the National Gallery of England', *Art Journal*, May

—— (1854–70), *Treasures of Art in Great Britain*, 3 vols, London: John Murray

Waterfield, G. (ed.) (1991), *Palaces of Art: Art Galleries in Britain, 1790–1990*, London: Dulwich Picture Gallery

—— (ed.) (1994), *Art for the People*, London: Dulwich Picture Gallery

Watts, M. (ed.) (1912), *G.F. Watts, Annals of an Artist's Life*, 3 vols, London: Macmillan

Weeks, Charlotte (1883), 'Women at Work: the Slade Girls', *Magazine of Art*, 6, June

Weinberg, Gail. S. (1997), '"Looking Backward": Opportunities for the Pre-Raphaelites to see "pre-Raphaelite" art', in M. F. Watson (ed.) (1997), *Collecting the Pre-Raphaelites: the Anglo-American Enchantment*, Aldershot: Ashgate

Wetherell, Charles (1995), 'The Great Reform Act of 1832 and the Political Modernization of England', *American Historical Review*, 100 (2)

What to see, and Where to see it! or the operative's guide to the Art Treasures Exhibition, (1878), Manchester: A. Heywood

Whitley, W. T. (1928), *Art in England, 1800–1820*, Cambridge: Cambridge University Press

—— (1930), *Art in England 1821–1837*, Cambridge: Cambridge University Press

Wilson, Shelagh (1995), 'Art and Industry: Birmingham Jewellery or Brummagem?', in K. Quickenden (ed.) (1995), *Silver and Jewellery: Production and Consumption since 1750*, Birmingham: Article Press

Yapp, G. W. (1852), *Art-Education at Home and Abroad: the British Museum, the National Gallery and the proposed Industrial University*, London: Chapman and Hall

Index